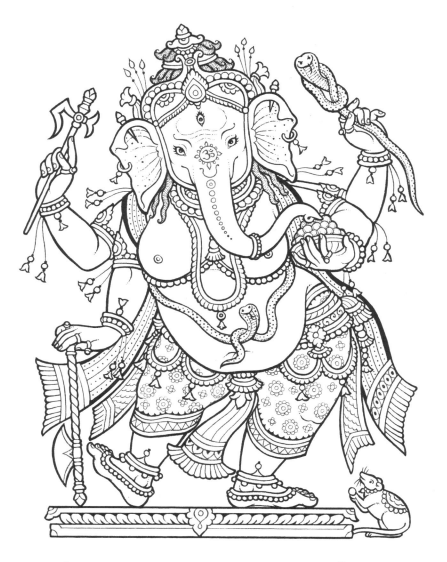

वागीशाद्याः सुमनसः सर्वार्थानामुपक्रमे ।
यां नत्वा कृतकृत्याः स्युः तां नमामि गजाननाम् ॥

I bow to that One-with-the-Face-of-an-Elephant,
she whom the primordial gods honored when beginning new ventures,
so that success might be ensured.

THE SHAKTI COLORING BOOK

Goddesses, Mandalas, and the
Power of Sacred Geometry

Illustrations & Text by
Ekabhumi Charles Ellik

Foreword by
Sally Kempton

SOUNDS TRUE
BOULDER, COLORADO

On the cover: Bhuvaneshvarī, goddess of spacious love, who wears all the beings of the universe as her ornaments.

On the frontispiece: Vaināyakī is the embodiment of Ganesha's radiant power, a gatekeeper who is able to protect thresholds and remove obstacles. On a more subtle level, she teaches us how proper understanding transforms all hindrances into meaningful steps on our path to realization. She is invoked at the beginning of endeavors to help them be auspicious. A devī of wisdom and knowledge, she is red in color and often portrayed joyfully dancing. This image is inspired by the folk art of Orissa in Western India.

Sounds True
Boulder, CO 80306

© 2015 Ekabhumi Charles Ellik
Foreword © 2015 by Sally Kempton

SOUNDS TRUE is a trademark of Sounds True, Inc.

This work is solely for personal growth and education. It should not be treated as a substitute for professional assistance, therapeutic activities such as psychotherapy or counseling, or medical advice. In the event of physical or mental distress, please consult with appropriate health professionals. The application of protocols and information in this book is the choice of each reader, who assumes full responsibility for his or her understandings, interpretations, and results. The author and publisher assume no responsibility for the actions or choices of any reader.

Cover design by Jennifer Miles
Book design by Lisa Kerans & Ekabhumi

Printed in Korea

Library of Congress Cataloging-in-Publication Data
Ellik, Ekabhumi Charles.
 The shakti coloring book : goddesses, mandalas, and the power of sacred geometry / illustrations and text by Ekabhumi Charles Ellik ; foreword by Sally Kempton.
 pages cm
 Includes bibliographical references.
 ISBN 978-1-62203-415-4
 1. Hinduism—Miscellanea. 2. Hindu goddesses. I. Title.
 BL1212.74.E45 2015
 294.5'2114—dc23
 2014043294

10 9 8 7 6 5 4 3 2 1

To Mom

CONTENTS

LIST OF GODDESSES FOR COLORING

NOTES TO THE READER

The images in this book were lovingly rendered in pencil and ink on paper. Many are based on traditional forms and some are directly inspired by famous masterpieces. Readers familiar with Sally Kempton's book *Awakening Shakti* will recognize similarities between some of those illustrations and the images provided here (with her blessing—thanks, Sally!) for coloring. All have been modified to fit this book's square format.

The language used in this book is intended for general readership. Many Sanskrit words are transcribed into the Roman alphabet without diacritical marks, corresponding to phonetic pronunciation, especially if the word is already in common usage. Simplified diacritical marks are used in formal names and in mantras where correct pronunciation is strongly suggested.

There are two important examples: A vowel with a bar above it (such as *ā* in *mālā*) must be enunciated for twice as long a normal *a.* The difference in the length of enunciation changes the meaning of the word. *Mala* is "dirt," whereas a *mālā* is a rosary of prayer beads. In the mantra *Oṁ,* the letter *ṁ* is pronounced as a pure nasal sound, more like *ng* than *m.* It resonates mostly inside the skull rather than mostly in the lips. This moves the energy inward and upward in the body, rather than outward.

This book is an expression of devotion, not a scholarly work. My intention is to inspire, not to provide historically precise reproductions. The images were thoroughly researched, however, and direct guidance was received from masters of several different artistic traditions. The Mantra-mahodadhi and Tantrasāra are the primary references for iconography; many passages from other texts have been newly translated just for this book. For a full bibliography, attributions, notes, audio recordings of the invocations, and full-color examples of the yantras and mandalas, please see *The Shakti Coloring Book* page at my website, One Earth Sacred Arts (oneearthsacredarts.com).

If anything here contradicts direct instructions of your own teachers, I recommend following the wisdom of your living teacher. Nothing here should be mistaken as initiation into a specific lineage or deity practice.

FOREWORD

Ekabhumi Charles Ellik's book is a threshold into one of the most powerful practices of the Eastern traditions. The deities he celebrates here represent subtle archetypal energies that exist in the universe and within each of us. As we allow ourselves to become intimate with them, they can literally open us to parts of ourselves that we may have only suspected. Ekabhumi is an adept in the approach to enlightenment known as deity practice. So this is not just a coloring book. It is also a series of portals into a secret world.

In the Indian and Tibetan Tantric traditions, deity practice has been for centuries a core method for becoming intimate with your sacred self. In deity practice, you tune yourself to one of the archetypal figures of the tradition. Such a being incarnates qualities like enlightenment, protection, compassion, divine love. If you're a Buddhist, it might be Buddha or one of the Boddhisattvas, emanations of Buddha's energy of awakened compassion. If you're a Christian, it would be Jesus or Mary. For a Hindu or Tibetan, the figure might be one's own guru, but it's just as likely to be a god or a goddess, one of those mysterious presences who exist in the subtle realms and interface with the human world through our meditation and invocation practice.

A practitioner of deity meditation would work with a mantra—one of the powerful sound forms associated with that deity. She would also practice visualizations, usually based on a painting or statue of the deity, or with a mandala, a geometric form that holds the energetic patterns of that deity's subtle presence. She would work with the images and sacred sounds as focal points for meditation and, finally, attempt to bring the energy of the deity inside.

These practices would start with focusing the mind. As the practices are continued over time, pure emotions would start to surface: experiences of devotion, peace, compassion. And there would be a growing feeling of intimacy with higher realms of your own consciousness. You might start by invoking the deity as a cognitive focusing device, or as a way of clearing the mind, or more relationally, as a protector or a guardian or a model of enlightened awareness. Ultimately, though, your practice would have loosened the boundaries between the physical universe and the subtle, often to such an extent that you would experience yourself as a human form of the archetypal energy you seek.

In these traditions, sacred art is never just decoration. At its best, it is a skillfully calibrated sacred technology for activating archetypal energies. When you interact with sacred art as a practitioner, your aim is not only to enjoy and appreciate it. What you really want to do is let the art transform you on ever-deeper levels. The more aesthetically beautiful the painting or mandala, the easier it is to experience the activation. But the power in the art is not only a result of the artist's skill. The power also comes from the depth of the artist's meditative practice and especially from the mantra that the artist puts into the work. When the artist's inner work is deep, the art itself carries a power to transform the viewer.

Ekabhumi Charles Ellik is an artist in this tradition, and he is someone who takes the inner work seriously. Not only has he studied with masters of the form, but he has also done many hours of deity practice, mantra repetition, and invocation for every drawing in this collection. When you hang out with his art, the power he's infused into it literally seeps into you.

Let me tell you a story. Ekabhumi illustrated my book *Awakening Shakti*, and because I loved his drawings, I asked him to paint a Shrī Yantra for me. As this book describes, the Shrī Yantra is one of the most significant mandalas in the Tantric tradition, and it's also become extremely popular in the contemporary yoga world. I thought that Eka's painting would be a beautiful adornment for my bedroom wall.

But when I saw the yantra, I immediately realized that I couldn't use this painting as a decorative wall covering. The painting was pulsing with power, with Shakti. It felt alive. More than that, it seemed to demand something from me and to have something to give me. I hung the yantra in my meditation room and, little by little, built an altar around it. I began to notice that the yantra evoked certain energies in me. It seemed to have an intense quality, a pulsing force field that everyone who saw it could sense. But at the same time, it emanated a feeling of softness, a palpably sweet energy. I asked Eka about it, and he confessed that while he and his assistants were working on the painting, they had been chanting mantras not only to Lalitā, who is the traditional deity of the Shrī Yantra, but also to Kālī, the Hindu goddess of intense, revolutionary freedom, and to Lakshmī, the Hindu goddess of abundance, harmony, and love. The energies of both sacred archetypes had come to infuse the painting.

I'm telling you this because I really want to encourage you to look at the drawings in this book as opportunities to open yourself to the living energies of the sacred archetypes they depict. Coloring these mandalas and deity drawings can be a profound spiritual practice, which can integrate the separated energies in your psyche and also connect you to their higher octaves. In other words, working with these drawings and mandalas can bring deity energies alive in you. As you meditate on the energies within the drawings, and work with the invocations that go with them, you'll find yourself opening to aspects of yourself that you may not have known.

So set aside some time. Put on a beautiful piece of sacred music—perhaps a chant, or an instrumental piece that opens your heart. Contemplate the drawings and ask yourself which colors to use. And as you color the drawings, do it as a meditation. Notice what arises within you as you do this practice. You'll be participating in the process of sacred self-transformation.

Sally Kempton is the author of *Awakening Shakti: The Transformative Power of the Goddesses of Yoga* and *Meditation for the Love of It.*

INTRODUCTION

I live on Earth at present, and I don't know what I am. I know that I am not a category.
I am not a thing — a noun. I seem to be a verb, an evolutionary process —
an integral function of the universe.

Richard Buckminster Fuller (1895–1983)

Years ago, while teaching youth yoga, I drew pictures of the monkey deity Hanuman in various yoga postures for my young students. Coloring the pictures made study fun for the kids, and it helped them with memorization. As my own studies progressed, deity practice became part of my daily routine. Illustrating deities evolved from an aspect of instruction to the hub of my spiritual life. I found that meditating on the deities and the rich symbolism of their depictions as I worked deepened my internal practice immeasurably. Though my young students and I both enjoyed this creative activity, it did not occur to me to provide adult practitioners with images for coloring until I was asked. After seeing the illustrations of deities I'd done for books by scholars, readers wrote to me requesting copies of the artworks.

Many readers, especially yoga students, also wanted to know more about these images, including the meaning of visual devices like multiple arms and the symbolism of geometric shapes. Most of all, they wanted to know about the practice of making sacred art. While there are many books explaining Hindu iconography, and a few that cover painting, there are precious few books that actually explain how to make art as a yogic practice. So I typed up handouts to give to students; the information in these handouts was later refined by hands-on, practical experience. Collecting these images and lessons into a book was the logical next step.

In those years as an instructor, I taught in yoga studios filled with beautiful but nonyogic art. Even in studios filled with Hindu imagery, people did not know what the images symbolized. This is problematic because mixing and matching artworks from different traditions with different methodologies can create confusion and subtle impediments to yogic spiritual practice. Most yoga students know that what we eat and how we eat it affects our health and spiritual development. What we put in our eyes is just as influential as what we put in our belly. When our artworks are in alignment with our spiritual goals, they shape our values in a way that complements our spiritual practice. Mystic artworks give us accurate models for our meditations, acting as guides for our internal journey.

My first intention with *The Shakti Coloring Book,* therefore, is to introduce you to these glorious goddesses. You will learn how beneficial it is to recognize the symbolism in their depictions and how it relates to yogic practice. Just as it is helpful for a beginner to get to know the yoga postures *(āsanas)* before joining an advanced class, so too is it helpful to get to know the goddesses in general before choosing to invite one into your home or practice. Only widely revered goddesses are included, none whitewashed or candy coated. These images are all originals, though they are inspired by famous examples from different regions and historical periods. These are playful depictions, not definitive icons.

Diversity is a characteristic of Shakti, so this collection is diverse as well.

Part 1, "Recognizing Shakti," gives you an explanation of what a goddess is and the keys to understanding the many layers of meaning in these images. Readers who want to know more about the hidden symbolism, such as why artists include all the extra arms, will enjoy this section.

Once we know what we're looking at, we can learn what to do with it. In part 2, "Embodying Shakti," we explore spiritual practices associated with the creation of mystic artworks. This is an introduction to making sacred art as a spiritual practice.

Part 3, "Coloring Shakti," is our reward: images of stunning goddesses and their scintillating mystic diagrams. The brief descriptions on the back of each image are for anyone who has ever looked at a Hindu goddess and wondered, "Who is *that?*"

Part 4, "Manifesting Shakti," is a step-by-step manual for creating a yantra, a specific type of mystic diagram composed of elemental shapes—what we call "sacred geometry" in the West. It is also a guided meditation that will help spiritual seekers purify their energetic body and recognize the inherent unity of all things.

It is not necessary to read or understand all the information in this book to enjoy coloring in these images. It is said that just catching a glimpse of these goddesses is a blessing. The information in this book is intended to help beginners get started on the spiritual path, to enrich the practice of those who have already begun their journey toward self-realization, and to help anyone enjoy these goddesses and the wisdom they hold. This is the book I wished for when I began making devotional art: a practical guide for creative, art-loving people who want to spiritualize their craft and begin making art as a method of self-realization.

RECOGNIZING SHAKTI

I am the Sovereign Queen; the treasury of all treasures; the chief of all objects of worship;
whose all-pervading Self manifests all gods and goddesses; whose birthplace is in the midst of
the causal waters; who in breathing forth gives birth to all created worlds,
and yet extends beyond them, so vast am I in greatness.

Rigveda, Devī Sukta, Maṇḍala X, Sukta 125

RECOGNIZING SHAKTI

What Is Shakti? Or Who?

Shakti is power, both manifest power and the power within all experiences. The root, *shak,* means "to be able," and the term *Shakti* describes divine creative power and the hypnotic beauty of appearances as well as the power to transform and destroy. It is not power over others in a hierarchical sense; it is the electric juice of life. Women in particular exemplify this principle and therefore may also be called shaktis. Even deadly weapons are given this name, indicating this power must be treated with care.

While *shakti* may be used as a general term for any goddess, it is not so much a name as an epithet, carrying with it the implication of spiritual might. All that can be seen, felt, smelled, or tasted is shakti. When we use the word *Shakti* as a proper name, however, we are speaking of the Great Goddess (Mahādevī) who takes birth as all beings, whose body is all reality. To make the distinction clear, she is sometimes called Parāśakti (or Parāshakti, "the Supreme Power"). She cannot be described, exactly, and therefore cannot be portrayed in figurative form. This primordial being is analogous to what is known as Brahman ("Expansive Spirit") by followers of Vedanta, or Śiva ("Ultimate Consciousness") to Śaivites. If we are to describe Her as being like the ocean, then all of us, even deities, are like waves—temporary appearances that seem distinctive and independent, yet are not separate from the whole.

Some modern philosophers have tried to explain this unfamiliar truth to Western readers by claiming that Hinduism is monotheistic—that all Hindus know their diverse goddesses and gods as mere faces or symbols of the one supreme being. This is not a wrong view, but some say it is incomplete. The nondual view must also include diversity as an essential component of unity. As the goddesses of this book demonstrate so colorfully, embracing the principle of diversity allows for different expressions of the whole. With this understanding, we can recognize how the practice *(sadhana)* of any one goddess can be a complete path. Complete union (yoga) necessarily and spontaneously includes all the others. This principle remains true whether we think of the goddesses as people or as virtues. A yogin *(yogin* is a gender-neutral version of the word *yogi)* who completely embodies one virtue will naturally express all the others as well. The individual self (and thus diversity) is not a means to an end, nor is it the end. It just is.

There are different ways sacred art points toward this truth of nondualism: Goddesses are portrayed taking birth as different avatars, or living inside the heart of other goddesses, or displaying multiple heads. Goddesses are often portrayed in groups, such as the ten Wisdom Goddesses, the seven (or eight) Mothers, the sixty-four Yoginīs, and the nine Durgās. Each group is a mandala (sacred circle), yet each goddess also sits at the center of her own mandala in a bewildering kaleidoscope of beauty and power.

Western readers are accustomed to logical hierarchies, order, clearly defined symbols, and philosophical models of reality that validate our own human biases. But the universe doesn't always conform to human reason, and as uncomfortable as it may be to admit, the human brain just doesn't have the capacity to grasp the universe in its entirety. This is why yogins speak of calming the mind and relying on intuition. We can still be aligned, act harmoniously, and *know* without grasping all the details. This is when we rely on the wisdom mind, located at the heart, rather than depending only upon the thinking machine inside our head. Meditation, ritual, and creative activities (like making sacred art)

help us to cultivate our intuitive wisdom. This is why the heart is always at the center of a sacred art composition.

The Sanskrit word for "goddess" is *devī,* which can be roughly translated as "shining" or "playful." There are different classes of *devīs,* from local geographic deities to great enlightened devīs who exemplify cosmic principles. Historically, goddesses associated with forces of nature and significant landmarks were worshiped as local deities and village protectors. Like people, goddesses grow and change over time. Some of these tribal goddesses became preeminent divinities (such as Durgā) or came together in groups encompassing a spectrum of universal principles (such as the ten Wisdom Goddesses). *Devī* is a more specific word than *Shakti.* All beings are forms of Shakti, but not all shaktis are devīs.

It is of utmost importance to choose an enlightened goddess as our tutelary deity. There are unenlightened goddesses, just as there are unenlightened people. It is said that these goddesses are not completely realized due to their identification with a feeling of ultimate bliss without impermanence or pain. Hidden beneath the glory of such beings is a sense of incompleteness that eventually leads to spiritual destitution. It is important for us as spiritual seekers to understand this, as it helps us to recognize the value of a human birth. Our physical body, along with all the pleasant and unpleasant experiences it affords, is said to be the supreme vehicle for realization. Humans have a great deal of freedom to experiment with different ways of being, and the difficulties we experience provide great motivation to seek out spiritual practices. We are not rejecting our humanity when we do deity practice; we are working with these powerful enlightened beings to expand our notion of self to include the cosmos. Full realization necessarily includes the "bad" stuff, which is why some of the goddesses may appear frightening. They have an important role to play in our spiritual journey: they show us how to cultivate equanimity amidst impermanence and pain. We must embrace their lessons if we are to be complete; the wondrous path of the Goddess encompasses all phenomena. When we embrace Her totality without aversion, we may then relax into the blissful, expansive state that is our true nature.

Symbolic Animals

Many goddesses are depicted sitting on a characteristic animal, known as their vehicle (*vāhana*). Animals also appear frequently as apparel and decorative motifs. Animals help both to identify a goddess and to give insight into how her power is expressed.

Antelope or deer: longevity, faithfulness, tranquility, peace, harmony
> *When held:* regent of animals, control of natural forces
> *Antelope skin:* mastery over the flitting mind

Boar or sow: loyalty, perseverance, courage, hunger

Bull: strength, discipline, endurance, wealth, sexual power

Centipede: poison, hatred, fear, darkness

Cow: generosity, abundance, patience, fertility

Crocodile, fish, or *makara* (a mythical beast with the tail and feet of a bird and trunk of an elephant): water, fertility, fearsomeness, wealth

Crane: patience, focus, grace, longevity

Crow: intelligence, karma, death

Dog: guardianship, loyalty, impurity

Eagle: speed, wind, righteousness, the sun

Elephant: strength, intelligence, equanimity, self-control, wealth
> *Elephant skin:* mastery over ignorance

Fish: water, fertility, nourishment

Horse: courage, speed, power

Human: devotion, intelligence, freedom, sensuality, desire
> *Human skin:* mastery over desire
> *Human corpse:* mastery over death and unseen forces

Lion: power, protection, dignity, fearsomeness

Monkey: curiosity, playfulness, mind, devotion

Owl: wisdom (or ignorance!), night, mystery

Parrot: speech, intelligence, immortality, love

Peacock: beauty, dignity, romance, digestive power, immortality

Ram: force, vigor, fire, perseverance

Rat: greed, cleverness, activity

Snake: immortality, *kundalinī-shakti,* water, danger, sexual power

Swan or goose: discernment, breath of life, boundlessness

Tiger: power, destruction, beauty, fearlessness, passion
> *Tiger skin:* mastery over passion or anger

Swords, Books, and Lotuses: The Goddesses' Attributes

How do we know which goddess to approach for guidance or what type of commitment we might get ourselves into if we do? An easy way to begin is by considering what the goddesses hold in their depictions. Usually, a goddess's two key distinguishing attributes are represented by what she holds in her foremost pair of hands. The symbols or gestures of her other hands modify or expand upon her basic attributes, helping to give a more nuanced understanding of her nature. The objects a goddess holds (referred to as attributes) or the gestures she makes (known as *mudras*) represent virtues, qualities, and/or characteristic powers. She is not *defined* by these attributes; she is *described*.

These attributes also allude to the mystic practices of the deity and of the likely benefits of engaging in her practices. They are also a warning: playing with sharp weapons may lead to painful experiences. Scholars say these attributes represent magical powers that are the fruit of worshiping a goddess in that form. Those who use icons of goddesses for self-realization also understand a goddess's attributes as a specific set of virtues. Be aware that the interpretations of what these attributes represent depend on many factors, including regional variations and lineage-specific teachings. The orientation of this book is toward invoking the goddess's virtue-blessing power, so they have been listed accordingly.

Where the attributes are held usually corresponds with two of the three main energetic channels *(nādīs)* of the subtle body. These channels are represented by the symbols of sun, moon, and fire, which appear frequently together in mystic artworks. The main central channel, *Sushumnā Nādī,* is "the cool fire" and is balanced in nature. Symbols related to this channel are usually not held in the hands, but worn as ornaments. On the right side is *Pingalā Nādī,* which is active, solar, and masculine in nature. Usually, objects, like weapons, that require some kind of motion or activity to put them into use are held the right hands. These symbolic objects represent skillful means or ways in which enlightenment is actively expressed, which is why they are known as "method"

attributes. On the left side is *Idā Nādī,* which is passive, lunar, and feminine in nature. Objects that contain, bind, pour, or radiate are held in the left hands. These symbolic objects represent the discriminating awareness from which activity arises or ways in which enlightenment is passively expressed, which is why they are known as "wisdom" attributes.

The attributes a goddess holds in her hands are usually depicted in complimentary pairs, corresponding with the right and left channels. For example:

Her Right Hand (Method)	Her Left Hand (Wisdom)
Abhaya gesture (palm turned upward) fearlessness	*Varada* gesture (palm turned downward) generosity
Thunderbolt: revelation, vigor	Bell: emptiness, clarity
Prayer beads: devotion, mantra	Book: knowledge
Skinning knife: renunciation, honesty	Skull cup: nectar of realization
Goad: guidance, perseverance, power	Noose: connection, stillness, restraint
Sword: discernment, worship	Shield: duty, dharma
Head chopper sword: nonattachment	Head: personal ego, conditioned mind
Discus: revolving time, illumination	Conch: resonant presence, fearlessness
Trident: will, knowledge, and action	Drum: pulse of creation
Lotus: purity, cosmic womb, radiance	Jar or pot: effulgence, fertility
Club or mace: truth	Staff: discipline, authority, justice
Arrow: love, focus, perception	Bow: release, discipline, concentration

When attributes are joined together in a single hand, or shown in groups, their meaning is modified. Most commonly seen together are five arrows. They can represent five methods (generosity, discipline, patience, effort, and concentration), five senses (sight, sound, smell, taste, and touch), five passions (ecstasy, burning, unconsciousness, bewitchery, paralysis), or five poisons (ignorance, desire, aversion, pride, jealousy).

The meaning of an attribute is modified by how it is depicted and the presence of other attributes. For example, a bow made of sugarcane (sweetness) and five arrows made of flowers (five senses) carry a different implication (sensory pleasure) from those made of wood and iron and designed for warfare (focused action). A single arrow (love) and ornamental bow (release) may carry a different interpretation altogether (liberation). All these examples of bows and arrows relate to the piercing quality of sensory perception, but differ markedly in the associated principle. The first example relates most closely to pleasure *(kāma)*, the second to intentional activity *(dharma* or *artha)*, and the last to liberation *(moksha)*. An elegant benevolent goddess carrying a sword (discernment) and a shield (duty) is interpreted differently from a blood-spattered wrathful goddess carrying a head-chopper sword (nonattachment) and a head (conditioned mind). In both cases, the sharp blade symbolizes the power to separate real from unreal, but the different depictions allude to how we may experience and express that same power when it is invoked through the lens of a particular goddess's personality display.

Some items may be held in either hand; in these cases, the placement indicates whether the attribute represented by the object is expressed actively (right side) or passively (left side). So a sword held in the right hand indicates that a deity has an active, cutting attribute of discernment that may be felt intensely by the practitioner. A sword held in the left hand indicates that the same attribute is present, but is more subtle and gentle in nature. By carefully studying what attributes a goddess carries, and what side they are carried on, we gain insight to how her influence is likely to be experienced.

The depiction of multiple limbs is a relatively recent innovation in the vast scope of Indic art history. This visual device is useful for combining a deity's many attributes in one image. It also conveys a quality of multiplicity and motion inherent in most deities and is a clear indication of omnipotence and omnipresence. For centuries, Indic deities were depicted with only two arms, even though they had multiple forms, attributes, and powers. A great, enlightened deity exists across time and space, manifesting many locations simultaneously. In this sense, extra arms on deities are like overlapping photographs of a body in motion, or a Cubist painting showing multiple points of view. We are seeing many realities all at once. It is *not* true that a deity with ten arms is more powerful than a deity with only two, but it may be that the rituals associated with a deity holding many attributes feel more intense than rituals associated with a deity having only two.

Ornamentation: The Power of Beauty

Europe is merely powerful; India is beautiful.

— Savitri Devi (1905–1982)

Ornamentation *(alankara)* is an expression of character, status, and power, as well as love, devotion, and piety. In traditional Indic culture, no work of architecture or art is complete until it is ornamented. The layers of embellishment seen on temples and statues are an expression of authority as much as aesthetic fancy.

On a personal level, an ability to attract was understood as power on par with brute strength, so both kings and queens were praised by poets as being beautiful and alluring. Beauty was considered the physical manifestation of fecundity, authority, and power, so ornamentation was both a delight and a political necessity. Adorning oneself and one's environment was fundamental to one's dignity, self-possession, and propriety. What's more, ritual jewelry, scented oils, even one's posture and confident gait give spiritual protection. To venture outdoors unornamented was to invite misfortune.

Some basic ornaments remain remarkably consistent in depictions of deities: crowns, earrings, necklaces, garlands, belts, armlets,

and anklets are worn by males and females alike. All are highly symbolic, and most relate directly to esoteric anatomy. Metal ornaments are positioned on energetic nodes to hold and direct energy within the body. Metal jewelry is said to have the quality of Shiva: cold and unmoving, it envelops and directs the warm, living energy of Shakti. These ornaments also serve a visual function in the image, making the figure both easier to draw and more visually captivating. This may explain why they remain popular among artists. Many goddesses are portrayed heavily ornamented, even when the ancient scriptures and tales that the artworks are based upon explicitly state that they wear none!

Both the male and the female deities are frequently portrayed topless in ancient Hindu art. Most are *not* nude; they are simply well dressed according to a standard unfamiliar to modern viewers. As scholar Vidya Dehejia explains, "[T]he human body of the Indian artistic tradition is neither naked nor nude; it is invariably the body adorned." Goddesses are sumptuously garbed in translucent silk scarves, leggings, belts, jewelry, crowns, and elaborate hair wrappings befitting royalty. Making images of deities sexy and scantily clad conveys the potency and attractive power of the teachings they exemplify. One who embodies truth and fearlessness has nothing to hide!

Lavish ornamentation is so ubiquitous on images of deities that any lack thereof is significant. In ancient times, a woman with unbound hair and no jewelry was much more scandalous than one who was simply topless. No ancient viewer would miss the significance of an unadorned goddess. A notable example is Dhūmāvatī. She wears only rags, as she is completely unconcerned with appearances and status. Much like the renunciate Buddha, she has earlobes that remain stretched from the heavy gold earrings she wore in her youth and now dangle empty to symbolize her complete disregard for social status. Images of Tapasvinī depict her engaged in great austerities to win her husband Shiva's heart. She wears little more than flowers and seeds, marking her as an ascetic. Rare indeed is the "sky-clad," or completely nude, deity, like fearless Kālī, but even she is depicted with a garland of human heads

and a skirt of arms. Deities with no ornament are beyond worldly cares, so close to absolute truth they can hardly even be said to have a body, much less jewelry!

Most forms of deities have characteristic colors, which are seen in their skin tone, robes, and ornaments. Benevolent deities wear flowers, leaves, berries, seeds, precious metals, soft fabrics, and gems. They generally wear cheerful and harmonious colors. Wrathful deities also wear crowns and exuberant ornamentation, but theirs are made of bones, snakes, skins, intestines, and freshly severed heads! They generally wear harsh combinations of intense colors. The symbolism of various materials, such as *rudrāksha* beads (worn by Pārvatī/Shiva) or *tulsī* beads (worn by Lakshmī/Vishnu), and the numerous flowers and gems in Indic art is fascinating, wondrously complex, and far beyond the scope of this book.

Suggestion: Colors have been proven to influence our emotional disposition and blood pressure. The use of ritual jewelry and ornament is universal. Try wearing a meaningful ornament while you work on your sacred art to help create a reverent mood. It is especially powerful to wear the characteristic color of a goddess while coloring her image.

Mandalas: Sacred Circles

It is called mandala because the Ḍākinī who occupies it is auspicious, because it is the abode of the host of Yoginīs, and because of its beauty.
— Kulārnava-Tantra

A mandala is a circular enclosure or grouping of objects into which divine energies are invoked. Mandalas are usually created on a flat surface, and a mantra or ritual object (like a pot of water) is placed at the center to hold the energy of the deity. The term *mandala* has become so widely used that it is now listed in English-language dictionaries as a synonym for "sacred space." Hindus, Buddhists, and Jains all use them as ritual diagrams.

Scholar Robert Thurman explains, "It is a blueprint of an individual's ultimate liberation and supreme bliss . . . fully integrated with his or her environment and field of associates." He goes on to say that, "It is the architecture of enlightenment in its bliss-and-compassion-generated emanations. It is a womb palace within which infinite wisdom and compassion can manifest as forms discernible to ordinary beings."

Ceremonial mandalas tend to be large and visually complex—in many cases, big enough for practitioners to enter and walk around inside. The outer circles and lines represent protective barriers. Mandalas are often temporary constructions, made for specific ceremonies and symbolically destroyed afterward. They are constructed with areas of color and elaborate designs, often including figurative images of the deities who inhabit them. Mandalas usually describe a relationship between many beings or symbolize the entire cosmos. Unlike a yantra, the Hindu mandala has no intrinsic power until the deity is invoked into it. Esteemed scholar Gudrun Bühnemann wrote, "It is not possible to summarize all attempts at defining 'Mandala,' 'Yantra,' and 'chakra' in the literature. The use and function of these terms are complex, and it will be impossible to arrive at a universally valid definition."

Hindu temples are architectural mandalas, a sacred space enclosing, protecting, and focusing the power of the enshrined central deity. In some meditation practices, the deity is visualized sitting at the center of the top floor of an enormous palace built in the shape of a mandala. We enter the imaginary palace just as we would a temple. As we pass through a gate and move toward the center, we move from the gross to the subtle, from diversity to unity. We are climbing a symbolic mountain, beginning with the densest element (earth) and moving upward toward the most subtle (space). For yogins, this symbolizes the subtle movement of our consciousness from the lowest energy center (chakra), at the base of the spine, up toward the highest, at the crown of the head. (We will learn a simplified version of this practice in part 4, "Manifesting Shakti.")

Yantras: Realization Devices

If mantra is the soul of the initiate's chosen deity, yantra is the deity's body.

— George Feuerstein, PhD (1947–2012)

Traditional yantras are revelations. When the great yogins of the ancient past were in deep states of meditation, what they heard were mantras (mystic sounds) and what they saw were yantras (mystic diagrams). These seers said that the energy bodies of goddesses resemble these mystic diagrams, and they passed this knowledge to their students through oral lineages. Most of this knowledge is still secret. It is only in the last century that some information has become public, though much is still not commonly known.

Scholars explain that a deity yantra represents an archetype, but yogins say it is more than a symbol. Yantras do not simply *describe* a being—they *are* the being in manifestation and are therefore potent. They have blessing power. When we meditate upon these mystic diagrams, we are repatterned into a more enlightened state.

Roughly translated, *yantra* means "tool" or "device." The term *yantra* is broad enough to also include hexes, charms, and talismans. The Sanskrit word can be broken into two parts: *yam,* meaning "to support" or "to hold," and *tra,* meaning "to protect" or "to liberate." So the spiritual yantra holds the energy of liberation; it is a realization device.

Often portable and small in size, yantras may be inscribed on metal plates or wood, painted on cloth or paper, and even be worn as ritual jewelry. Yantras are *written;* their power comes from the lines, mantras, and/or spells inscribed upon them. Their designs vary wildly, from curving symbols that almost look like handwriting to complex geometric patterns that resemble (and may also be) mandalas. For example, yantras made for mediation may lack text. Though scholars say these yantras are historically Tantric, it is difficult to say for certain where they originated because similar geometric shapes appear in mystic diagrams worldwide. The yantras we see today were refined over hundreds

or even thousands of years. Most are used to fulfill worldly desires, but deity yantras are gateways to the divine.

Yantras created for deity practice align the viewer with a specific form of divinity. We can intensify the experience by chanting the appropriate mantra for long periods of time while creating, coloring, or meditating on the yantra. Repeating a mantra while meditating on a yantra is a bit like rubbing a bit of steel against a magnet until the steel becomes magnetized; we are transformed by repeated exposure. Yantras are both a device and a vehicle of essence in the same way that a human body is both an organic machine and a seat of self-awareness. A deity yantra is simultaneously a living being, a map of reality, a base for ritual, and an aid for mediation. Harish Johari wrote, "No idol or picture of a deity is as powerful as a Yantra. An iconographic idol is a personal thing, whereas a Yantra is universal, because it is composed of archetypal forms that are common to all existing phenomena."

Geometry: Vocabulary of Reality

Philosophy is written in this grand book, the universe, which stands continually open to our gaze. But the book cannot be understood unless one first learns to comprehend the language and read the letters in which it is composed. It is written in the language of mathematics, and its characters are triangles, circles, and other geometric figures without which it is humanly impossible to understand a single word of it; without these, one wanders about in a dark labyrinth.

— Galileo Galilei (1564–1642)

A deity yantra is an energetic diagram of an enlightened being and may be used as a template for our own realization. These mystic diagrams also show how the five great elements *(mahābhūtas)*—earth, wind, fire, water, and space—may be invoked in an auspicious configuration. Mandalas and yantras can be read like a sentence; the geometric shapes within them are like words. A simple yantra may use only one symbol, invoking the energy of that element (or principle) to accomplish a specific task. A complex yantra may be used to rectify imbalances among all the elements. The list below includes common shapes and symbols, from most simple to most complex, and explains how they are utilized in sacred art.

Center dot: The dot at the center of the yantra is called the *bindu* ("seed"). This primordial symbol is equated with the center of the universe, the place of cosmic stillness around which all creation revolves. This is not a physical location on a map; it is the "all-point" and the origin of all manifestation. It is where the male and female principles (or Shiva and Shakti) unite, where differences cannot exist. It is the summit of a symbolic mountain, from which the rest of the universe (and the yantra) flows. Though the element of space is sometimes portrayed as a dot (usually a circle), space also pervades the other four great elements and is inseparable from them. Meditating on the *bindu* makes the mind one-pointed and still. (Note: There are usually twenty-seven, and as many as thirty-six, elements in classical Tantra. Most are more subtle than space, like the "element" of time.)

Line: If we move away from unity in any direction, a line is formed. Two dots, symbolizing Shiva (consciousness) and Shakti (power), become separate discernible locations on the same line, connected yet apparently different. This line separates "this" from "that" and creates duality. All shapes in a yantra are understood to be radiating from the center, like rays of the sun, which is why lines are associated with the piercing quality of light. A vertical line is associated with the upward-moving nature of fire, while the horizontal line is associated with the spreading quality of water. Diagonal lines imply movement and are thus associated with the wind. Lines direct attention and energy.

Circle: It is the force of desire that causes us to expand outward from the center, and because this primordial desire moves in all directions, we draw it as a circle. The radius of desire creates space for all of existence; thus, the circle represents the space element, the wheel of life and death, and the eternal cycles of nature.

Many yantras have three concentric circles grouped together. Their meaning depends on where they are located. When they are located immediately around the central yantra, they usually represent the three primordial principles of reality *(tri-guna):* harmony

10

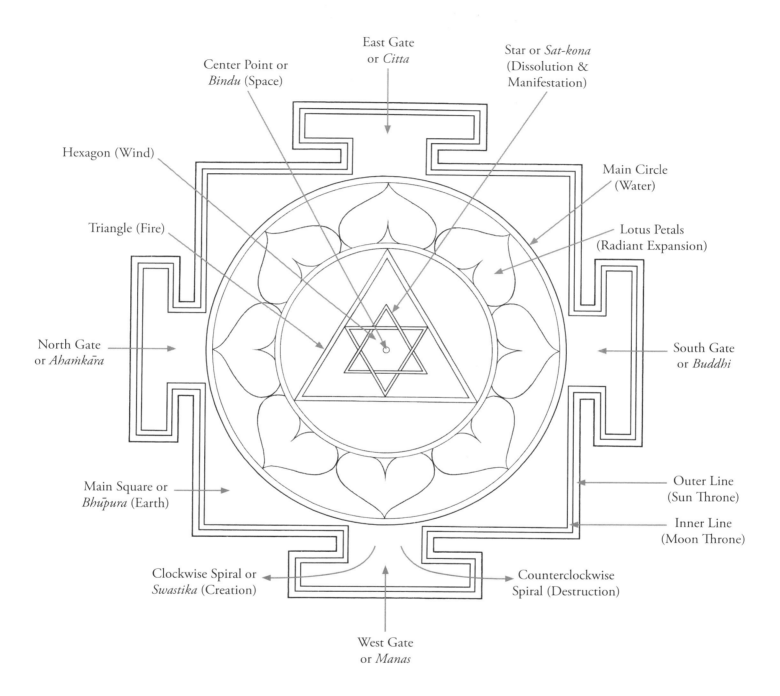

Center Point or *Bindu* (Space)

East Gate or *Citta*

Star or *Sat-kona* (Dissolution & Manifestation)

Hexagon (Wind)

Main Circle (Water)

Triangle (Fire)

Lotus Petals (Radiant Expansion)

North Gate or *Ahaṁkāra*

South Gate or *Buddhi*

Main Square or *Bhūpura* (Earth)

Outer Line (Sun Throne)

Inner Line (Moon Throne)

Clockwise Spiral or *Swastika* (Creation)

Counterclockwise Spiral (Destruction)

West Gate or *Manas*

The Five Great Elements: The Mahābhūtas

Yogic philosophy postulates that there are as many as thirty-six elements, all of which are different from the material elements of Western science. Known as *tattvas,* these subtle levels of reality range from most subtle (primordial consciousness) to most dense, the earth element. Between these two extremes are phenomena such as will and time.

Here is a list of the five great elements and their associations. The combination of their five colors is popular throughout Asia and used in many different traditions. The five elements yantra, which I will show you how to create in part 4, utilizes this list.

Element	Color	Shape	Quality	Location	Mantra
Earth (*prithvī*)	Yellow	Square	Stability	Root chakra, lower legs	*Lam*
Water (*apas*)	White or silver	Crescent	Flow and solvency	Pelvis	*Vam*
Fire (*agni*)	Red	Triangle	Transformation	Belly to heart	*Ram*
Wind (*vāyu*)	Green or gray	Hexagon	Motion	Heart to eyebrows	*Yam*
Space (*ākāsha*)	Black or crystal	Circle	Spaciousness	Head, from eyebrows upward	*Ham*

(sattvas), transformation *(rajas)*, and inertia *(tamas)*. When they encircle the central yantra and the radial lotus petals, yet remain inside the large outer square, they usually represent the three phases of time: past, present, and future. An entire mandala surrounded by a circle of flames represents the fires of the cremation ground and how identification with the world of physical appearances leads to death. In all cases, the unbroken line of a circle shows that the principle being represented is eternal or cyclic in nature.

Crescent: The water element is associated with nourishment, life, fluidity, and connectivity. It is represented by a crescent. According to one of my teachers, this is a bowl, seen from the side, which holds the water element. It would normally be drawn between the outer square (symbolizing earth) and the inner triangle (representing fire). Most deity yantras do not have an obvious crescent shape. Rather, the water element is implied by a circle of lotus petals (see the description of the watery lotus below) drawn over the area where a crescent would normally be located.

This shape also resembles the moon, which is a complex and multilayered symbol itself. The ocean's tides, the cycles of nature, nocturnal passions, and secret midnight rituals are all associated with the crescent moon. This symbol appears in the hair or on the crowns of many deities.

Triangle: The triangle is the most common shape used in yantras. If you see a conspicuous triangle in any piece of Hindu or Buddhist art, it is a clue to the mystic meaning of the image. The triangle represents the fire element, heat, light, and transformation. The three points of a triangle are generally associated with the three primordial powers of the Goddess: will *(icchā)*, knowledge *(jnāna)*, and action *(kriyā)*. Another interpretation is that the horizontal line represents space, the left diagonal line represents time, and the right diagonal represents object. The number three is associated with many mystic concepts, however, including creation, preservation, and destruction; waking, dreaming, and deep sleep; and tranquility, transformation, and entropy. The symbolism of the number depends on the deity and the ritual.

The downward-pointing triangle represents manifestation and is associated with the substance of water, the female dynamic, and nature *(prakriti)*. It is sometimes called a *yoni*, like the female generative organ. The upward-pointing triangle represents dissolution and is associated with fire, the masculine dynamic, and spirit *(purusha)*. It is a common mistake to assume all goddesses must be represented by a downward triangle. The orientation of the inner triangle depends on how the goddess is being invoked in a ritual, or how we wish to relate to her as a guide, not her gender. So if

one wishes to invoke a goddess in her role as creatrix, the yantra utilizes a downward-pointing triangle. For dissolution or a yogic experience of unity, an upward triangle is utilized.

Square: The square shape represents the earth element, the material world, and the four directions. When it is sitting flat on one side, it represents stability; when it is balancing on a corner, it represents dynamism. A square with an opening on one or more sides (these are called gates) is called a *bhūpura* (literally "earth wall"). (See the yantra diagram.) These gates may be indicated by elaborately drawn miniature gateways, little doorways, a symbolic T shape, or a just rudimentary rectangular shape. Most yantras and mandalas have four gates, representing the four cardinal directions, as well as four components of awareness: the faculty of judgment *(buddhi),* mind *(chitta),* personal ego *(ahaṁkāra),* and the faculty of attention *(manas).* These four components are the portals to our experience of life. The earth element itself is associated with mass, hardness, and solidity, and it helps to hold and stabilize the energy invoked by transformative practices. Many deity yantras are enclosed by two outer lines, representing the sun and the moon, which enlightened deities symbolically rest upon, like thrones.

Hexagram: Known as the *sat-kona,* the six-pointed star is formed when two triangles are superimposed upon one another, pointing in opposite directions. This symbolizes a perfect and stable balance of the male (dissolution) and female (manifestation) dynamics. It is analogous to portraying the divine couple Shiva and Shakti lovingly conjoined. The six-pointed star appears throughout the world in ancient art, but in Europe since the seventeenth century it has been strongly associated with the Jewish people, for whom it is emblematic. Use of the *sat-kona* in yantras predates its use as a symbol of Judaism by many centuries.

Hexagon: The six-sided shape created inside the *sat-kona* is a hexagon, which symbolizes the wind element. Wind in this case is not physical air blowing, but rather the quality of mobility. Yogic lore teaches that the mind (and its tendency to move) is associated with the wind element. In many ancient Tantric texts, it is represented simply as six smoky black dots in the shape of a hexagon.

Pentagram: The five great elements are represented by the five-pointed star. When the apex of this star points upward, much like a triangle, it implies unity and dissolution, whereas when it points downward, it implies diversity and manifestation. Five-pointed stars are often incorporated in decorative folk patterns known as *rangoli* or *kolams,* honoring the goddess Lakshmī and/or the earth goddess Bhū-Devī. In some cases (most famously in the case of Shiva) the pentagram may also symbolize the five divine powers: creation, preservation, destruction, revelation, and obscuration.

Octagram: When two squares are placed one on top of the other at different angles to create a figure with eight points, the shape they create symbolizes preservation or civilization. The two superimposed squares represent a balance between a static and dynamic expression of the earth element. This figure is implied in a yantra or mandala that has four gates (see the earlier description of the square). The eight-sided shape generated inside the two figures is an octagon, which is often used as a seat by deities when they are portrayed resting on a golden throne instead of a lotus.

Spiral: The famous swastika is a stylized spiral. The swastika is a truly primordial figure that appears in art throughout the world, including Native American art. It has been used extensively in Indic art for at least 4,300 years, but belongs to no single culture. The term *swastika* is a combination of two Sanskrit words, *su* ("good") and *asti* ("to exist"). In a yantra, a clockwise movement symbolizes the outward spiraling power of creation, while a counter-clockwise symbolizes the inward direction of destruction. Indic culture associates this symbol with the effulgence of the sun, good luck, welfare, prosperity, and spiritual victory. The T-shaped figures we see in one the four sides of most mandalas and deity yantras are derived from two opposing swastikas, one laid atop another. This indicates that a deity's powers of creation and destruction are stable and balanced.

Lotus: The lotus is the most widely utilized symbol in Asian art. It is the only representational image that commonly appears in both yantras and mandalas, and it brings with it all the metaphorical values for which the lotus is renowned. It is associated

with purity because the lotus flower is unstained by the muddy waters from which it grows. The lotus we see in a yantra is highly abstracted, its simplified petals seen from above, tips pointing outward from the center. Circular in shape, this figure is associated with the water element (where lotuses grow) and thus an ability to nourish and flow. The radial arrangement of the lotus petals symbolizes the expressive or radiant quality of a deity. In other words, it symbolizes the pure nurturing power of the Goddess, which flows in all directions. Some primitive yantras dispense with these petal shapes and instead have eight rudimentary lines drawn in a radial pattern. The basic symbolism is the same (radiance), which is why the lotus is included in this list of geometric shapes.

When a yantra has only a single ring of eight petals, these petals almost always correspond to the four cardinal and four noncardinal directions. The eight petals are sometimes assigned other meanings as well, such as the five great elements and the three *gunas (tri-guna),* or the five great elements plus mind, intellect, and ego. In most rituals, these eight petals are assigned to eight guardian deities, the *Dikpālas.* When a yantra has more than one ring of petals, the extra rings correspond to the deity's retinue (their shaktis). The more rings of petals, the more shaktis and thus more powers. Some goddesses have dozens of petals on their yantras.

Suggestion: Look around. These primordial shapes are in buildings, furniture, machines, and natural forms. Which appear most often in your home, apparel, and artworks? What shapes are you drawn to? Which elements do you express most powerfully?

Choosing Colors Mindfully

If your motive for picking up this book is just to have fun, then feel free to color these images just as you wish. It is said that all offerings made with love and no desire for selfish gain are accepted by enlightened deities. While most traditional schools of sacred art require great precision and adherence to strict rules, their artworks are intended for powerful rituals and perhaps permanent installation in temples. If you are simply making art as an expression of devotion, then the main rule is to let love be your guide. What's more, making art intuitively, with no agenda, is said to have soothing, healing, and clarifying effects on the artist. The information provided here about the use of color is intended to enrich the art-making process. Any extra steps we take to make our offerings more personalized for a goddess simply help deepen our connection with her.

When using an icon for ritual, seeking a specific result, or asking a deity to fulfill a personal desire, following established guidelines is wise. Yantras and mandalas are spiritual devices wherein the first priority is function, not whimsy. Precision helps assure an auspicious outcome. As author Madhu Khanna wrote, "Color is never used arbitrarily to enhance the decorative quality of a diagram, but refers to philosophical ideas and expresses inner states of consciousness." Every aspect of the image is functional, including the ornamentation. Even when yantras are not filled with colored shapes, they utilize colored lines. The combination of red lines on a golden yellow background is most common. Mandalas may allow a bit more room for creative freedom, yet there are no distracting, disharmonious, or contradictory colors in their composition. When art is intended for use in ritual, form follows function in regard to color. Precision helps assure a more predictable and auspicious outcome for any ritual or ceremony.

Colors are used to communicate energetic principles in much the same way as letters are used as building blocks for a word. Most letters have one meaning in isolation and another when gathered in sets to become words. For example, the letter *i* has a certain meaning when presented alone *(I* as in *me)* and a different meaning when it is arranged in a word like *trio.* So too do colors have a different meanings when they are arranged into characteristic groups. The color red, by itself, usually represents the feminine dynamic *(Shakti).* When red is arranged in a group with yellow, white, green, and black, however, then we know it represents the fire element. We must always consider the context before interpreting the symbolic meaning of a color.

There is no single list of colors and meanings that can be applied to all the sacred arts of Asia. Indeed, there are many lists and tremendous regional variation. The ritual texts of different deities ascribe different colors to the directions of the compass, and thus of the many faces of a deity, for example. Different regions and lineages use the same colors to represent different principles, but traditional artists do not stray from the meditation manuals, scriptures, and guidelines of their particular lineage. It would be like mixing words from two languages together, resulting in gibberish. An artist was either born into a regional culture, with its own rules for colors, or found a teacher and did exactly what every artist of that teacher's school did for generations.

Today, we have a perplexing number of options and historical examples. While there is no single list of colors and meanings, we can make some generalizations. The colors assigned to the Five Great Elements, the three Gunas, and the Bhavas and Rasas are fairly consistent across Hindu culture. Below is a list of colors and their general associations.

Red: blood, energy, passion, Shakti, *Pingalā Nāḍī*, transformation
 (rajas), the sun, anger

Orange (saffron): flames, renunciation, devotion, valor, vigor

Pink (rose): bliss, youth, fecundity

Yellow: wealth, learning, knowledge, luck, fat

Brown (yellow-brown): destruction, the earth, ghosts

Green: intelligence, vegetation, play, innocence, love

Blue: spaciousness, sky, water, interconnectivity, *Sushumnā Nāḍī*

Violet: meditation, mystery

Black (or dark blue): power, reabsorption, wrath, void, inertia
 (tamas), fear, lust

White: ashes, semen, Shiva, *Idā Nāḍī*, harmony *(sattvas),* fun,
 the moon

Crystal (or white): liberation, clarity, peace, diamond, immortality

Silver: the moon, nourishment, coolness

Gold: the sun, transcendence, light, bliss, peaceful flames, awe

Colors of the Three States of Reality: The Tri-guna

The term *guna* means "cord" and refers to qualities or characteristics of phenomena, like hot or cold. Though there are many *gunas,* when we speak of the *tri-guna,* we are speaking of the three primordial states, qualities, or principles of manifestation that, when woven together, result in material reality:

- **Sattvas (white):** tranquility, balance, purity, harmony, equilibrium, lucidity, stasis

- **Rajas (red):** transformation, activity, dynamism, energy, passion, growth

- **Tamas (black or blue):** reabsorption, inertia, attachment, heaviness, entropy

These are the ingredients of which nature *(prakriti)* is constituted and are never truly separate. Like cords, the *gunas* bind the soul to material existence. Mystic literature abounds with references to them, especially *sattvas,* which is considered an ideal quality to cultivate in many spiritual traditions. In one of India's most popular tales, the Bhagavad-gītā, Krishna tells the hero, "Purity, passion, and inertia—these qualities, O mighty-armed Arjuna, born of Nature, bind fast in the body, the embodied, the indestructible!"

The *tri-guna* appears frequently as a motif in sacred art. It may be the only symbolic color scheme that remains consistent throughout the Indian subcontinent. If you see white, red, and black in close proximity, the combination is likely to be an allegory for the *tri-guna.* Three dots or rings of these colors are frequently used in yantras and mandalas as well. A goddess having skin of one of these hues is likely to reflect the qualities associated with it.

Suggestion: Do research on the goddess you are coloring. How is she described in devotional poetry? How is she portrayed in different regional styles? What are her songs? Such study is in and of itself a devotional offering and a form of spiritual discipline.

EMBODYING SHAKTI

The ignorant believe that I am merely nature,
but the wise experience me as the true self within themselves.

Tripura Rahasya

EMBODYING SHAKTI

Sacred Art: A Yogic Method

If your good karma has brought this book into your grasp, now is the time to begin the practice of making sacred art. Creating our own devotional art is like eating from our own garden; we are nourished by the process as well as the product. We gain a much more profound connection to the principles illustrated in the artworks than we would from simply looking at a print. Like a wise friend or role model, the deity in our artwork has a positive influence on our personal development. The images themselves also contain a wealth of traditional wisdom in mythic form, and that wisdom is deeply imprinted on us during the creative process. Our intuitive and analytical aspects are both cultivated in the process of making art. Much like the mystical pairs of male and female, sun and moon, Shiva and Shakti, the union of these seemingly opposite aspects of our nature is the fruit of yogic practice. Artists experience this as a state of creative flow, which is why it is fitting that the river goddess Sarasvatī, whose name means "She Who Flows," is also patroness of the arts.

The goddesses who appear in this book encompass the entire spectrum of cosmic phenomena, mirroring our own most expansive Self. It is not necessary to practice deeply with more than one goddess, but we experience the beauty, power, and vast scope of our own divine nature when we know them all. Their mystic diagrams—their mandalas and yantras—have a powerful influence on our awareness when we meditate upon them and visualize them internally. Our energy body is repatterned in this process, helping us to recognize behaviors that are out of alignment with our own most expansive nature, which is the Goddess herself. We may then focus on cultivating the virtues these goddesses exemplify and

allow unnecessary patterns to fall away. A virtuous life leads to improved health, happiness, and harmonious relationships.

Making sacred art is a type of meditation, helping us to come into stillness, focus our attention, and align with the principles portrayed in our artworks. Many yogic systems utilize visualizations, and most recommend spiritual artworks as "material support" for these inner techniques. Daily visualization of one's tutelary deity is a fundamental practice in classical Tantra. This is because the sense of sight is associated with the fire element and, thus, the power of transformation. For most people, the sense of sight is the primary way of perceiving our world and is thus a direct and powerful avenue by which yogic teachings can reshape our understanding of the cosmos. Drawing a deity is a proven method for memorizing his or her details, making our inner image of that deity more vivacious and helping us deeply absorb the wisdom he or she embodies.

Like hatha yoga, the practice of making sacred art utilizes physical means to stabilize, support, and shape the spiritual aspirant's internal experience. Many of the images are instructive in nature, so they also show auspicious new ways of being present in the world and help us expand our notion of Self. It is not the activity alone that causes transformation, however, any more than stretching makes people enlightened. It is the awareness, attitude, intention, and energy we bring to the physical act that ensures personal growth.

While cultivating artistic skill is an important aspect of this practice, the point is self-mastery, not making pretty objects. The artworks that result are the fruit of our personal journey, almost a side effect of the play between our inner experience and the physical world. The artworks that arise from our spiritual discipline

may or may not have any distinctive personal style, however. Most devotional art traditions discourage individualistic flourishes to avoid aggrandizing the personal ego and bolstering any sense of being special. Like any other yogic technique, making sacred art involves "yoking" the individual ego to the larger dynamic of the universe itself. We artists are simply choosing the creative principles of engagement, manifestation, and connecting, rather than the ascetic principles of renunciation, dissolution, and nonattachment as our path toward this union.

When we are so overflowing with awe, love, and appreciation for being *present* that our sense of fullness overflows, we share with others. For creative types, this effulgence is expressed as sacred art. Unlike meditation, which is primarily an internal experience, making sacred art results in functional objects. When made with precision, they become devices that aid others on their spiritual journey. In this way, making art is transformed from a form of personal expression to a form of community service. The emphasis shifts from individual to collective, from separate to connected, and our inner experience of unity is manifested in daily life. Creativity as a devotional practice transforms us into a vehicle for the Goddess's blessing energy. Creativity *is* Shakti. The role of the devotional artist is choosing to become the path of least resistance for this divine creative flow.

Suggestion: Just as yogins practice each day and monks meditate at a specific hour, spiritual artists benefit from regular practice. Schedule a regular time to make art. Perhaps is it on a specific day of the month or the week or at a specific hour each day.

Preparing Ourselves: Transforming Personal Circumstance into a Mandala of Realization

East is the concept of wakefulness. The direction in which we are going, or the direction we are facing, is unmistakable. In this case, the word "East" is not necessarily the geographical direction. Here, it means simply the place you see when you can open your eyes and look fearlessly ahead of you.

— Chögyam Trungpa (1939–1987)

The mandala of our life is the crucible in which sacred art is forged. Do we live in a divine or a dysfunctional mandala? Cultivating radiant health, arranging a tranquil living and work environment, and nurturing meaningful relationships are three fundamental tasks of a sacred art practitioner. Transforming our personal circumstances into a mandala of realization isn't simply preparation for making sacred art; it *is* the art. Artworks that we create are a joyful side effect of our lifestyle, the natural effulgence of our daily practice.

Our physical body is at the center of our personal mandala. Profound and lasting transformation is more likely if we take care of this divine vehicle. When bad luck, ill health, strong emotions, or creative blocks arise, pause and evaluate whether any of the following critical components of mind-body health are lacking: enough clean water, healthy food, restful nighttime sleep, vigorous exercise, or loving human touch. If they are, try correcting the physical imbalance before starting spiritual practices. Daily exercise, gentle yoga postures, fresh and nourishing food all support physical health. Daily quiet time, loving interaction with others, and regular sleep greatly aid mental health. A healthful routine and excellent habits form a kind of energetic structure that helps contain the power of our spiritual practice. Artists tend to be adverse to structure, but it is needed for support while we use spiritual techniques to dismantle and reconfigure our definition of Self. Self-care is not a distraction from making art; it is the first step.

Once we have stabilized our health and sanity, we can soberly assess our home and workspace. Is it clean, well arranged, and comfortable? Not all of us have the luxury of a dedicated art studio, but we can improve any room by doing what we do best: being creative. Look around: how might we prepare if a goddess were to visit? Why not live that way every day, celebrating our own inner divinity as it manifests both through our sacred art and our virtuous conduct? If we live in a dirty, disorganized, and distracting environment, we are unlikely to become enlightened simply by hanging a picture of a goddess on our wall. If our spiritual practice is to change our life, then we must actually *change our life,* including our actual living situation.

After physically cleansing, arranging, and beautifying our space, we can ritually cleanse it. There are innumerable purification rites, often utilizing prayers or mantras. These procedures are said to dispel unhelpful spirits and make the helpful ones feel welcome, but they also have a practical benefit of preparing us emotionally for making art. Many ceremonies include delightful physical components, such as lighting incense, ringing a bell, or sprinkling rose water. Try one and see if it helps inspire a creative mood.

Purification can be a realization practice in and of itself if we understand impurity to be anything that is untrue or unaligned with our spiritual duty (dharma). We are a product of our environment as much as we are the creator of it. From the mystic's point of view, our energy body extends far beyond our physical body to include our home and ultimately the entire universe. Beneficial changes to our environment, therefore, benefit our internal spiritual practices and have a positive influence on our art as well.

When we are preparing our space for the practice of making sacred art, it is helpful consider all of the five great elements:

Earth: Are there comfortable places to sit and tables well positioned for work? Does the room smell pleasant? Do you feel grounded here?

Water: Is everything clean? Are there refreshments nearby? Do you feel happy?

Fire: Is there enough light? Is the area visually pleasing? Are there inspiring artworks to look at?

Wind: Is the air fresh? Are you able to move freely? Do you feel focused here?

Space: Is there enough room to stretch out? Do you feel clear-headed here? Do you have fresh flowers? Is the room quiet, or can you play gentle acoustic music?

The point of systematically cleaning, organizing, and beautifying our personal space is not to achieve physical perfection, but to continuously align our living situation with our spiritual practice though self-observation. If we do so successfully, our artworks will no longer be allegories of ancient masters; they will be the fruit of our own self-mastery. Even if we cannot physically adjust our space, we can use our imagination. Remember, the holy lotus is rooted in muddy waters; divine art may be made in humble circumstances.

Cultivating friendships with like-minded people who are doing the same spiritual practices is of utmost importance—so much so that in some traditions, our spiritual community (kula or sangha) is known as the "daytime star" by which we navigate the challenges of daily life. Just as each individual has an aura, groups can also form a cohesive energy body. Certainly, finding a living master with whom to study is the first step recommended in all yogic traditions, but until we find such a master, we can begin closer to home. Try finding a friend, fellow artist, or seeker on the spiritual path to be a practice buddy. If possible, plan gatherings. Group practice generates powerful karmic momentum that speeds everyone's development, and mutual support helps us through times when we feel distracted or discouraged. Not all of us live in areas teeming with yogins and spiritual artists, so even if we don't have a practice buddy, we can seek out people who embody the virtues we seek to nurture in our own conduct. What is key is to choose our friends with care, rather than reacting mindlessly to circumstance, indulging old habits, or succumbing to the fear of being rejected. Art classes, workshops, and spiritual retreats are all great places to make new friends. Enthusiasts are easy to find via social media. Some masters will even tutor students over Internet video connections. If you do nothing else, make a heartfelt prayer asking to connect with other people who share your interests.

Poor health, humble circumstances, and a lack of companions should not hinder the start of our sacred art practice because the practice itself invokes the goddesses' guidance, protection, and blessing powers. Yet we must remember that art is not created in a vacuum. Patiently maintaining or even improving upon our circumstances is part of our creative discipline. In all traditions of making sacred art, physical accomplishment and spiritual realization are complementary goals. Auspicious results are unlikely if a schism exists between

spiritual teachings and our personal conduct. Our personal mandala is more deserving of our focused attention, creativity, and enthusiastic effort than any artifact. Our life is our greatest work of art.

Virtue Cultivation: Spiritual Practice in Daily Life

We bow to Her who is good fortune itself in the dwellings of the virtuous, ill-fortune in those of the sinful, reason in the hearts of the intelligent, (and) faith in those of the good.

— Mārkandeya Purāna

Sacred art makes subtle teachings tangible to those who see it, and you will enjoy tangible benefits when you apply these teachings to daily life. Each goddess is a model of the enlightened state that we can emulate, and the attributes she holds represent real-world accomplishments that result from her practices. Scholar Diana L. Eck explains that deity "images are not only visual theologies, they are also visual scriptures." In another popular book on goddesses, David Kinsley clarifies: "The goddesses . . . often illustrate important ideas of the Hindu tradition, ideas that underlie the great Hindu philosophic visions." The images we color and meditate upon are like maps for us to follow, guides toward a specific way of expressing our enlightened nature.

At the risk of oversimplification, we might say that images of devīs exemplify virtues, while their opponents, the *asuras,* exemplify vices. With this understanding, the myths and artworks of India take on a whole new layer of meaning. The battles and alliances between the devīs and the *asuras* become metaphors for our own internal struggles and hint at the kinds of challenges we face during our spiritual journey. When we create and meditate upon images of deities, it appears that we are venerating external supernatural beings. From this deeper yogic understanding, however, we may understand that meditation on these images brings forth the enlightened virtues the deities exemplify in our own actions of body, speech, and mind. We are not trying to become a devī as an act of self-negation; we are shifting to a more expansive sense of self. Tantrāchārya Dharma Bodhi writes, "Deity yoga is

Examples of Enlightened Virtues

Contentment, compassion, creativity, equanimity, devotion, dedication, dignity, discernment, discretion, divine knowledge, freedom, generosity, gratitude, loving-kindness, harmony, honesty, humility, integrity, intuitiveness, loyalty, nonattachment, one-pointedness, open spaciousness, patience, perseverance, playfulness, restraint, self-sacrifice, sexual integrity, skill, simplicity, stillness, truthfulness, vigor, focus, wisdom.

a Tantrik practice for bringing forth the qualities of the devas and devīs within oneself. Through identifying with the virtuous display of the deity, the practitioner dissolves dualistic relating and unites completely with the deity as their own personality display."

We must avoid reducing the status of deities to mere metaphors or psychological models. This strategy aggrandizes our personal ego by default. Rather, we are utilizing the ancient images of goddesses as templates to emulate until the fully realized state beyond any such model naturally unfolds in our lived experience. The deity represented by the image is not simply an archetype; she is a living, helpful presence during this reconfiguration and expansion of our Self. When we completely identify with our tutelary deity, and act as a living expression of her energy, we exhibit her characteristic virtues spontaneously.

To be clear, *virtue* is not being used in a simplistic moral paradigm of "good" and "bad." Virtuous action isn't always nice. Rather, the word *virtue* in this context has to do with behavior that benefits all beings in a larger cosmic view. For example, the result of meditating upon a goddess who holds a sword is said to result in improved discernment. Her practices will help us act discerningly, even if our conduct seems rude or cutting to some. Whether the guiding principle is discernment, wisdom, loving-kindness, or any other virtue, the result is the same: Our conduct of body, speech, and mind will be more cohesive, impeccable, and *dharmic.* Our words will match our intentions, our

intentions will match our actions, and our actions will take on the flavor of the deity we venerate. "[One] who performs all work out of a sense of love, such a person practices devotion characterized by virtue," says a passage from Devī Gītā, a well-known text studied by devotees of the Goddess.

Suggestion: Do you have a virtue you wish to cultivate or strengthen? Try coloring the image of a goddess who exemplifies this virtue, and then place the image where you will see her regularly, as a reminder of that virtue. When we see a deity image, we have the opportunity to reflect on our own conduct. For example, when we see an image of Lakshmī, we might ask, "Am I being generous?" When we see Kālī, we might ask, "Am I being fearless?" If we discern that we are not being generous or fearless, then we have an opportunity to find what belief patterns are limiting us.

Enlightened virtues are not qualities that need to be manufactured; they are innate and merely need to be revealed. Yet it does require some effort to compensate for living in a modern consumer culture, which often rewards unvirtuous behavior. We build spiritual strength the same way we build physical strength: regular practice. Looking at a pretty picture will not make you enlightened any more than gazing at a barbell will make you stronger. Just as you must pick up the barbell and start exercising, you must also practice the virtues you wish to strengthen. We must also recognize the deity image as a reminder to wake up and recognize our own state of being. Then we may exercise our will and choose to act accordingly.

Devotees make a practice of recognizing each appearance of a deity as an opportunity to reflect on their personal conduct, and they make it more intimate and visceral by treating icons as if they were alive. They avoid immoral conduct when in the presence of goddess icons because she is looking at them. Courtesy forbids such immoral behavior in front of an honored guest. From a yogic point of view, we might say the consequences of any action are greatly amplified when the power of a deity is invoked. When we are coloring or meditating on a deity image, we are invoking her energy. Unconscious habits (or patterns of conditioned behavior) incompatible with the deity's virtues become obvious to us. Whether this realization is the result of the influence of a supernatural being or an expression of our own unconscious programming is beside the point; we have an opportunity to resolve a once-hidden karma. In this sense, the device of a deity icon successfully circumvents the conscious mind. This is why some practitioners surround themselves with images of enlightened deities. Each glimpse of a deity is an opportunity to recognize and release behaviors incompatible with the deities' virtues. The more visceral we make the practice, the more visceral our experience will be.

Suggestion: Take time to get to know a goddess and get a feeling for her personality before starting on her image. Then try creatively adopting one or more of her characteristics. What kind of music would she enjoy? Play it. What type of food or drink might she enjoy? Try a taste (all you need is a taste) before beginning work. Saturate yourself in this flavor of divinity until it overflows as art.

Flavors of Life: *Bhāvas* and *Rasas*

The realm of pure wisdom can be accessed in several ways: through the yogic practices of sacred ablutions, worship, oblations, meditations, reciting mantras, and so on. This [realm] can [also] be experienced through an intense emotional experience that arises from within (Rasa). One who presents a pure-hearted offering with focused attention to the particular Mandala of Goddesses associated with an intense rasa will experience the transformation [of that rasa] into the Supreme universal consciousness (samvit) of one's true Self.

— Tantrāloka

The best-known and most widespread system of Indic aesthetics is based on a principle called *rasa* ("flavor" or "juice"). This aesthetic

system is closely associated with the performing arts, especially theater, but has tremendous influence on the visual arts as well. It has been called "emotive aesthetics" because it revolves around how the viewer, artist, and/or aesthete (*rāsika*) feels as the result of appreciating a work of art. This system focuses primarily on the experience that results from enjoying a finished work of art, but it is understood that the artist benefits also by cultivating this experience during the creative process.

Bhāvas ("to become") are intrinsic states of being we all possess. *Rasas* are the aesthetic experiences, moods, or emotive states that arise from *bhāvas*. We could not say that one theater production has more *rasa* than another; *rasa* is an internal experience that cannot be measured. A legendary sage named Abhinava-Gupta defined *rasa* as the universal bliss of the Self colored by the emotional tone of a drama. In his commentaries, he posits that it is not enough for art to have literal meaning and metaphorical meaning; it must also possess a mysterious and inspirational aesthetic quality that has nothing to do with the other two levels of meaning. Great art, then, stimulates the imagination and lifts us from our worries to a more expansive state. The arising of *rasa* depends on the skill of the artist, to be sure, but one cannot force a member of the audience to experience *rasa*. The viewer must be a participant, actively savoring the arising emotional state. It is as much the responsibility of the aesthete to appreciate the art and to engage it with all her imaginative faculties as it is for the performer.

Rasa is also sensuous, visceral, and aromatic. Though primarily an internal experience, *rasa* can also fill an environment and everyone inside it. Consider the experience of an audience watching a horror movie: They watch carefully crafted images and highly skilled actors on a screen. They set aside their skepticism and become swept up in the spectacle. The *bhāva* of fear is established. Then the music rises to a crescendo, a figure leaps, blood spurts, and the audience flinches and screams. Yet no one flees because they are actually *enjoying* the experience. This is the *rasa* of horror—not simply an emotion but also a refined state of appreciation. When

Bhāvas, Rasas, and Colors

The colors listed below are those used in classical Indic theater. The earliest text describing this system (Natya-Shatstra, fourth century CE) held that the erotic *rasa* was king, but this view has changed over time. According to the great sage Abhinava-Gupta, the *rasa* of peace (*shānta*) is supreme, permeating and linking all the others like the silk chord in a string of pearls.

Bhāva	Rasa	Color
Pleasure/lust (*rati*)	Romance/love (*shringāra*)	Light green or blue-black
Energy (*utsāha*)	Valor/heroism (*vīrya*)	Yellow or golden orange
Disgust (*jugupsā*)	Repulsion (*bībhatsa*)	Blue
Anger/malice (*krodha*)	Wrath (*raudra*)	Red
Fun (*hāsa*)	Comedy/humor (*hāsya*)	White
Wonder/surprise (*vismaya*)	Awe (*adbhuta*)	Gold or yellow
Fear (*bhaya*)	Horror (*bhayānaka*)	Black
Sorrow (*shoka*)	Compassion (*karuna*)	Gray or "dove colored"
World-weariness (*shama*)	Peace (*shānta*)	Brilliant white or "jasmine"

the movie ends and the lights come back on, everyone is delighted because they did not mistake the story as being real. They leave feeling exhilarated. The experience of the emotion of horror in real life may be dreadful, but the *rasa* of horror is only delightful! We are better able to handle the challenges of life when we have first experienced them in a work of art. It is a bit like being inoculated

against a deadly virus. We aren't so horrified by violence if we have watched actors courageously deal with bloodshed, and we remain aware and fully present during the performance. Art helps us build psychic strength.

This aesthetic system of how emotions are experienced shows how unpleasant emotions can be transformed into loving awareness. Emotional states that might have resulted in unthinking reactivity instead open us to an equanimous state of contentment. In this peaceful, nonjudgmental state, we are better able to express our inherent virtues. One excellent example is how sadness *(shoka)* can be transformed into the *rasa* of compassion *(karuna)*. The two are related, but one leads to a sense of powerlessness and separation, while the other leads to loving action and unity. We may use our understanding of *rasa* to train ourselves to move from the contracted state of reactivity to the expansive state of discriminating awareness and *dharmic* action.

Great art inspires us to a state of wonder, where we recognize the sublime in every experience. The challenge is apply this principle to life outside of the theater, to actual experiences, so all of life becomes a grand play. If we are unable to recognize *rasa* while sitting in a dentist's chair getting our teeth drilled, for example, we aren't truly using it as a spiritual technique. Strong emotions like aversion or attachment may arise, but if we are able recognize that they are all part of a play staged by the Goddess, our experience of those emotions does not bind us. If we follow this energy of the emotion back to its source, it can be a direct conduit to spiritual awakening. The raw power of emotion *is* Shakti. Recognizing this, any powerful experience can result in fascination, delight, and fulfillment. This quiescent state is *shānta rasa.* From it, we are, as the divine witness, able to recognize all other *rasas* welling up from inside our own being. This helps explain why yogins love terrifying deities as much as the compassionate ones: both are powerful conduits to realization. This ability of the aesthete to be delighted by all experience, whether painful or pleasurable, is said to be similar to the enlightened state.

Suggestion: Try watching a movie or play without being swept up in the drama. Recognize arising emotions. Relish the artistry, and recognize this act of relishing as originating from a peaceful state that underlies all experience. It helps to use a simple mindfulness practice, like counting the breaths, to maintain your equanimity. Try inhaling for a count of five and exhaling for five, or whatever is a comfortable and consistent count, throughout the show.

PART 3

COLORING SHAKTI

Truth is one; the wise call it by various names.

Rig Veda

COLORING SHAKTI

Getting Started

Work in a relaxed and meditative manner; the process is as important as product. You are invited to draw new details into the backgrounds of images, but it is wise not to change the main figure or inner patterns of diagrams. Such alterations may dramatically change the symbolism of the icon and distort or destroy any benefits of meditating on the image. In general, any appropriate color or ornamentation may fill the blank area behind the yantras and deities, or this background area may be left empty.

A short salutatory invocation is provided with each goddess image; this invocation is to be chanted silently while coloring. For each of the yantras and mandalas, there is a contemplation you can engage in while coloring it. You may also reflect upon the virtues of each goddess while coloring her image or her mystic diagram. The purpose of silently chanting an invocation or engaging in contemplation is to keep our mind from wandering while we are coloring and to invoke the blessing power of the goddess's name.

Information about each goddess and mystic diagram is on the backside of each image, so an image and its description will remain together if you remove the page from the book. If any of this text from the backside of an image shows through the page, just slip a piece of black paper behind the image, and the text will disappear from view.

Please be respectful of these venerable icons: do not place them in the trash, set dirty objects upon them, or disfigure them. If there is one you no longer want, consider giving it to a friend or recycling it. These fierce goddesses are not simply mythological figures; they also exemplify aspects of our own nature that must be befriended if we are to progress on the spiritual path. By honoring them, we honor ourselves.

Sacred Art Basics

Here are general steps for engaging in a sacred art practice:

1. Pick an auspicious time to begin—perhaps at sunrise, a new-moon day, a full-moon day, or a holy day.

2. Purify your body, tools, materials, and workspace before you begin. Try using a simple technique like sprinkling rosewater, burning incense, and/or bell-ringing to do so.

3. Divinize the body *(nyāsa)*. Place the inner wrist of the right hand over the third eye, so the middle finger is on the top of the head. Chant *Oṁ* three times to charge the hand. Then awaken the power of the three main energetic centers of the body: place the right hand first on the lower belly, then on the heart, and then on the crown of the head, chanting *Oṁ* once for each energetic center as you do so.

4. Invoke a reverent mood by organizing and beautifying your workspace. Try wearing the goddess's color, a scented oil, and/or meaningful jewelry as you work.

5. Read the description and the contemplation for each goddess before starting to color her image.

6. Close your eyes and vividly visualize the goddess as a living being, radiant and encouraging.

7. Begin silently reciting the goddess's invocation to focus your mind or recall the provided contemplation to invoke a devotional mood. Keep it going while you are working.

8. For the goddess images, start by coloring the background. It is okay to draw new details in the background if desired. Work from the outside of the image toward the center. On yantras and mandalas, start from the outside and work inward toward the center. Work in a clockwise direction for manifestation and counterclockwise for dissolution.

9. Cultivate elegance and simplicity in technique. Try to find a rhythm in the work.

10. Notice if your mind wanders. Notice *why* it wandered. Gently bring it back to the invocation recitation or the contemplation.

11. Check in with yourself regularly: Are you breathing deeply? Is your heartbeat steady? Are any sensations or emotions arising? Allow the breath to release any strong emotions, patterned behavior, memories, or other tensions from your system. Feel free to take a break, stretch, or adjust yourself if there is physical discomfort.

12. The last thing to be colored in is the center of the pattern, or the eyes of a goddess.

13. Seal the practice with a concluding prayer or by chanting, *"Oṁ, Shānti, Shānti, Shānti-hee."*

14. Pause and gaze at the finished image. Try not to judge or evaluate it; simply enjoy it and give thanks for the experience of being a vehicle for Shakti's creative power.

15. Consider giving a finished image to someone who could use that goddess's guidance and/or protection.

Coloring Mediums and Tips

Colored pencils: Ideal. Pencils can be sharpened to a fine tip, easily blend with one another, and can be used gently to create subtle fades and layering. To apply layers of color, turn the paper forty-five degrees between each layer for cross-hatching. Some colored pencils are water-soluble, so a small brush and a little water can be used to spread colors. Use only a little water or the paper will crinkle.

Felt-tip pens: Take care, as the colors are bold and may bleed through the paper and ruin the next image below. Slide a few pieces of blank paper between pages to prevent bleeding, and test the pen on scrap paper before starting.

Crayons: Fun for kids! Adults may find that crayons' colors fade quickly, and they are difficult to use for small details.

Poster paints, watercolors, and acrylics: Use sparingly. They are likely to crinkle the paper if applied heavily.

Extras: Glitter, gold leaf, stickers, gems, and other ornamental materials may be added. They're even traditional. Have fun!

Mandala of the Trident and Lotuses

*The swan of dazzling whiteness drinks the world again
and says with immense joy: I am That (haṃ-sa).*

—Tantrāloka

This complex mandala was utilized in initiation rites for the Tantric lineage known as the *Trika* ("the Trinity"). The number refers to three goddesses. They sit at the tips of a trident (the symbol of Shiva), which is to be visualized three-dimensionally as arising from the center of the pattern upward toward the viewer like a flag pole. The central lotus is visualized suspended midway up the shaft, like a shelf. From the center of this lotus emerge the three prongs of the trident. Parā (center) is the knower, sweet and gentle, associated with willingness, unity, and emission. Parā-parā (left) is wrathful, associated with knowledge, knowing, unity in diversity, and stasis. Aparā (right) is utterly terrifying, associated with that-which-is-known, acting, diversity, and reabsorption.

COLORS: The colors of the lotuses and the four corners of the inner square are very specific. The large central lotus is white, as is the smaller one above it. The left lotus is red, and the right is dark red or black. The center circles of all four are golden yellow. Behind the lotuses, the upper left corner is black, the upper right corner is red, the lower right corner is red, and the lower left corner is golden yellow. The large main square is red.

For the rest of the yantra, there is some freedom to choose the colors. The following are suggested: The geometric shapes framing the main square (from top left to right) can be white, golden yellow, red, white (center), red, golden yellow, and white in an alternating sequence. The shaft of the trident may be made black, with a gold bulb at the base. The three prongs may be colored red. The circles around the lotuses may be white, and the spaces between petals may be gold or green. The mandala offered here is based on the work of Stephanie Sanderson, who recreated it from the original Trika source text with guidance from her husband, Professor Alexis Sanderson.

CONTEMPLATION: Enlightenment can happen spontaneously, at any moment, effortlessly and without cause. Enlightenment is not a thing we can conquer, win, or earn. It is already innate in our own fundamental nature; we need only relax into our fullest sense of Self. Pause for a moment and do nothing. Who are you beneath all the layers of memories, the stories, fears, desires, and obligations? What remains if there is nothing left to *do?*

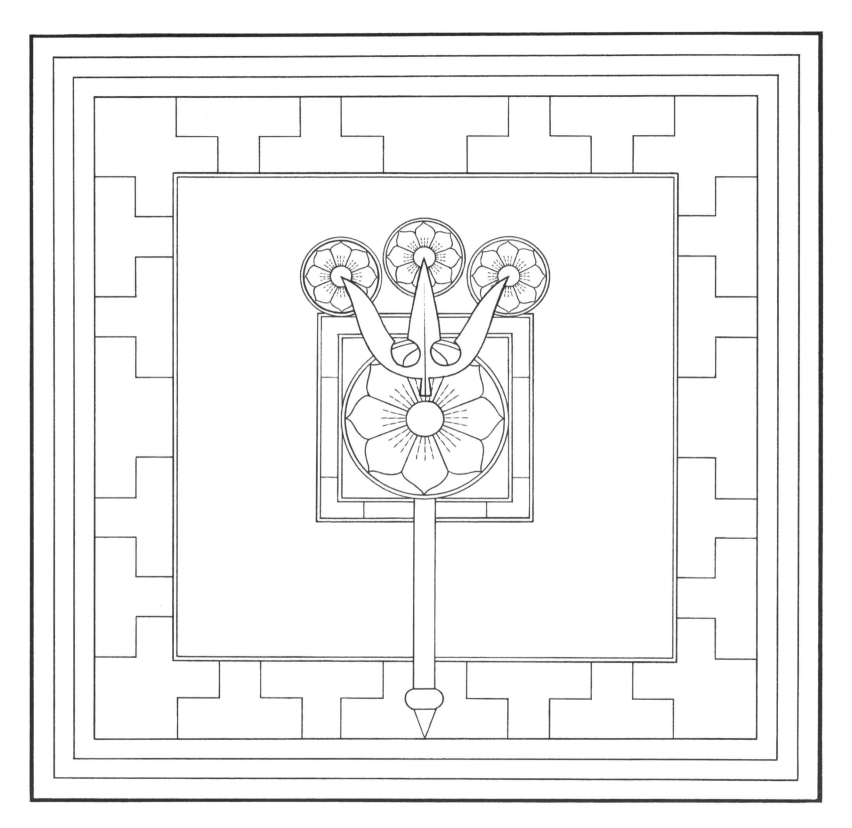

Mandala of the Trident and Lotuses त्रिशूलाब्जमण्डल

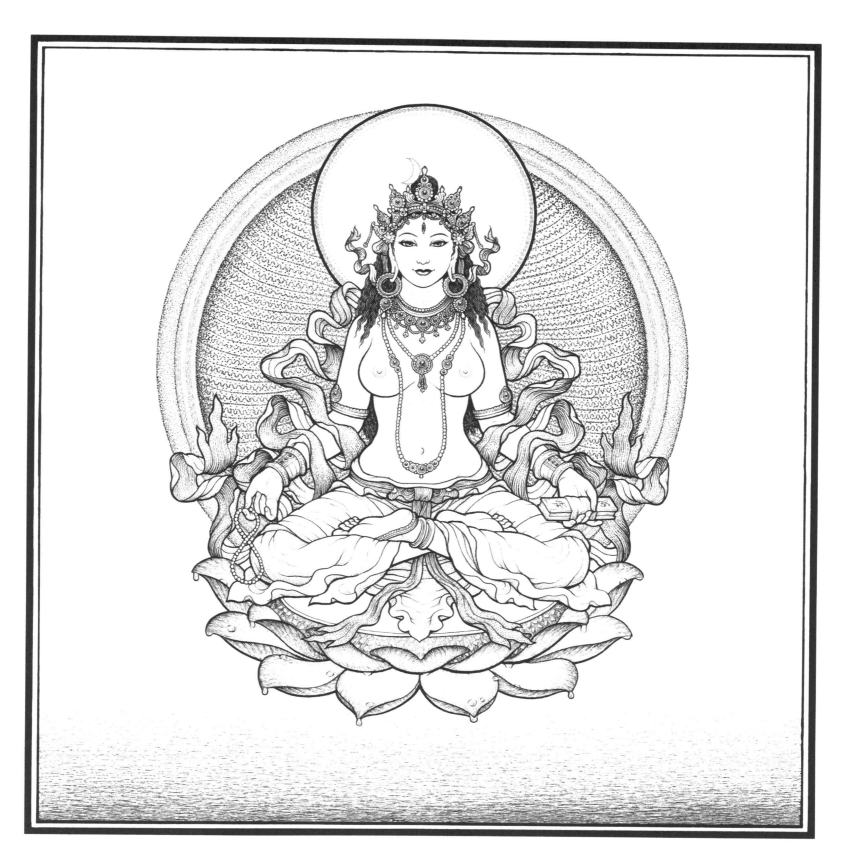

Parā Vāch परावाच्

Parā Vāch

Supreme Word and Creative Inspiration

She is the primordial, uncreated Word, the very essence of the highest reality,
pervading all things and eternally in creative motion:
She is simply luminous pure consciousness,
vibrating with the greatest subtlety (as the ground of all being)

—Abhinava-Gupta (c. 950–1020)

PARĀ VĀCH is the primordial goddess of creation. Her name means "Supreme Word," and her essence is of the most subtle vibration, the patterning of consciousness, the primordial structure of reality. She is spontaneously arising knowledge, the answer with no question.

The importance of speech, words, and language in Indic mystical lore cannot be overstated. Speech is the vehicle for knowledge of liberation, and spiritual teachings were passed along in oral traditions for thousands of years. Speech is also believed to have the power to alter the nature of reality itself though the use of mystic phrases called *mantras*. This magical quality of speech in the form of mantra is her power.

Parā Vāch is one of the most ancient goddesses of India, featured prominently in the Vedas and once worshiped across India. She remains widely acknowledged, though not often honored in her own right. Her worship was incorporated into other spiritual traditions, like the Shrīvidyā lineage, where she is visualized as Lalitā's heart. A Tantric lineage named the Trinity *(Trika)* venerated Parā Vāch as supreme, believing her to be the inner essence of Sarasvatī, the more widely known goddess of creativity. She is portrayed as the primordial source, at the edge of what can be described or depicted, both effulgent and quiescent.

INVOCATION: *Oṁ Parāyai Namaha (Ohm Puh-rah-yai Nuh-muh-huh)*

IMAGE DESCRIPTION: Parā Vāch is described as having a crystal body, luminous like sunshine on snow. This is customarily portrayed as pure white. Artists commonly use pastel colors for her robes, trim, ornaments, and aura to give the image definition and visual interest. A faint warm pink is used to shade her limbs and face to subtly indicate curves and volume. This original portrait is done in the modern Newar style. Parā Vāch holds the scriptures (knowledge) and prayer beads (truth) and emerges from the primordial void as the embodiment of the joyous creative impulse. She is clad simply and sits in full lotus posture to convey her subtle nature. The arrangement of her left leg on top and the moon in her hair emphasizes the lunar orientation of her mystic practices.

VIRTUES: intuition, divine knowledge, creative inspiration, expansiveness, unconditional love.

Durgā Yantra

O Devī! Thou art the power of understanding By Which the essence of all scriptures is known;
Thou art Durgā, the vessel wherein we cross the dangerous ocean of the world.

—Mārkandeya Purāna

According to the well-known author Harish Johari, the eight petals of Durgā's yantra represent love, mercy, sacrifice, penance, selfless service, devotion, faith, and detachment from achievements. The radial form of the lotus petals symbolizes the expressive or radiant quality of the deity; her power moves outward in all directions. In this yantra, there are eight small lotuses at the tips of each of the large petals, symbolizing how she spreads purity in all directions. Her peaceful aspect is being invoked here; when Durgā is victorious, she lays down her weapons and holds only lotuses in her many hands. The three concentric circles enclosing the triangles represent the *tri-guna*. The many triangles represent her great power for transformation. The nine-pointed star is created by four triangles superimposed over one another. They represent her nine shaktis *(nava durgā).* The three upward-pointing triangles represent creation (Brahmā), preservation (Vishnu), and destruction (Shiva). The fourth, downward-pointing triangle, to be colored yellow, represents the divine body of light. The overlapping of all these triangles produces another triangle in the center, which is colored red. This innermost triangle points upward, meaning her primal energy leads toward dissolution of the individual ego.

COLORS: This yantra is typically colored with reds, oranges, and yellows, which have positive, warm, alkaline, and astringent qualities. These colors are associated with sunlight, and Durgā is divine radiance expressed in a female form. Meditating on the saffron color of Durgā's yantra produces a complementary calming blue color when your eyes are closed.

From the edge to the center, the outer line is iridescent gold; the next is light yellow. The large square enclosing the entire figure, the *bhūpura,* is a warm orange-peach color. The small lotuses are white, while the large petals are scarlet red. The small triangular shapes at the base of the petals are a slightly darker red. The circles are iridescent gold, with two rings of white between them. The area behind the triangles is brilliant white. The upward-pointing triangles are similar in color to the *bhūpura,* but slightly more reddish. The downward-pointing triangle is lemon yellow; in the three areas where it overlaps the upward-pointing peach-colored triangles, their two colors are blended, resulting in a light yellow-orange. The innermost upward-pointing triangle is blood red, and the *bindu* (center dot) is iridescent gold.

CONTEMPLATION: Durgā is legendary for never losing her pleasant smile, even while she is being attacked by armies of demons. She is the embodiment of divine wrath, which is dignified, whereas demons personify selfish impulses, which are ignoble. She does not pursue them. Rather, they lust for her. When they try to take her by force, they are annihilated. In a sense, it is her composure itself that destroys them, and they are reabsorbed into the fullness of their cosmic mother.

How do we artists react to our own creations? Are we able to see the beauty in our artworks, or do the mistakes leap out at our eyes? Are we amused by the minor flaws, even the apparent disasters? Next time an error appears, are we able to understand it as an opportunity to improve our technique? Can our unplanned act be creatively incorporated back into the overall design? This process of recognition and refinement can continue throughout the entire process of coloring these goddesses.

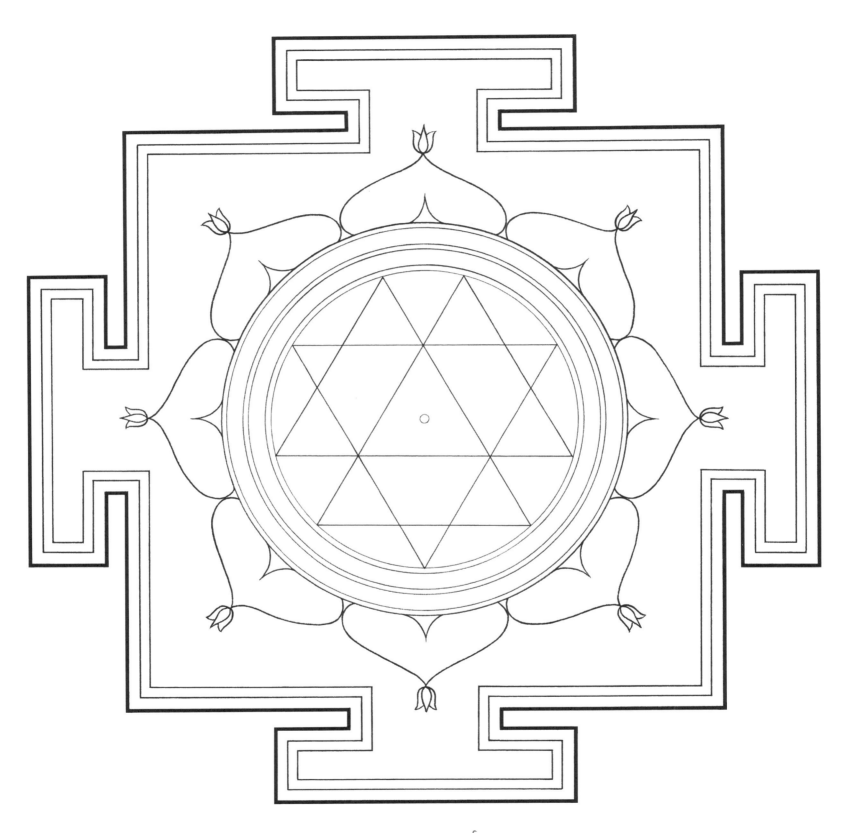

Durgā Yantra दुर्गा यन्त्र

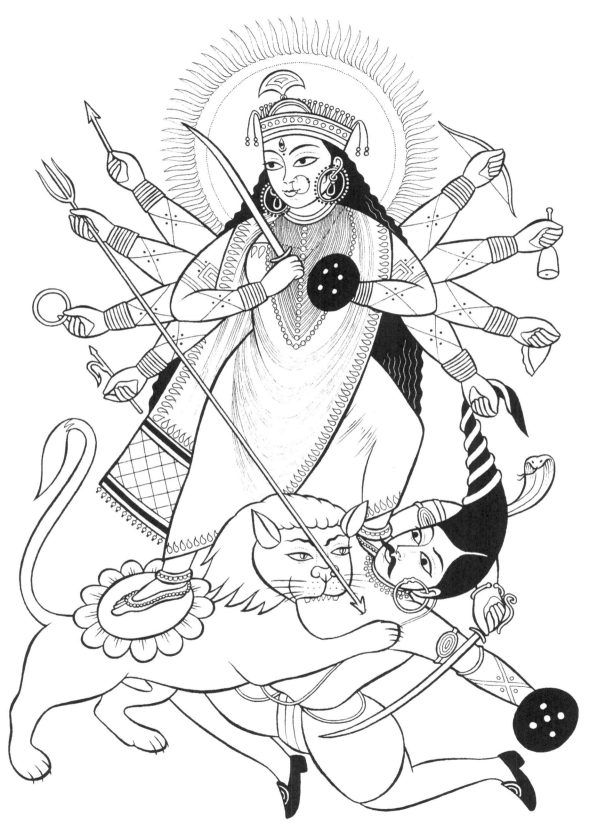

Durgā दुर्गा

Durgā

Demon Destroyer of Impregnable Power

O Fierce Lady! wander in my heart, By whom the act of formidable titan (Mahisha)
was shattered, Destroy the calamities which deeply pierce me . . .

—Tantrasāra

DURGĀ (a.k.a. Mahishamārdinī, Chandī) is said to have emerged from a sacred fire formed by the combined wrath of the gods to conquer Mahishasura, a demon that could not be defeated by any man or god. Hence Durgā's popular epithet, Mahishamārdinī. She patiently waited in a pleasure garden until he was lured by her laughter and coy charm. When she refused his proposal, he tried to take her by force. A great battle ensued, with armies of demons attacking her and her shaktis. She finally defeated Mahishasura in single combat, even as he transformed into many different animals, including a buffalo.

Durgā's stories are well known, and there are many interpretations. Some say the demon is thought, others say ego, and still others say lust. Perhaps he is all three. Other versions of her story pit her against the demon brothers Shumbha (self-conceit) and Nishumbha (self-depreciation). Some say Durgā is Shiva's consort and the mother of Kālī. Others say she is Mahālakshmī or *kundalinī-shakti* personified. Regardless of the tale, she is always identified with fierce compassion, as well as dignity, poise, beauty, and humor. She is often portrayed with ten arms, which symbolize the ten directions: up, down, the four cardinal directions, and the four noncardinal directions.

Durgā rides a tiger or lion, symbolic of her power and fearlessness. The name *Durgā* in Sanskrit means "Fort" or "the Inaccessible" or "Difficult to Approach in Battle." Another version of her name is *Durgatināshinī,* which translates into "the One Who Eliminates Sufferings." In India today, she is commonly considered to be the most powerful form of divinity, Shakti personified, carrying all the weapons of the gods (devas), as well as a lotus and conch. She is perhaps the best known and most widely worshiped of all Hindu goddesses, embraced by many traditions. As a result, there are many different versions of her story and innumerable depictions in different regional styles.

INVOCATION: *Oṁ Durgāyai Namaha (Ohm door-gah-yai Nuh-muh-huh)*

IMAGE DESCRIPTION: Durgā is usually shown wearing red. Her skin color depends on the form being invoked and ranges from blue to "the color of sunrise." This image is based on the customary arrangement and style of her depictions found in the northwestern state of Bengal, where she is portrayed with yellow or golden skin and wearing red robes. The lotus she stands on is yellow with red petals. The demon has green skin and red shorts, while the lion is white with a yellow mane and tail. This image is inspired by a charming piece of art from Calcutta of the mid 1700s, a traditional folk style that has changed little in the past three hundred years.

VIRTUES: wrathful compassion, unlimited power, vigor, focus, integrity, dignity.

Shrī Yantra

Let us worship that Supreme Goddess who is rising in a splendor of innumerable lightning flashes, who is like a new rose blossom resembling dawn, whose form is that of thick, blissful nectar. One should contemplate her as consisting of pure consciousness, as the shining, embodied flower, who resembles a resplendent light.

—Shārada-tilaka Tantra

The Shrī Yantra (a.k.a. Shrī Chakra) is the most famous of all yantras. It is said to carry the energy of the manifest universe—the diversity, vibration, and expansion and contraction of everything. *Shrī* is a general term for the Great Goddess and often used as an honorific title. Though this yantra originated from the Shrīvidyā ("Auspicious Wisdom") tradition, it is also used to invoke Kāmākhyā and many other goddesses. Each and every point is associated with a specific mantra. There are five main downward-pointing triangles and four upward-pointing ones, showing her overall energetic expression is more oriented toward manifestation. Drawing all the triangles so that the lines intersect neatly, without any gaps, requires focus and precision, hinting that successfully invoking this goddess in all her glory is a great accomplishment. The inner ring of eight petals corresponds to eight goddesses who control the flow of blessings, while the sixteen petals of the outer ring are her wish-fulfilling attendants (shaktis). Entire books have been written about the symbolism of the many overlapping triangles and lotus petals. The Shrī Yantra can be used as a model of the universe, of the energetic centers of the human body, and of the legendary Mount Meru upon which Shiva resides.

COLORS: This version of the Shrī Yantra comes from the Himalayan region, where it is intricately decorated. Every place but the central triangles (which are plain red) and the spaces between them (plain white) is filled with ornamentation. This drawing is provided without ornamentation, so you can add your own.

The following colors and decorative patterns are suggested, moving from the edge inward. The entire yantra is framed with red, then golden yellow. The next inner layer of the frame is filled with a geometric pattern, usually alternating blocks of red and blue with white highlights. There are several more layers of decorative frames next to the gates, in the sequence of blue, a wide band of black,

then a thin band of golden yellow, then red. It is auspicious to fill all these layers with bands of dazzling geometric patterns.

The main yantra has a thin double line of white (with dots) all the way around. The top quadrant (east) of the main square *(bhūpura)* is blue. To the right (south) is the yellow quadrant, on the bottom (west) is the red quadrant, and to the left (north) is the green quadrant. Consider filling the quadrants of color with sinuous "peaceful flames" and floral patterns. The sixteen petals of the outer ring are white. The next circle holds eight red petals. Feel free to add elaborate, scrolling ornamentation to any of the petals. The innermost circle is a ring of golden rays. The circular area behind the yantra is light green. The triangles are all blood red with white spaces between them. It is traditional to wait until rest of the yantra is complete before adding in the center dot *(bindu);* it may be made white (effulgence), black (void), or gold (divine knowledge).

CONTEMPLATION: Sometimes that which is hidden is most profound. The principle of hidden power permeates yogic scriptures in the form of shadow language. When we read an obscure metaphor and know the meaning is not obvious, we are drawn to inquire more deeply. Most Asian art includes layers of meaning, from the obvious to the subtle to the encrypted to the completely hidden. For example, mystic symbols are often written on the *backside* of Himalayan *thangkas,* out of sight. Ritual artists may also mix precious substances into their paints. None of these symbols or substances are obvious at first glance, yet they give an icon a certain power; we can sense there is more than meets the eye.

Consider hiding something important within your coloring of this yantra. Perhaps a private wish can be written in a light color then covered with a darker one. Perhaps a prayer can be written on the back. What is your secret power, your hidden desire, your divine wish?

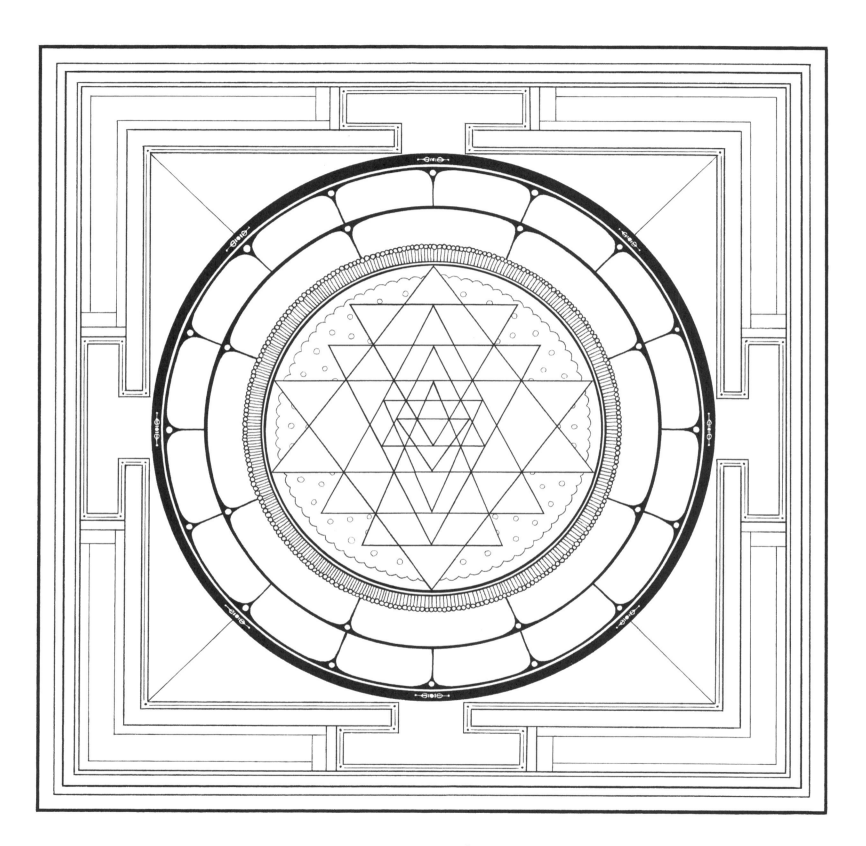

Shrī Yantra श्री यन्त्र

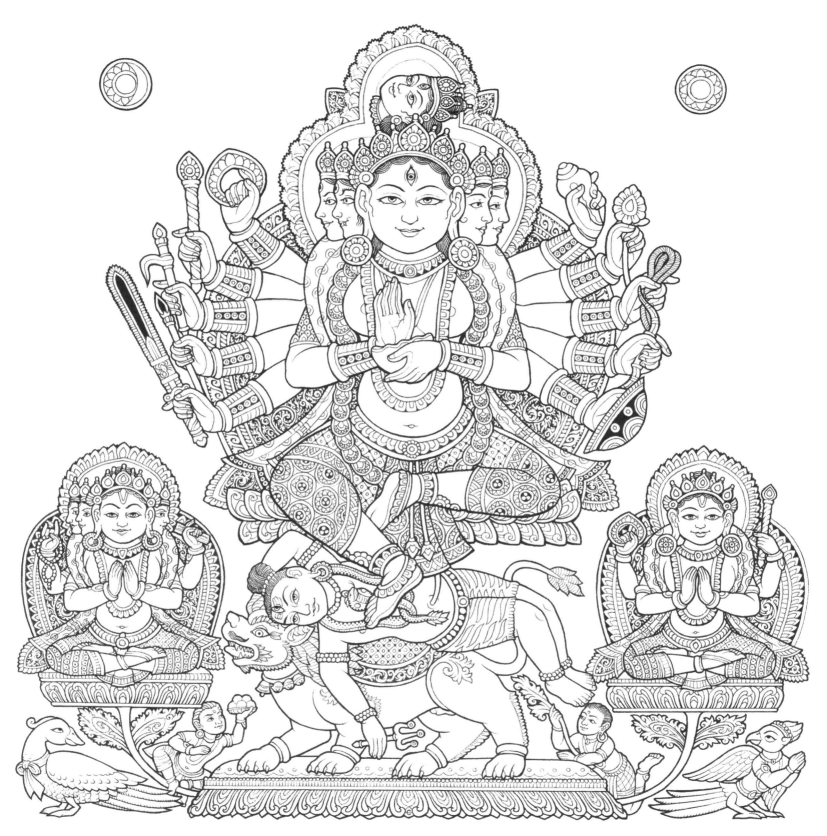

Kāmākhyā कामाख्या

Kāmākhyā
Generative Power of Desire

O Mother, your perfect embodiment is supreme, this majestic glory of the entire universe,
filled with the blossoming of spontaneous, playful delight, completely full with the highest bliss!

—Kālikā-stotra

KĀMĀKHYĀ is the primordial source, the womb of creation. Her name means "She Whose Eyes are Filled with Desire" and is related to the word *kāma,* meaning desire, wish, and longing. *Kāma* is commonly associated with sexual desire, but on a more profound level refers to any pleasure of the senses, as well as aesthetic appreciation of life. This shadowy northern sister of Lalitā is the quintessential example of a goddess associated with a geographic feature—in this case, a spring that wells up from a stone cleft. Her hill in Assam has been the site of goddess worship since time immemorial and remains renowned as a place of Tantric worship. It is one of the most important Hindu pilgrimage sites in the world, preeminent among the fifty-one ancient goddess sites of India known as *shākti pīthas.* Each of the sites is associated with a part of an ancient goddess named Satī, and Kāmākhyā is said to be the location where her vulva *(yoni)* fell to earth. Thus, Kāmākhyā exemplifies the Goddess's generative power.

Satī's story shows how she brought consciousness down to earth for the benefit of all beings. The creator, Brahmā, implored the Goddess to take birth as Satī (being) and win the heart of Shiva (consciousness) and entice him to participate in creation. Her culture-bound father, Dākshā (cleverness), however, disapproved of the wild, tiger-skin-wearing yogi and did not invite Shiva to an important ceremony that honored all the gods. His daughter was furious and used her yogic powers to burst into flames and immolate herself in the ritual fire, desecrating the ceremony. News of her death sent her new husband into a grief-stricken rage. Shiva ripped out a dreadlock, and he threw it to the ground. It sprang up as a wrathful warrior named Vīrabhadra, who attacked everyone at the event. Many of the old Vedic gods were slain. He then carried Satī's burnt corpse through the cosmos, howling in agony and disrupting the cosmic order. The gods implored the deity of preservation, Vishnu, to intervene. He threw his magical discus and sliced Satī's body into pieces. Where each piece fell to earth became a hallowed site for goddess worship. Shiva withdrew into deep meditation, until Satī took birth again so they might have children together. Please see Tapasvinī's story for how she won back his heart.

INVOCATION: *Oṁ Kāmākhyāyai Namaha (Ohm Kah-mah-khah-yai Nuh-muh-huh)*

IMAGE DESCRIPTION: She is pictured as a girl of sixteen at the first blooming of fertility, sitting upon her supine consort, who lies across her vehicle, the lion. She is depicted with six heads, representing the four cardinal directions, the center, and the place or state of being that is beyond them all. From left to right, they are colored white, red, tawny, golden yellow, and black (or dark blue). The upper head is warm pink. From top to bottom, her arms are warm pink, white, red, golden, and black (or dark blue). Kāmākhyā's front two arms and feet match her center face, which is tawny. Shiva has white skin shaded with bluish gray. The snow lion is white shaded with warm gray, but his mane and tail are red. Brahmā, in the lower left corner, has red skin and white (or pastel) robes, while Vishnu, in the lower right corner, has blue skin and golden yellow robes. All ornamentation is gold with blue and red details. Most significant among her many attributes are those of her two front hands: the gesture of fearlessness and a skull cup filled with the nectar of realization. According to one source, the lion she sits on represents Vishnu (preservation), while the lotus is Brahmā (creation), and, of course, Shiva (destruction) is her consort. So she is supported (and commands) the three main male deities of the Hindu pantheon. This image is inspired by the sumptuous work of contemporary Newar artist Gyankar Bajracharya.

VIRTUES: fertility, sacred sexuality, secret knowledge, generosity, all-embracing love.

Yantra of the Cosmic Womb

Origin of the world Thou art,
yet hast Thou Thyself no origin.

—Bhairavī Stotra

There are countless mandalas, yantras, and symbols used to represent or focus the power of Shakti, but none more simply than the downward-pointing triangle. It represents the cosmic womb, the feminine dynamic of manifestation, the exhaling breath. The three points of a triangle are generally associated with the three primordial powers of the Goddess: will *(icchā),* knowledge *(jnāna),* and action *(kriyā).* Another interpretation is that the horizontal line of the triangle represents space, while the left diagonal line represents time, and the right diagonal represents object. The number three is associated with many mystic concepts. The symbolism depends on the ritual and who is asked their opinion.

There are many variations of this yantra. This image was inspired by a seventeenth-century example from the desert region of Rājasthān and is based on the design of an ancient Vedic ceremonial fire pit *(yoni-kunda).* Interestingly, this is not a symmetrical triangle, but is built atop an underlying grid, making it proportionally wider. This grid is normally hidden by the colored paints of a finished yantra, but is included here as dotted lines to display its elegant beauty. Feel free to color over the grid or incorporate it into your color design.

COLORS: The original yantra was drawn with golden yellow ink, probably made from turmeric, rather than the black ink used in books. So you can try to duplicate this effect by filling the areas between the thin parallel lines of this image with a golden yellow. The wide lines around the triangle, moving from outside in, are black, red, and white. The central main area of the triangle is a deep indigo blue. The inner vertical line is red. The innermost triangle (which looks like a downward-pointing arrow) is outlined in gold and is red inside.

CONTEMPLATION: It is said that your mother is your first guru. Pārvatī is an excellent example of a parent who gifts her children with not only love and sustenance, but also wisdom. How do you give care and support to the children in your life? In Vedic astrology *(jyotisha),* the karmas of children and students are both associated with the same karmic house. So even if you don't have your own children to nurture and mentor, you can play out this karma in an auspicious manner by caring for students. This needs to be done with no expectation of gratitude or reimbursement, as this care and support is an offering given to repay your own karmic debt to parents, teachers, and ancestors. Perhaps this support can be in the form of loving attention or mentorship of a child in need, but it could also be in the form of a donation to a scholarship fund. It could even be a gift copy of this book!

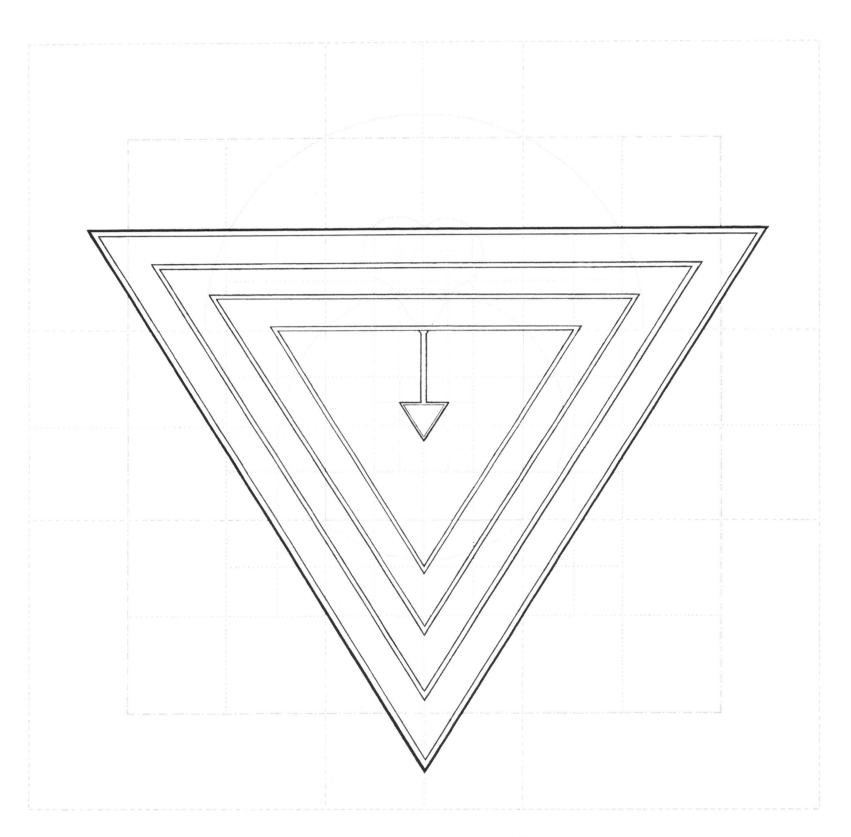

Yantra of the Cosmic Womb योनि यन्त्र

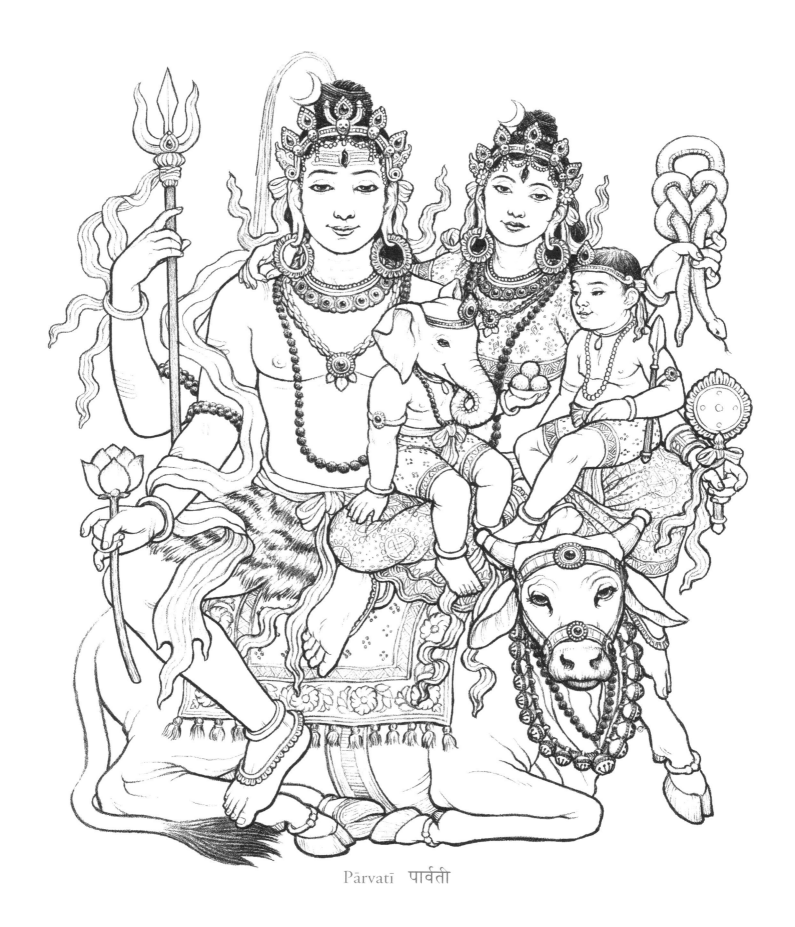

Pārvatī पार्वती

Pārvatī

Marriage as Spiritual Union

I call to mind the Mother of all the worlds who creates this universe,
whose nature is both real and unreal, who preserves and destroys by Her dynamic, static, and entropic qualities,
and in the end resolves all these into Herself and plays alone in the period of Dissolution.

—Devī-bhāgavata

PĀRVATĪ (a.k.a. Gaurī, Jagadambā, or Umā) is renowned for her power, perseverance, and wisdom. She is a householder goddess, exemplifying the nurturing qualities of the feminine dynamic, rather than being a transcendental deity. Pārvatī is the only major Hindu goddess regularly portrayed with her family. Her name as Shiva's bride, Gaurī, "the Fair One," shows how she is able to remain unstained, or *sattvic,* even while immersed in a householder's life. *Pārvatī,* the feminine form of the word for "mountain," hints at her regal majesty. In myth she is the reincarnation of the ancient goddess Satī, born as the daughter of the mountain king, Himavan. Esoterically, the Himalayas are analogous to vertebrae, the mountains of the spine. At the base of the spine dwells Shakti in her mysterious energetic form known as *kundalinī-shakti.* It is this force that yogic disciplines are designed to awaken. *Kundalinī* is directed up the spine so she may join her consort, Shiva, who resides atop the mythical Mount Meru, analogous to the crown of the head. It is this blissful and fecund state of union that is shown in this portrait. Many Hindu goddesses are said to be forms Pārvatī has taken for various tasks, emanations of her primordial will to be.

INVOCATION: *Oṁ Pārvatyai Namaha (Ohm Pahr-vuh-tyai Nuh-muh-huh)*

IMAGE DESCRIPTION: This is an original image in the modern Newar style, based on ancient temple statues of the family as a group. Shiva and Ganesha (with the elephant head) are white, while Pārvatī and Kārttikeya are red. Pārvatī holds one hand on Shiva's shoulder, in the gesture *(mudrā)* of knowledge *(jnāna).* In her other hand she holds a mirror, which symbolizes both wisdom and the emptiness of appearances. Shiva holds a pink lotus with his front hand; it is only when he is in direct contact with Shakti that he holds this symbol of peace and purity. His other front hand is wrapped around her torso and hidden from view. In his rear hands he carries his signature trident and a knotted serpent *(kundalinī),* symbolizing that his ultimate freedom includes the option to be bound. Ganesha carries a bowl of sweets, showing his satisfaction, while Kārttikeya carries the spear (also called a shakti) of piercing knowledge. The family sits atop the deity known as Nandi ("the Joyful"), who takes the form of a white bull with a black tail.

VIRTUES: parental love, wisdom, devotion, compassion, patience, self-discipline.

Auspicious Twelve Lingas Mandala

One sees me wherever one finds a person who knows me.

—Devī Gītā

This is an example of a lesser-known yet intriguing style of mystic diagram that is composed over a grid of underlying of squares. It is called a Bhadra ("auspicious") Mandala. In ceremony, the geometric pattern acts as the base for a ritual vessel into which a deity is invoked. It is modular in nature, with parts and shapes that can be switched in and out for different deities. It is a clear example of a yantra within a mandala.

The large central square is called a Sarvatobhadra ("auspicious from all sides") Yantra, which can be utilized for any divine being. When it is surrounded by other symbols, however, it becomes a mandala. In this case, the twelve black shapes (see the color diagram) are very abstract *lingas* (phalluses), hence the name Dvādasha Lingato Bhadra, or "Auspicious Twelve *Lingas.*" It is notable that this symbolic representation of a *linga* depicts it inside a *yoni* (vulva); they are a conjoined pair. Thus, the goddess invoked into the central square is surrounded by twelve divine couples, making this a mandala, even though it is square in shape. Diagrams utilizing *lingas* are used for worship both of Shiva and Tapasvinī, who is known as Gaurī ("the Fair One") in this tradition. This style of mandala continues to be utilized by the Smārta community in Western India, though rarely in other parts of Asia. This particular figure is described in a nineteenth-century text, the Bhadra-mārtanda, which recommends that it be constructed on a flat surface and from colored grains or powders.

COLORS: Colors of this style of mandala are strictly defined. Creating it requires one to be restrained and disciplined, much like Tapasvinī. Please refer to the color diagram provided.

CONTEMPLATION: In modern consumer culture, we are taught that our beloved is acquired by means of seduction, wealth, and good looks. Yet Tapasvinī provides a different model: her beloved is

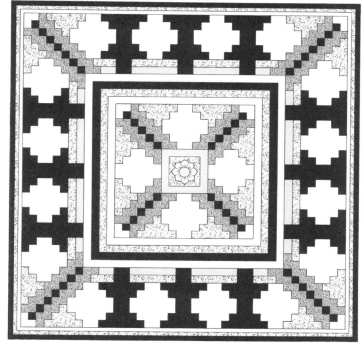

Color diagram for the Auspicious Twelve Lingas Mandala

■ Black	▨ Red
□ White	▨ Green
□ Yellow	

consciousness itself, and union is won through self-discipline and focused effort. In most cultures, the artist aspires to make a beautiful object. The objective is different when we engage art creation as a yogic discipline. Now the emphasis is on the creative activity and the insights it gives. The beauty that results is almost a side effect of our training. Are we disciplined about making art? Do we have a regular time set aside for practice? Have we ever scheduled an art date with a friend or a group of artists to be creative together?

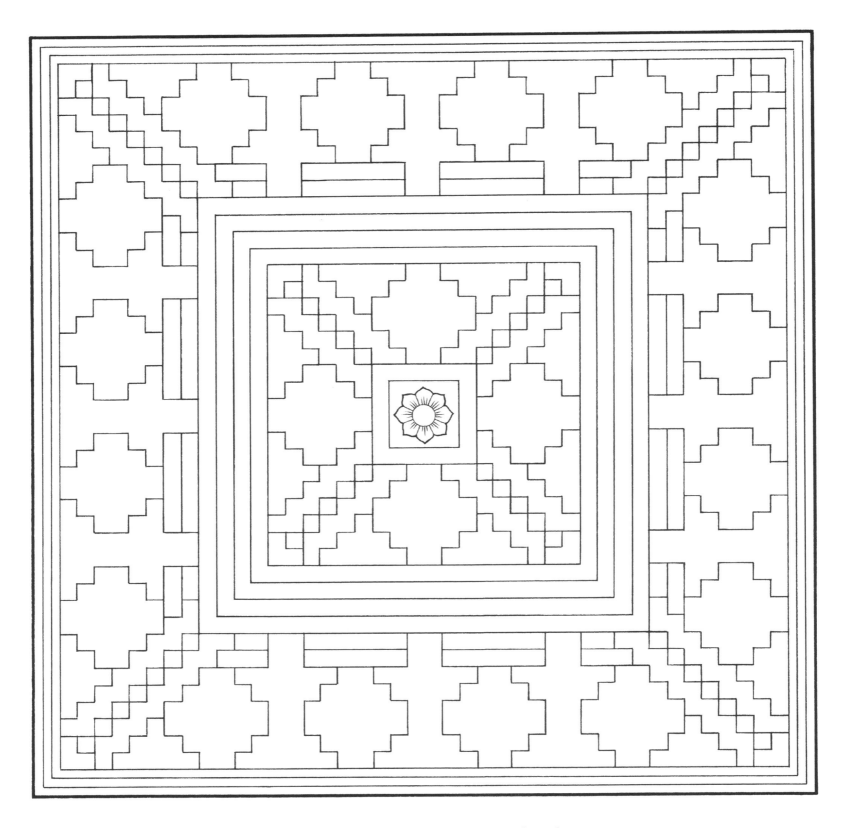

Auspicious Twelve Lingas Mandala द्वादशलिङ्गतोभद्र मण्डल

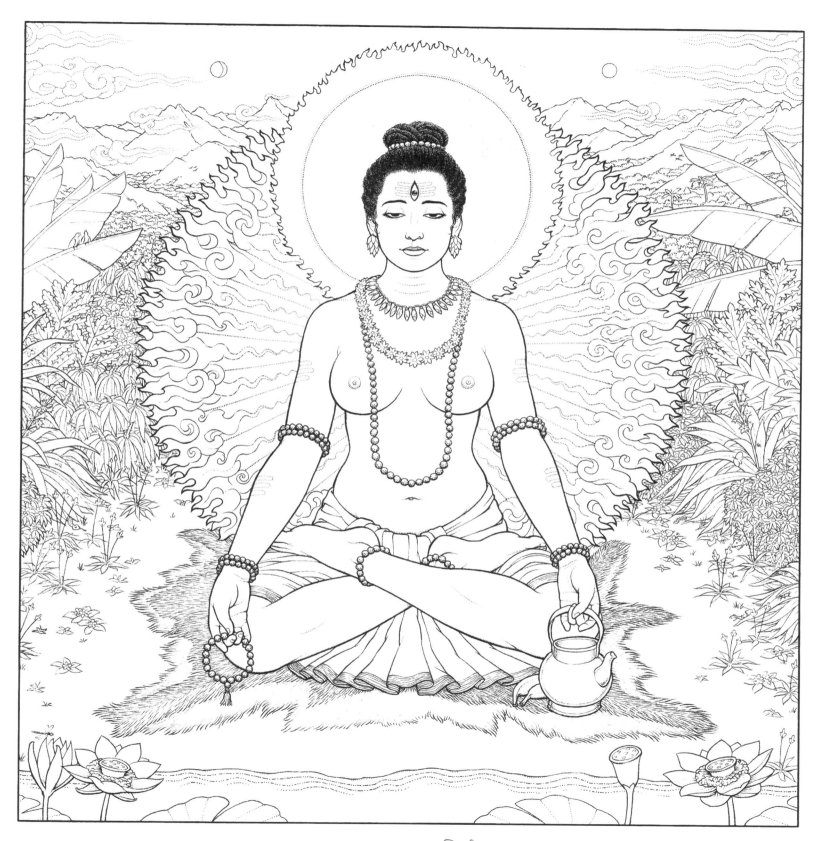

Tapasvinī तपस्विनी

Tapasvinī
Absolute Self-Mastery

I prostrate before the Supreme Power that flows in all of creation uninterrupted.
She is ever youthful, eternal, enigmatic, and her everlasting waves cannot be measured,
but are seen only by the yogic vision.

—Ganapati Muni (1878–1936)

TAPASVINĪ (a.k.a. Aparnā, Yogeshvarī) is a youthful form of Pārvatī, who engages in yogic disciplines *(tapas)* to save the world. After the death of her previous incarnation (Satī), her husband, the grief-stricken Shiva, withdrew from the world and became absorbed in meditation. Meanwhile, a powerful demon ran amok, threatening the cosmic balance. All attempts to lure Shiva back to kill the demon failed miserably, so the gods implored the primordial Shakti to take birth once again. She did so, but Shiva rebuffed her attempts to lure him out of his self-imposed exile. So she matched his own yogic austerities to win his love. If we look deeply into the story and understand the demon as exemplifying selfishness and Shiva as exemplifying consciousness, it becomes apparent that Tapasvinī represents the need for discipline to recognize and rid ourselves of self-destructive behavior. We must also recognize that Shiva is not simply enticed by Tapasvinī, but he is also unable to act without her.

Tapasvinī demonstrates that full realization may include the world of appearances. Though requiring great self-discipline, hers is a path of embodied realization that includes love, fecundity, and creative play. As the manifest form of divinity, she entices transcendental consciousness (Shiva) down from his lofty meditation cave into the world through rigorous ascetic practices, not through seductive beauty. She is not an object to be possessed, but a full-fledged master of body, speech, and mind. It is through her self-mastery that Shiva's teachings become available to benefit all embodied beings and that cosmic balance is restored. Many of India's most profound spiritual treatises are composed in the form of philosophical conversations between Shakti and Shiva on the nature of reality, exemplifying the archetypal relationship between guru and disciple. Tapasvinī's story is an allegory for the yoginī's quest to merge with the Absolute.

INVOCATION: *Oṁ Yogeshvarī Svāhā! (Ohm Yoh-gesh-waree Swah-haa!)*

IMAGE DESCRIPTION: This image is based on contemporary images of Brahamacārinī, one of the nine forms of Durgā. In these images, the goddess is depicted with human skin color (ranging from pink to dark brown) and white robes. Unfortunately, many modern depictions of yoginīs show them as emaciated from their austerities, unlike ancient depictions, in which they are always robust. This image honors the ancient scriptures by portraying Tapasvinī as voluptuous, nourished by her practices rather than depleted by them. A fiery nimbus surrounds her, symbolizing incredible yogic power, yet she sits next to a stream to show how her blessings flow to all beings. In her hands she holds a rosary *(mālā)*, showing her complete devotion to ultimate consciousness, and in her other hand she holds a specialized type of water pot. Water pots are like canteens carried by wandering ascetics, and they symbolize spiritual effulgence. When the pot has a spout, it shows that this effulgence can be poured out, so the pot in this image signifies that Tapasvinī is a teacher. Lush vegetation and all the surrounding beauty of the natural world show that her realization is in harmony with manifest reality.

VIRTUES: divine knowledge, self-discipline, patience, focus, simplicity, generosity.

Festival of Lights Kolam

She is the power of enjoyment, the tree of plenty, the wish-fulfilling gem.

—Sītā Upanishad

Throughout India, common people make intricate patterns on the thresholds of their homes or on the ground at festival sites to welcome guests. These patterns have many names, such as *kolam, rangoli, alpana,* or *mandana,* depending which region in India they are found. Historically, the patterns and color combinations from each culture were distinctive because they were based in the native materials available. As commercial powdered pigments became available, these regional variations grew less distinct. There is a general division between those patterns that are made freehand and those composed over an underlying grid of dots.

This *kolam* incorporates both elements. Unlike *rangolis,* their more colorful cousins, *kolams* emphasize linear elements. Those that are made completely freehand, with no rulers or stencils, are a physical as well as creative challenge, requiring great patience and a steady hand. Drawing one is an exercise in focus, precision, and piety. After the summer harvest, India celebrates the Festival of Lights *(Diwali),* and *kolams* drawn for this celebration usually incorporate tiny candles or oil lamps. Though there are different interpretations of the meaning of this festival, one story is that these little lamps were lit by grateful citizens of Rāma's kingdom to welcome back the king and queen after the war and their long journey. The lights are still lit each year in remembrance of the victory of knowledge and inner light over ignorance and spiritual darkness.

Presented here is an unfinished *kolam,* showing the underlying grid of dots. It is for you to complete, if you wish. Start with the most obvious connections and work outward into less completed areas. Feel free to add as many extra layers or details as desired.

COLORS: Traditional *kolams* are made of rice flour, so their lines are white, but when modern powdered pigments are utilized, brilliant colors are often used instead. While for yantras or mandalas, there are rules limiting what colors may be used and in what combinations, there are no such rules for *kolams.* The only rule is the final artwork should be beautiful!

CONTEMPLATION: Artists celebrate freedom, but often forget that ultimate freedom includes both spontaneity *and* discipline. An auspicious way to discipline ourselves is to be loyal to a cause, principle, or duty larger than ourselves. Like a vow, our loyalty protects us from impulsive behavior and temptation, giving us freedom from distraction. Most devotional artists are loyal to their teacher or the lineage to which they belong, making art in that style for their entire lives. Who or what are we loyal to, beyond time and preferences, even when our loyalty is not earned or returned? What is worth dying for?

Festival of Lights Kolam दीपावलि कोलम्

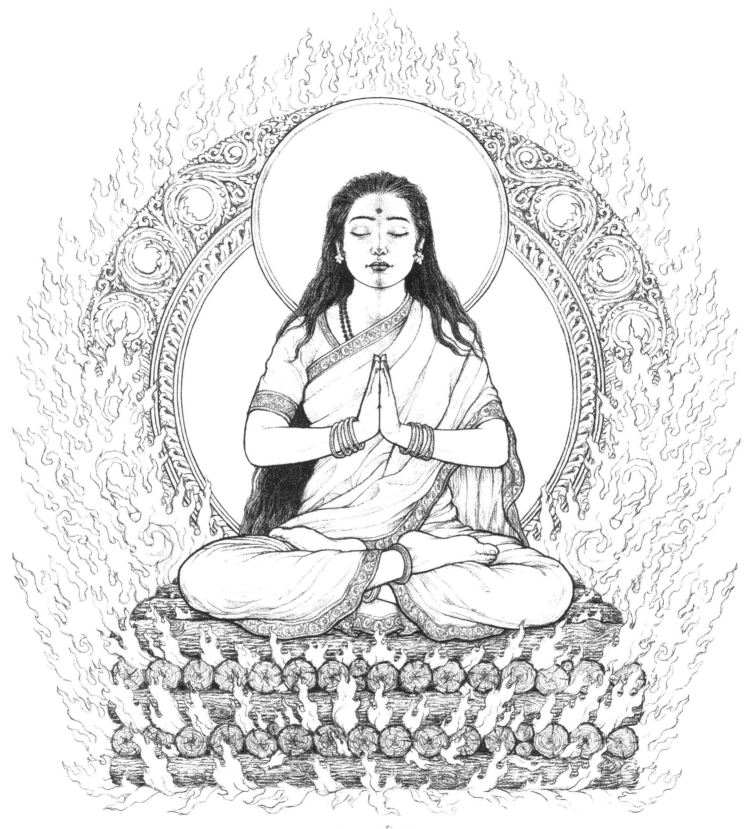

Sītā सीता

Sītā

Purifying Nature of Total Loyalty

She is all creation, and the gods of creation.
She is cause and effect, saints and demons, the elements, souls.
She is supreme virtue and supreme beauty. The worlds are illuminated by her form
as the sun; she adorns herself with lightning.

—Sītā Upanishad

SĪTĀ is a lead character in one of India's most famous of epic tales, the Rāmāyana. She was the wife of a legendary king named Rāma, though we know she is an incarnation of Lakshmī, just as Rāma is an avatar of Vishnu. They took birth together to rid the universe of the mighty demon Rāvana. Though Rāma is the hero of the tale, it is Sītā who goads him and all the other characters into action. Early in the story, Rāvana took Sītā captive and held her hostage. Ultimately, the demon was conquered and Sītā was freed, yet the couple were unable to reunite happily because of Rāma's famed dedication to propriety. The citizens of his kingdom questioned Sītā's chastity after she'd been held hostage by the charismatic demon for so long, and he felt duty-bound to have a public trial by fire. She was so pure that neither she nor the flowers she wore as ornaments were burned in the flames. Even the god of fire, Agni, appeared and apologized to Rāma, saying he was unable to harm her. She was accepted as queen and mothered two heroic sons.

Sītā is often held up as the paragon of submissive womanhood, yet her tale also shows her to be self-possessed. From the beginning, she refused to be smuggled away from captivity by Rāma's servant Hanuman, insisting her husband restore her honor personally, thus inciting a war between Rāma's allies and Rāvana's demon hordes. She also chose her departure from the world (and Rāma) after having her loyalty questioned a second time. She leapt into a chasm opened by her mother, the earth goddess, thus returning to the source from which she came. When public opinion becomes more important than love and devotion, Shakti takes her leave.

Her name actually means "furrow," and fertility is her defining attribute. It is from the riches of its fields that a kingdom is sustained, so her blessings are indispensible for stability and prosperity. She is the quintessential goddess of hearth and home, of marriage and fertility. Her steadfastness and loyalty beyond reason are qualities of the ideal spiritual devotee, one whose faith is never shaken, even by God himself.

INVOCATION: *Sītā Rāma, Sītā Rāma, Rāma Rāma, Sītā Rāma (See-tah Rahm, See-tah Rahm, Rahm Rahm, See-tah Rahm)*

IMAGE DESCRIPTION: Sītā is the goddess Lakshmī in human form, and she has golden or pale skin. She typically wears springlike colors, but in images of her trial by fire, her purity and humility are emphasized by a simple white sari. She holds her hands in the well-known prayer gesture, which not only emphasizes her devotion, but also signifies that the lunar left side and solar right side of her energy body are united at the heart. Her right leg is crossed on top of the left to show that her practices are orthodox in nature.

This portrait is an original work. Though it utilizes elements of Newar art, it is heavily influenced by the calendar art popular throughout India and inspired by the work of Indra Sharma, a renowned painter from Rājasthān.

VIRTUES: loyalty, surrender, devotion, patience, humility, endurance, dignity.

Mandala of the Mothers

By you this universe is borne, by you this world is created.
By you it is protected, O Devi, and you always consume it at the end.

—Devī Mahatmyam

Chāmundā is widely recognized and worshiped, though often in secret. Examples of her mystic diagrams are therefore rare, and many are clearly intended to be used for wrathful rituals. This particular mandala is included here because of the way it is constructed: the symmetry and overlapping squares indicate the energy being invoked is stable and harmonious, and therefore more appropriate for public disclosure. It is not for Chāmundā alone, but for all of the eight Mothers *(Mātrikās),* of which she is one. Here they are invoked as guardians of the cardinal and noncardinal directions as well as all thresholds of consciousness.

COLORS: It is very difficult to find reliable examples of mystic diagrams for the *Mātrikās.* Those I have seen employ red ink on a golden background, and the mantras are written in black. Most use the same golden yellows, scarlet reds, and leaf greens as other yantras. A few utilize the wrathful colors of black and blue to fill in empty areas. Because this mandala is for all of the Mothers, a full spectrum of colors might be appropriate to represent the full range of their powers. In this one case, I suggest invoking your own intuitive abilities, asking the Goddess for guidance, and coloring this mandala in a way that is pleasing to the heart.

CONTEMPLATION: Beginning artists sometimes become infatuated with every single one of their creations. This can lead to stacks of mediocre artworks gathering dust. It can also lead to a debilitating fear of making mistakes, or feeling compelled to correct a tiny error and fussing over it until the entire image is destroyed. This fetishizing of our work kills creativity and limits our freedom to act intuitively. It can also lead to a kind of hoarding mentality, where we refuse to share our creativity with others because of a fear of our work being not good enough.

One powerful way we can eradicate this impulse is to ritually destroy our artworks. Ritual mandalas are usually destroyed at the end of a ceremony, symbolizing both the dissolution of the universe the mandalas portray and the dissolution of our own personal ego. Consider destroying one of these images after coloring it exquisitely, as an exercise in nonattachment and an offering to the Goddess herself.

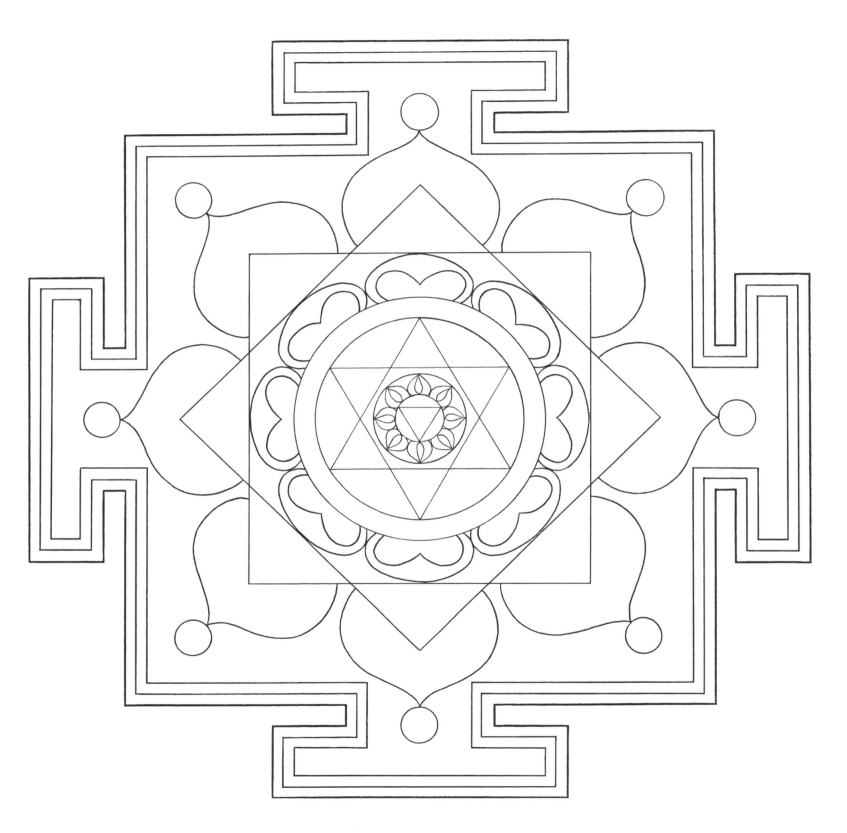

Mandala of the Mothers मात्रिकानाम् मण्डल

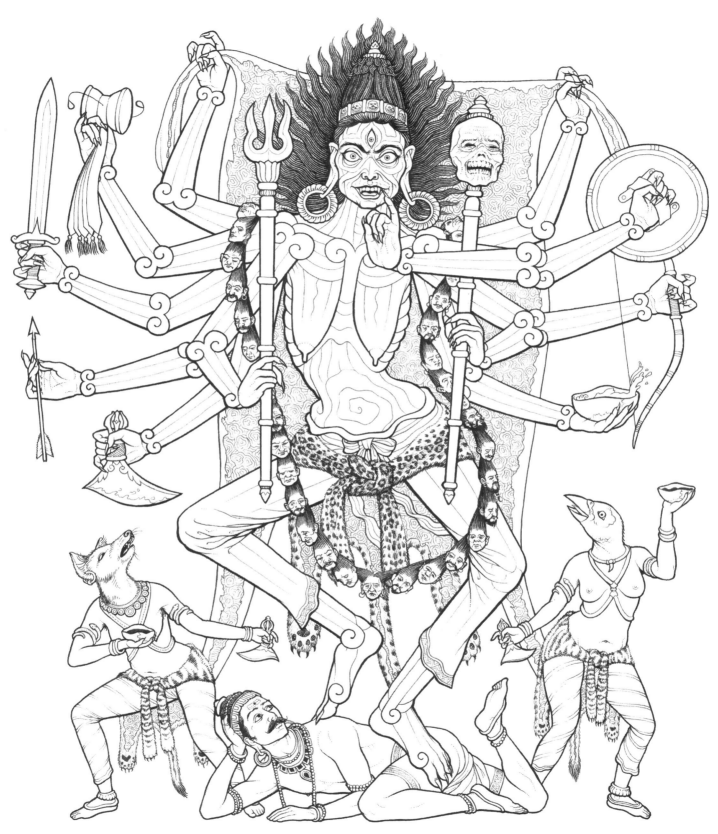

Chāmundā चामुण्डा

Chāmundā

Annihilation of the Separate Self

*A vision of radiance like that of a million suns mingled with a million bolts of lightning;
a form to inspire terror in both our eyes and our hearts. The Gods witnessed and cried out,
trembling with fear. Confronted with this form, even the remembrance of Her slipped away.*

—Devī Gītā

CHĀMUNDĀ is the thirsty goddess of annihilation, the personification of death, she who makes all things one within herself. With an emaciated body and eyes of flame, she resides in cremation grounds surrounded by jackals, ghosts, and goblins. As member of both the group of fierce Mothers *(Mātrikās)* and the wild sixty-four Yoginīs, she is a protector, a teacher, and a lethal force of nature. Though the term *yoginī* is now used in yoga classes to describe any woman who does yoga postures, in medieval times it was reserved for powerful female tantric initiates or referred to a class of semi-divine females who were sometimes depicted with the heads of animals.

If we are to have a complete understanding of the universe, then we must recognize both the creative and destructive aspects of the Goddess. Just as Shakti gives birth and nourishes all beings from her own body, so too she is hungry, thirsty, and all consuming. Chāmundā embodies the sober truth of our physical dissolution, reminding us death is always near. Her name comes from the names of the two demons she killed in battle who exemplify passion and anger, Cānda ("the Moon") and Mundā ("Shaven Head").

She is sometimes identified with Kālī or Durgā, but Chāmundā was widely known before the shapely Bengali Kālī we know today became popular, and they are distinctly different deities. She is still worshiped in her own right and in particularly unorthodox ways,

often at the edge of civilization or places where life and death meet. Terrible she may be, but her role is as important as any other devī, as she teaches us to master our fears and recognize divinity everywhere, even in the vilest circumstances. She is associated with the vice of depravity, yet as an enlightened goddess (she has three eyes), she shows us how to turn this vice toward virtuous action for the benefit of all beings. Ancient texts say that she is a nurturing and protective mother to her spiritual children.

INVOCATION: *Oṁ Chāmunde Culu Culu Svāhā! (Ohm Chaahmun-day Chu-lu Chu-lu Swah-haa!)*

IMAGE DESCRIPTION: She is described as having black skin, black or red hair, an emaciated skeletal body, desiccated breasts, sunken eyes, and red fangs. She is surrounded by red fire, gray smoke, and a dark sky that grows reddish brown at the horizon. In her foremost right hand she carries a trident *(trishul),* representing will, knowledge, and action. Her left hand is in an obscure mudra that is based on the ritual action of flicking a drop of wine as an offering to a statue of a wrathful deity. This image is based on a ninth-century sculpture from Rājasthān, with additional visual details supplied by a nineteenth-century Nepalese manuscript.

VIRTUES: nonattachment, wrathful compassion, vigor, focus, absolute commitment to truth.

Mahāsarasvatī Yantra

It was through me the Creator himself gained liberating knowledge.
I am being, consciousness, bliss, eternal freedom: unsullied, unlimited, unending.

—Sarasvatī Rahasya Upanishad

Mahāsarasvatī is a particularly powerful form of the goddess Sarasvatī (*mahā* means "great"), and this yantra is more complex than the ones typically used for her worship. The three large circles represent past, present, and future. The outer ring of sixteen petals associate this goddess with the nourishing quality of the moon. The inner ring of eight petals shows that her blessings flow outward in all directions. The six-sided star invokes her powers of manifestation and dissolution in a harmonious balance, but the inner triangle shows that the core of the rituals done with this yantra are for manifestation practices.

COLORS: As we move inward from the edge, the outside lines are gold and light yellow. The *bhūpura* is a light, misty blue. The three large circles are filled with iridescent gold. The area between the lotus petals is iridescent silver. The lotus petals are pure white, though a hint of very light blue or pale pink to give them definition is acceptable. The inner circle is also golden. The spaces around the arms of the star are cool lavender. The lines of the star are iridescent gold, and the space inside is the faintest blue, almost white. The inner triangle is brilliant pure white. The *bindu* is iridescent gold.

CONTEMPLATION: One of the many virtues Mahāsarasvatī expresses is divine knowledge. This knowledge can be received many ways, including intuition, through a trusted teacher, or from spiritual texts. When we study, we are embodying her power. Locations like libraries and bookstores also carry her energy.

Consider learning more about one of the goddesses in this book. This might be done with a field trip to a library, a visit to a local Hindu temple, or even a search of the Internet. If we wish to truly embody Mahāsarasvatī's power of discrimination, then we must carefully evaluate whether our sources are reliable. Is the information we find meant for children, or foreigners, or for serious spiritual seekers? Is it based on ancient lore or the author's opinion? How might we apply our newfound knowledge to coloring the image of our chosen goddess?

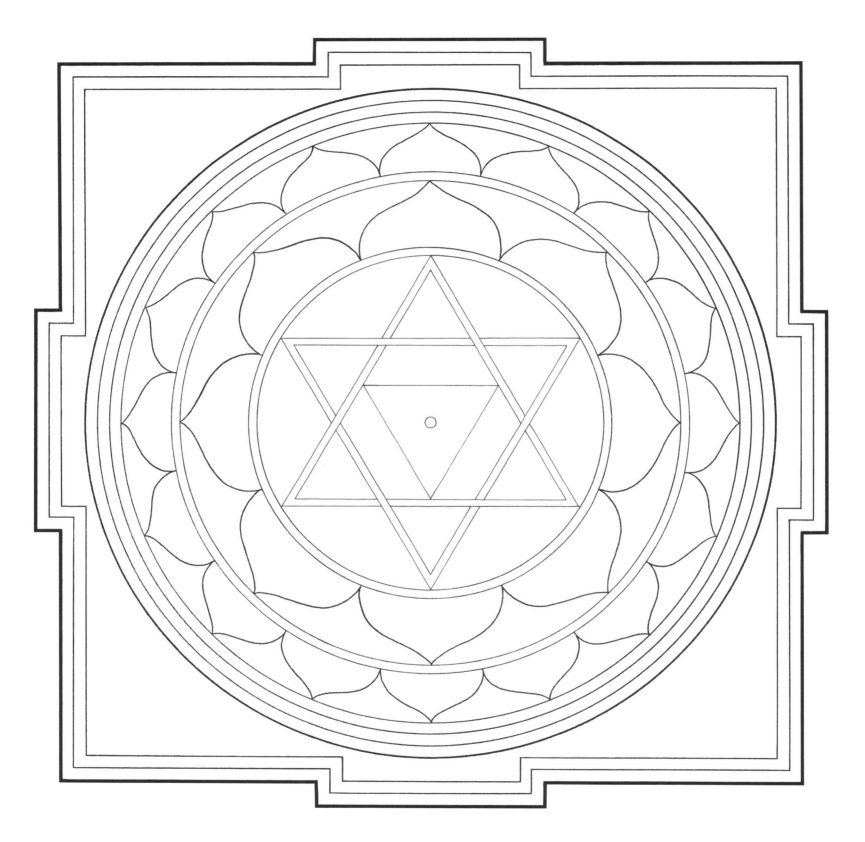

Mahāsarasvatī Yantra महासरस्वती यन्त्र

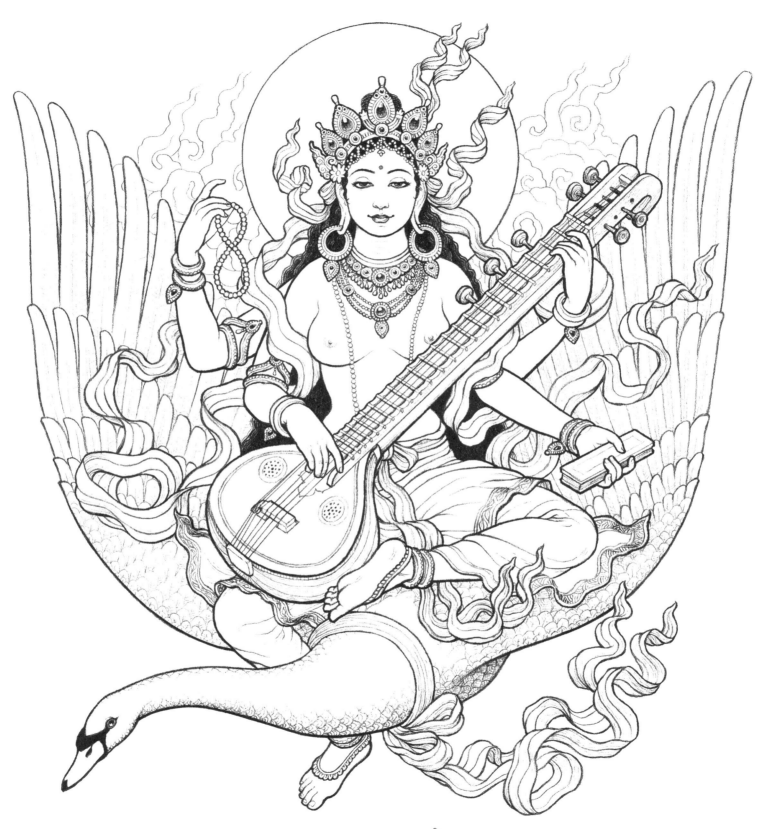

Sarasvatī सरस्वती

Sarasvatī

Flowing Imagination and Discerning Intuition

Goddess of wisdom, who appears as syllables, words, sentences and understanding,
Goddess in whom all meaning inheres from beginningless time, grant me your grace.
Goddess who purifies and enriches the soul, you who are the treasure of intelligence,
please accept these words, my humble offering!

—Sarasvatī Rahasya Upanishad

SARASVATĪ (a.k.a. Bensaiten), alluring goddess of creativity, knowledge, eloquence, music, poetry, and the arts, is all that flows. Historically, she was the goddess of a river in Northwest India where Vedic rituals were held. This may be how she became associated with speech and divine knowledge. Though the mighty Sarasvatī River dried up long ago due to geological changes, the goddess is still revered today and widely worshiped across Asia, especially by scholars and students. She is the shakti (power) of creation, and as a river goddess she is the power of celestial grace that flows down from heaven to enliven the earth. Rivers are associated with purity *(sattvas);* thus, she exemplifies this quality, as well as the spiritual concept of "crossing to the far shore" from bondage to freedom. She rides a regal swan, a white bird that remains clean (much like a lotus) even while swimming in muddy waters. The swan represents discernment; legend says it can separate milk mixed with water and leave only water behind. The goddess is often portrayed with a peacock as well, which gazes at her with admiration as a way of demonstrating that the beauty of knowledge trumps superficial appearances.

She came to be associated with the creator god Brahmā, but they are rarely portrayed together, nor is she described as sensually as other deities; she is eminently civilized, and her character has a certain dignified reserve. She is not a domestic goddess. She is invoked for knowledge and wisdom rather than material gain. Yoginīs frequently invoke her to awaken the imaginative principle and for the greatest knowledge of all: that of one's own most expansive Self.

INVOCATION: *Oṁ Sarasvatyai Namaha (Ohm Suh-ruh-swuh-tyai Nuh-muh-huh)*

IMAGE DESCRIPTION: She is always described as being pure white, like the moon or the *kunda* flower, brilliant as sunshine on snow. In practice, artists use pastel blue and other pale colors for her robes, ornaments, and aura to give her image depth and visual interest. A faint, warm pink is used to shade her limbs and face, as well as the body and wings of the swan, to subtly indicate curves and volume. Because she is a scholar, her raiment is more reserved than her more lavishly ornamented sister goddesses. She carries a musical instrument called the vina (the official musical instrument of India), which is an allegory for the human body; she plays the psychic energy that travels along the spine *(kundalinī-shakti)* for the delight of all beings. She also holds crystal prayer beads *(mālā)* to show her mastery of mantras and the vibratory principles that underlie creation. The book she holds is a book of ultimate knowledge. This original depiction is in the modern Newar style.

VIRTUES: divine knowledge, purity, creativity, discernment, dignity, skill, studentship.

Mandala of the Divine Dance

No fear of time-unconquered space;
Or light untraveled route;
Impede my heart that pants to drain
The nectar of thy flute!

—Sarojini Naidu (1879–1949)

Rādhā and Krishna are depicted at the center of a joyous group of dancing milkmaids *(gopis)*. The figures are portrayed in a circular dance, known as the *rās-līlā,* which means "sweet act" or "divine dance." This celebrated event took place during a full-moon night, when the milkmaids of Vrindavan snuck away from their households to the forest when they heard Krishna playing his flute. There, they danced and engaged in love play throughout the night. Esoterically, this long "night" is the Night of Brahmā, which lasts approximately four billion years! It is a metaphor for the dance of life and for the romantic nature of Bhakti yoga, wherein a devotee falls in ecstatic spiritual love with the deity.

Circular folk images like this originated as murals to bless the nuptial chambers of homes after weddings. Though not technically mystic diagrams, they fulfill the broad definition of a mandala as a sacred circle filled with divine beings. This image is drawn in the Madhubani style of folk art, inspired by the work of Shri Dhirendra Jha and Shrimat Vidya Devi of the Mithia region of Bihar state in Northern India.

COLORS: Bright, primary colors are utilized in this style of art, and the artists of this culture improvise freely. Be creative! Rādhā and the maidens may be colored in the varied flesh tones of Northern Indians, while Krishna is given brilliant, indigo-blue-colored skin in this regional style.

CONTEMPLATION: Anyone who falls passionately in love and experiences earnest romantic longing or cataclysmic heartache is feeling Rādhā's shakti. Ultimately, all longing is for union with the ultimate, the complete bliss of yoga. What we compulsively seek in others are aspects of our own cosmic self that we yearn to embrace. The constricted state of feeling incomplete arises from over-identification with personal ego. Let's consider our greatest loves and heartbreaks, even if they were secret and never requited. Set aside physical attraction for a moment, as two bodies may have their own karmas distinct from that of our souls. Consider the deep yearning simply to be in another person's presence. What is it we sought in that person? What was it about that person that made us feel complete? Can it be named? This quality is already within us, waiting to be invoked. Which goddess best exemplifies it? Consider spending extra time practicing with her.

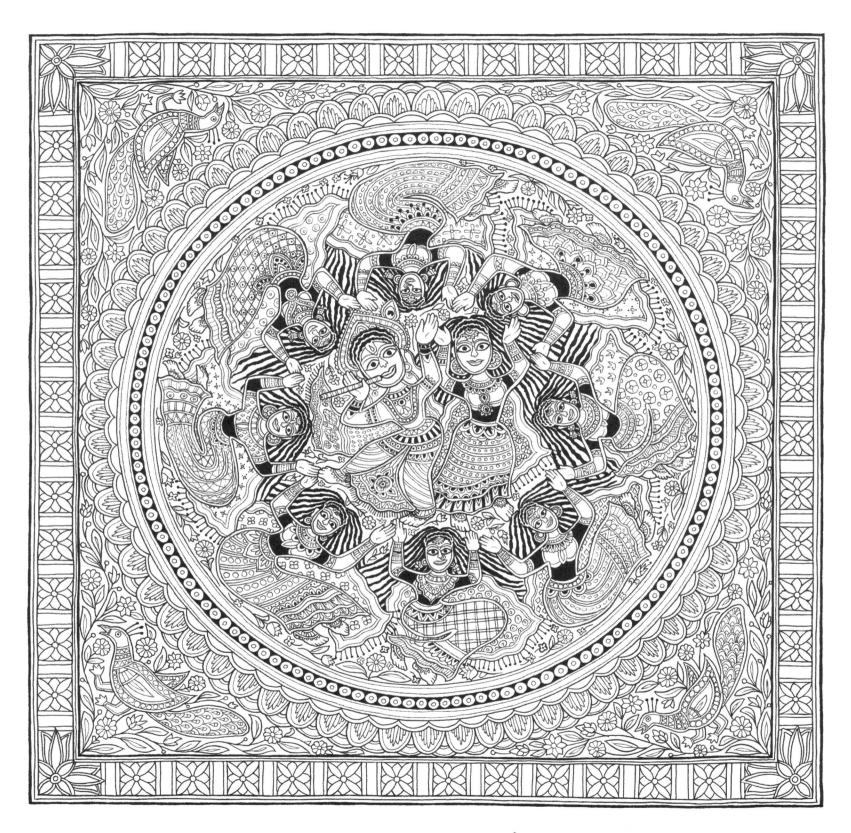

Mandala of the Divine Dance रास्लीला मण्डल

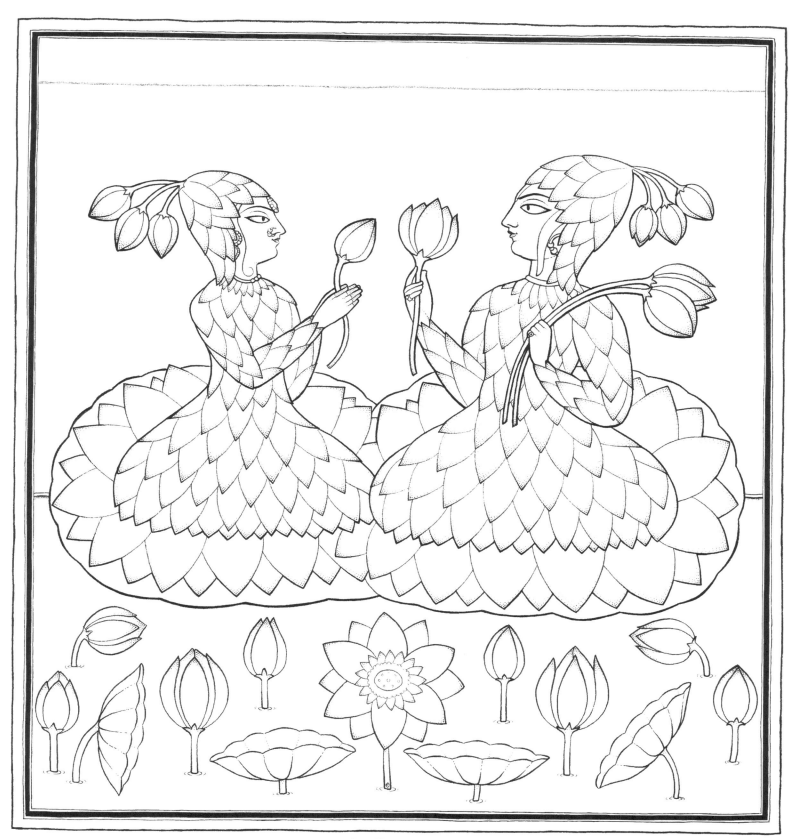

Rādhā राधा

Rādhā

Rapturous Love of God

Just as milk and whiteness, fire and heat, earth and fragrance,
and water and coolness are one and inseparable, so We are one.

—Brāhma-vaivarta Purana

RĀDHĀ and Krishna, often portrayed as intertwined lovers, exemplify romantic love in Hindu myth. It is noteworthy that Krishna is her lover, not her husband; their affair is charged with the thrill of danger and secrecy. This could be an allegory for devoting oneself to spiritual practice even when the rest of one's family does not. She was a simple milkmaid, but is usually portrayed as an enchanting young girl dressed in scintillating finery, surrounded by flowers and bucolic scenery, symbolizing the passion of her erotic play and zest for life. Rādhā is considered the supreme goddess by her devotees because Krishna enchants the world, but she enchants even him! She exemplifies the compelling power of romantic longing, as well as the bliss of union. Her love for him was so deep that she came to see him in every person, all objects, becoming the very embodiment of devotion. She possesses the power to attract the all-attractive personality of godhead, so she is the primordial potency of her beloved. Far from being a servant or a subdued wife, she is jealous and chastises Krishna when he strayed or neglected her for too long.

For the spiritual practitioner, the energy of longing for complete union is itself divine, as this impulse inspires one to seek beyond worldly concerns. Rādhā embodies the nature of this divine longing, which is irresistible to the object of her devotion, Krishna, who embodies the beauty of ultimate truth. Rādhā and her consort show how true love, truth, and devotion cannot be bound by conventional morality by meeting one another outside the village walls at night in the fabled forest of Vrindavan. Her tale has inspired generations of poets, musicians, and Bhakti yogins.

INVOCATION: *Rādhe Rādhe Rādhe Shyām (Rahd-hey Rahd-hey Rahd-hey Shahm)*

IMAGE DESCRIPTION: Rādhā was a human incarnation of the goddess Lakshmī, and her skin has a golden complexion. Krishna is dark in complexion, the color of a thundercloud, though he is often portrayed sky blue. Artists surround them with vivid springlike hues to convey the exuberance of their love. This image is inspired by a famous and widely copied eighteenth-century painting in the Basholi style, from the northernmost region of India. Here the two lovers are completely covered in lotus petals, symbolizing that the purity of their love has made them nearly indistinguishable from the cosmic source that the lotus represents.

VIRTUES: romantic love, passionate devotion, simplicity, focus, vigor, playfulness.

Annapūrṇā Yantra

Thou supporteth all beings visible and invisible, whose belly is the vessel which contains the universe.
Thou discloseth the subject of the drama of Thy own play and art the fount of the light of wisdom,
pleasing the mind of the lord of the universe. Presiding devī over the City of Kāśī,
O vessel of mercy, grant me aid!

—Tantrasāra

The many petals of this yantra indicate that Annapūrṇā is being invoked for her effulgent and nourishing powers. The inner circle of four petals is rare in deity yantras; they hint at an association with the root chakra, stability, the earth element, and *kundalinī-shakti.* The ring of eight petals represents the four cardinal and noncardinal directions, indicating that her power flows everywhere. The ring of sixteen petals are her many wish-fulfilling shaktis. This design is inspired by an image in an eighteenth-century copy of the Mantra-mahodadhi from Rājasthān.

COLORS: Colors for this yantra should be pleasant and bright, like fresh leaves and ripe fruit. Moving inward from the edge, the outer lines are gold and light yellow. The *bhūpura* is pastel blue. The outer ring of sixteen petals is orange red. The second ring of eight petals is golden yellow. The inner ring of four petals is pastel blue. The inner triangle is ruby red. Any fresh, springlike colors may be used for the areas between the petals, as well as the area around the triangle. (The artist who created the source image in the Mantra-mahodadhi manuscript chose to use leaf green and golden yellow.) The center *bindu* may be added when the rest of the yantra is completely colored in. Choose white for effulgence or gold for divine knowledge.

CONTEMPLATION: Images of Annapūrṇā feeding Shiva are symbolic of spiritual nourishment, but we cannot do spiritual work without physical nourishment. Cultivating health both in body and spirit is of vital importance. Annapūrṇā's legend reinforces this fact: When the goddess hears of spiritual teachers saying that the universe is just an illusion, she withdraws her nourishing power. All beings in the universe are plunged into hunger. Soon, even great masters are unable to do their spiritual practices. The gods gather to plead for her mercy, and it is Shiva, the great yogi himself, who is first in line to beg. This story shows us we must nourish our inner yogi, but it also demonstrates the importance of being generous. The act of feeding others is spiritually nourishing.

Consider embodying her generosity by literally feeding someone. Perhaps prepare a family meal. Perhaps feed a teacher or holy person. (This is a great way to encourage them—and, thus, the blessings they bring—to visit your home more often!) It is especially auspicious to feed someone who is in genuine need.

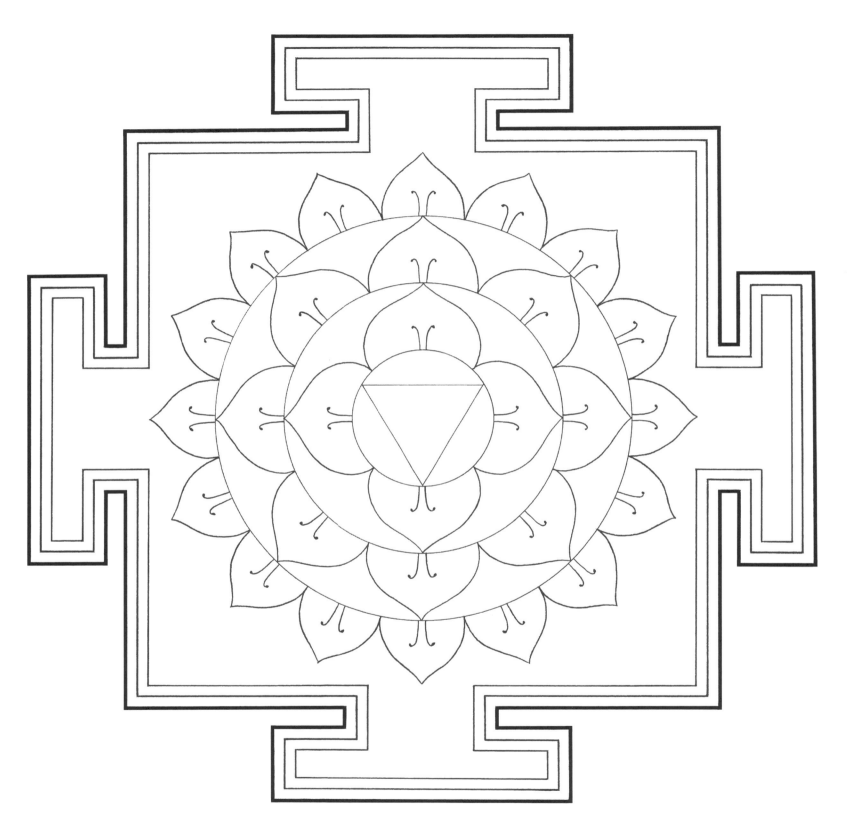

Annapūrṇā Yantra अन्नपूर्णा यन्त्र

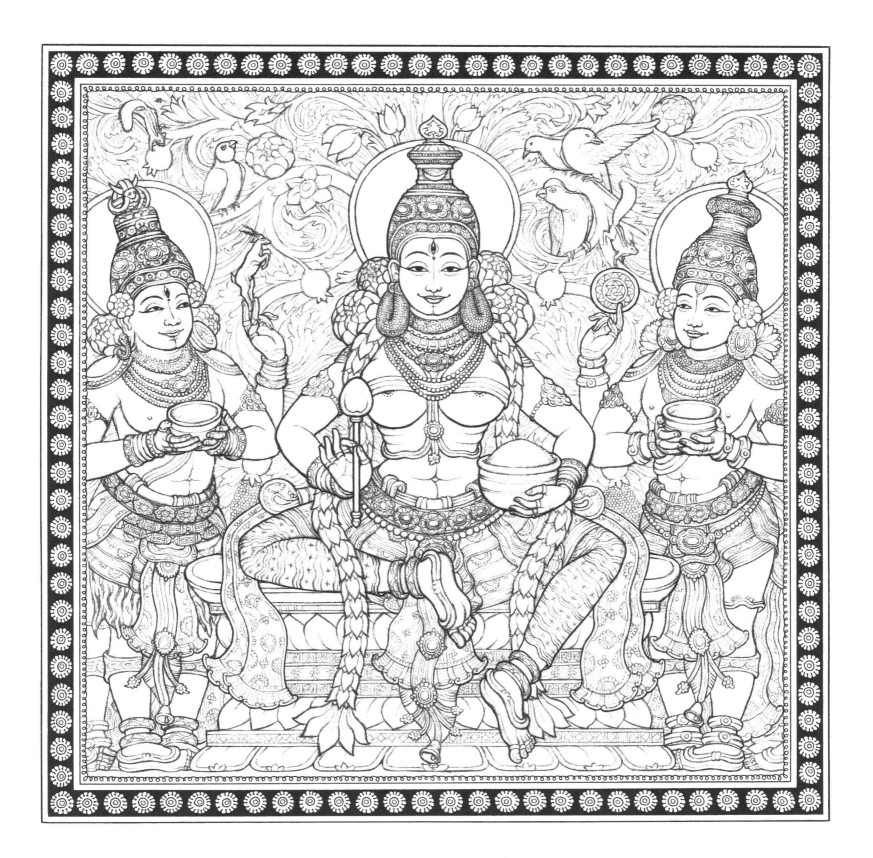

Annapūrnā अन्नपूर्ना

Annapūrṇā
Sustainer of Ultimate Consciousness

O Devī! Clad in fine garment, ever giving rice, Sinless One,
Who delights in the dance of Shiva, crested with the crescent moon.
O Annapūrṇé! Obeisance to Thee.

—Tantrasāra

ANNAPŪRṆĀ exemplifies abundance, the fathomless bounty of the entire universe. Her name means "Bountiful Lady" or "She Who is Full of Food," as it is from the body of the Goddess that all life is sustained, and it is the form of Annapūrṇā who best exemplifies this quality. Depictions of this goddess show her as a resplendent matron holding a ladle and bowl of food or pot of rice. Through her association with rice, she is identified with fertility, growth, abundance, and vitality. Often Shiva, the supreme yogi, is shown begging her for sustenance, illustrating how consciousness depends on physical form for life to exist and, in a more mundane way, how spiritual practitioners depend upon practical domestic arts and the generosity of others.

The seed itself is a potent symbol, associated with Shiva and with the *bīja* ("seed") syllables that enervate all mantras. It is the Goddess in any and all her forms who cooks these seeds to make them digestible and distributes them to the wise in the form of both food and spiritual nourishment.

The Goddess, whether she be known as Annapūrṇā, Parvatī, or any of her other names, brings Shiva and his teachings into manifestation through her ability to nurture and sustain. It is into the fecund body of the goddess that apparently lifeless seeds are inserted and where they burst into life. So too must the spiritual seeker care for her own body (which is also the goddess's) for teachings to bear fruit. Though the path of Shakti may include intense ascetic techniques, ultimately it is one that is nourishing and embraces joyful embodiment.

INVOCATION: *Oṁ Annapūrṇāyai Namaha (Ohm Uhn-nuh-poor-nah-yai Nuh-muh-huh)*

IMAGE DESCRIPTION: India's Southwestern region of Kerala has a distinctive style of art bursting with vivid color, vigorous pattern, curvaceous goddesses, and tropical foliage. This style has a characteristic luminous color scheme of saturated hues, with an overall warm orange glow. Murals are dominated by yellow ocher, Indian red, a warm white made from seashells, and a specific brilliant green closely resembling viridian. Lamp black is used for outlining, hair, the pupils of the eyes, and visual punctuation. Blues and purples are largely absent.

In this image, the goddess is holding a large bowl filled with cooked white rice and a ladle with which to serve it. Her form is curvaceous, like ripe fruit, with no apparent bones or sharp edges. Her skin is golden, with orange-red shading to give form. There are no shadows. To her right (our left) stands Shiva, who has ashy white skin. To her left (our right) stands Vishnu, who has black or blue skin. The golden bowls they hold are empty. This image is inspired by the eighteenth-century murals of Mattancherry Dutch Palace in Fort Kochin.

VIRTUES: generosity, compassion, patience, contentment, loving-kindness.

Yantra of the Three Bindus

The whole of existence arises in me, in me arises the threefold world,
by me pervaded is this all, of naught else does this world consist.

—Hevajra Tantra

This remarkable yantra has not one, but three dots *(bindus)* in the center. Like the figurative image of Ardhanārī with three arms, this configuration of three dots is extremely rare. Also unusual is the single ring of thirty-three petals. The eighteenth-century Nepalese manuscript in which this yantra is found gives no explanation of the number, though it continues the theme of threes and the number eleven is related to the eleven faces of Shiva as Lokeshvara, "the Lord of the Realms," who was assimilated into Buddhism as the eleven-faced Avalokiteshvara. The extensive use of red and white show that the powers of transformation *(rajas)* and harmony *(sattvas)* are being invoked. The ornamented black circle *(tamas)* makes it clear that dissolution is also acknowledged, signifying overall balance. It is a lovely diagram that elegantly illustrates the Shiva principle (white dot) and Shakti (red) merging in union (top dot).

COLORS: Moving inward from the edge of the page, the background behind the yantra is leaf green. The outer two lines are both red, the inner line being somewhat darker. The large, square, inner area of the *bhūpura* is white. The outer circle is red, and the circle of decorative fleurettes is dark blue. The small dots between the lotus petals are white. The petals themselves are scarlet. The ring of fine lines is gold. Inside this circle is a ring of dark green, a circle of gold dots, then a circle of light green. The area behind the main triangle is white. The main triangle and the circle inside it are all red. (In the original source version of this yantra, the artist used several different red hues for visual punctuation.) The top *bindu* is white on the left half and red on the right half. The lower left *bindu* is brilliant white. The lower right *bindu* is a deep blood red.

CONTEMPLATION: It is said that coloring and ornamenting an image is related to the energy of Shakti, while the measuring and line drawing is related to the energy of Shiva. So any coloring book tends to emphasize the Shakti dynamic. Ardhanārī can be emulated by seeking balance and cultivating the Shiva-related skill of drawing in relation to our coloring practice.

Try copying one of the yantras on a separate piece of paper. Plan carefully. Mindfully arrange all the tools and materials. Be systematic about the work. Use a ruler and compass to make accurate lines and circles. Try reading the drawing exercise in part 4, which explains how to make some of the basic shapes. The point of this practice is to make your best effort to cultivate focus and precision, rather than robotically make a precise reproduction. Color and ornament the finished yantra lavishly, thus infusing Shakti into the new yantra.

Did this copied yantra turn out different from the ones in the book? How? Do you feel differently about it than the others? Why or why not?

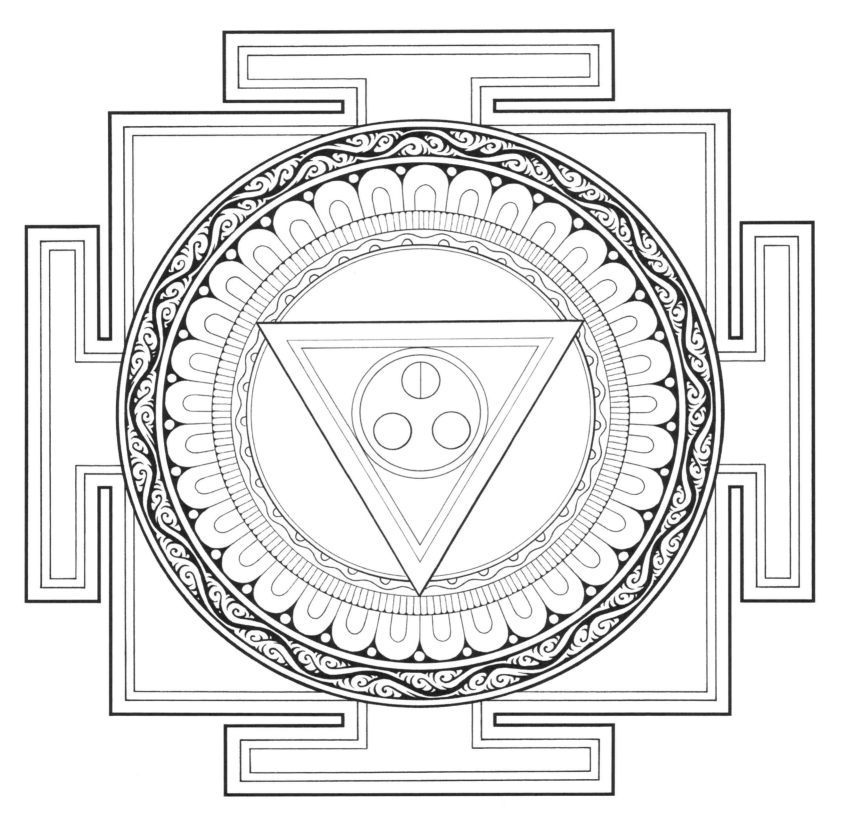

Yantra of the Three Bindus त्रिबिन्दूनाम् यन्त्र

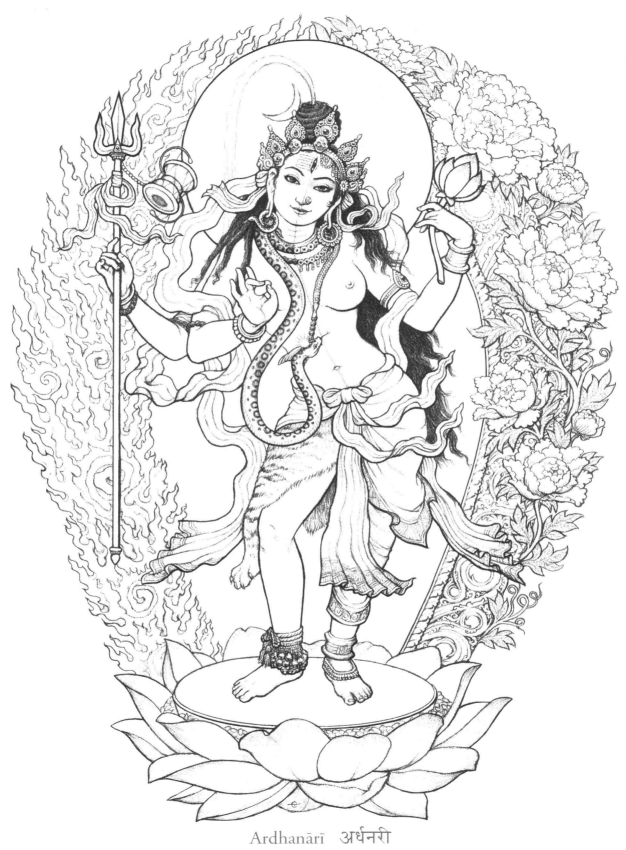

Ardhanārī अर्धनरी

Ardhanārī

Complete Union of Opposites

I am the Sun, I am the Moon, I am the Stars; I am beast, birds, the untouchables,
and I am the evil doer and the cruel deed; I am the virtuous person and the noble deed,
I am the female, male, and hermaphrodite.

—Devī Gītā

ARDHANĀRĪ (a.k.a. Ardhanārīshwara) is the androgyne who embodies the union of apparent opposites. Shiva and Shakti *(purusha and prakriti)* are not truly separate, and there are many ways of depicting their union. They include images of the couple dancing, riding a bull together, relaxing with their family, cuddling, explicitly conjoined, or merged half and half. They all symbolize the interdependent relationship between consciousness and power, wisdom and compassion, awareness and expression, subject and object.

This depiction, more than any other, displays their inseparable nature by visually grafting female and male together. This represents the union of two seemingly different spiritual paths: the aloof, ascetic spiritual renunciate of inner practices and the engaged domestic householder of outer disciplines. This Ardhanārī demonstrates that the two may be harmoniously integrated and spiritual discipline may be perfected anywhere. This form of divinity also shows clearly that worldly success *(bhukti)* and spiritual liberation *(mukti)* are not contradictory. They are, in fact, inseparable at their root.

It is notable that Ardhanārī is the only deity commonly portrayed with an odd number of arms: three. The right half is male (white skin), and the left female (ruby red skin), corresponding to the energies of the subtle body. While Ardhanārī is a popular ancient icon (about two thousand years old) found across India, few temples are dedicated to this form of the Goddess.

INVOCATION: *Om Ardhanārīshwa-rūpāya Namaha (Ohm Ard-huh-nah-reesh-wuh-roo-pah-yuh Nuh-muh-huh)*

IMAGE DESCRIPTION: This graceful image is done in the modern Newar style, inspired by the work of talented brothers Uday and Dinesh Shrestha Charan. The deity has white skin on the male side (the viewer's left) and red skin on the female side (the viewer's right). The male side of the Ardhanārī holds Shiva's signature trident (will, knowledge, and action), which has a small drum (pulse of creation) attached. He also holds in his front hand an item unique to Newar art: a tiny ball of compressed ash from the cremation fire, which Shiva rubs on his skin to give it the white color for which he is known. It is no coincidence that it is shaped like a *linga*. The female side holds a simple lotus, the quintessential symbol of purity, beauty, and the cosmic womb. So we have purity (lotus) and impurity (ash) in her front two hands, reinforcing the symbolic merging of opposites. The weight of the figure is shifted to the left side in a playful manner to emphasize her feminine qualities.

VIRTUES: balance, harmony, equanimity, union of opposites, pervasive love.

Kālī Yantra

Just as all colors disappear in black,
so all names and forms disappear in Her.

—Mahānirvāna Tantra

Many different yantras are associated with this goddess, each used to invoke a distinct aspect of her variegated nature. The one most commonly recognized has five downward-pointing triangles layered on top of one another as the central motif. The fifteen corners of the five concentric triangles represent the ways in which we experience and act and live in the world: the five organs of knowledge *(jnānen-driya)*, the five organs of action *(karmendriya),* and the five subtle breaths *(prāna).* This image is inspired by an example found in an eighteenth-century Nepalese manuscript. The balanced and harmonious design of this figure invokes the wrathful mother's powers in a stable manner; the bold colors should make it apparent she is still to be treated with caution, however. The powers of transformation *(rajas)* and dissolution *(tamas)* are being strongly invoked, as indicated by the emphasis on red and black in the color scheme.

COLORS: The outer line, which wraps around the entire yantra, is scarlet. The inner line is white, while the square field they enclose is black. The large dots between the lotus petals are white. The color of each of the petals alternates red and white, starting with red at the top. The red petals are outlined in white, and the white petals are outlined in red. In this and any other yantra in which the petals appear to have layers (or smaller inner duplicates), the inner area is only decorative and is usually the same color (or a slight variation) as the outer portion. In this yantra, both have golden yellow decorative highlights. The inner ring of dots is white, like little pearls. The circle of fine lines that look like rays of light goes from golden yellow at the tips to yellow-orange at the bases. The area behind the triangles is black. The triangles, from largest to smallest, are red, yellow, green, white, and blood red. In some Himalayan traditions, the center dot, representing the goddess herself, is not added until the ritual awakening *(prāna-pratishthtā)* ceremony. If you wish to add the center dot *(bindu)* to use this yantra for meditation, it may be made white (effulgence), black (void), or gold (divine knowledge).

CONTEMPLATION: Kālī is said to be the most mirrorlike of all the goddesses. When invoked, she appears to us in a manner that reflects our own inner state. From a yogic artist's point of view, any goddess (and all phenomena) appearing in our field of awareness is how the Great Goddess is showing up in that moment. The appearance of divine beings indicates that our good karmas have ripened to the point of manifesting in the material world! By contrast, European philosophers say that every work of art is a self-portrait. Even when the image is not of our own face, the choice of colors and the nature of the markings all reflect our current emotional state. If we use the word *Self* in the most expansive sense, then the yogic artist might agree.

Is it possible, while coloring each of these goddesses, to consider her a self-portrait, an aspect of our own fullest sense of Self? Can we imagine we are looking into a magic mirror, seeing one powerful version of our own enlightened nature? Are we that beautiful, that horrible, that free?

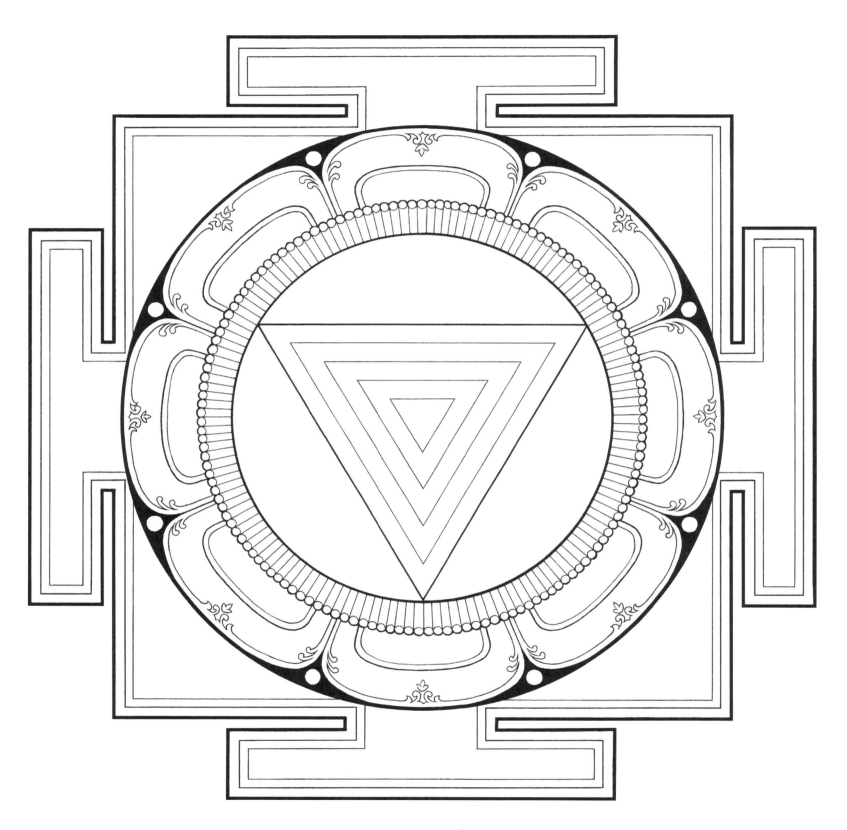

Kālī Yantra काली यन्त्र

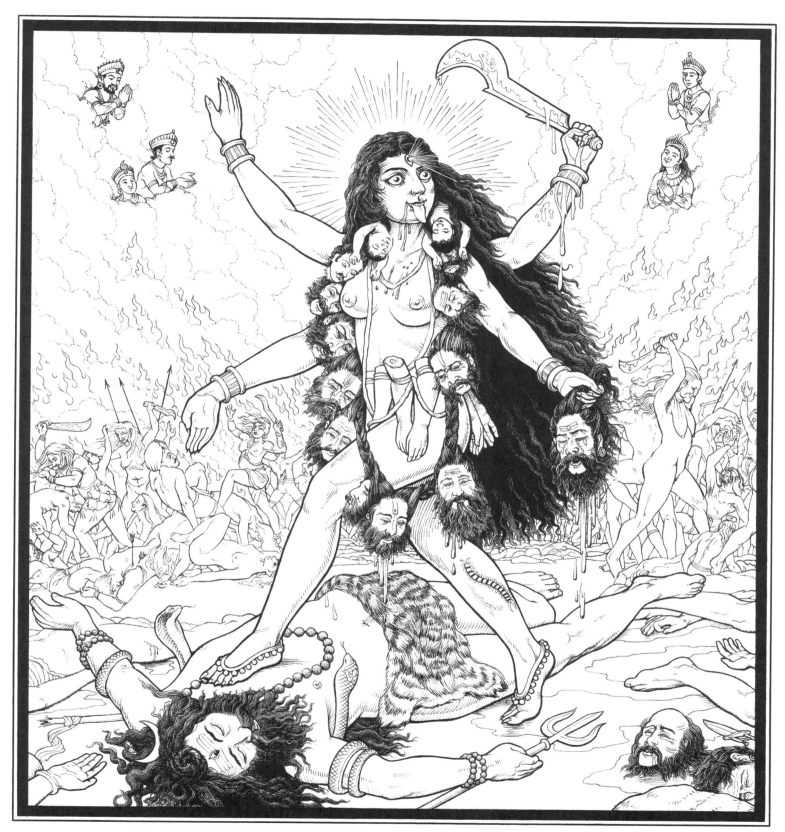

Kālī काली

Kālī

Total Freedom and Fearlessness

Who are you, Mother,
clothed in nothingness,
glowing in the deepest recesses of my mind?
Your frenzied laughter terrifies,
while your love, like lightning from a black cloud,
shocks the world with light.

—Rāmprasād (1718–1785)

KĀLĪ is first of the ten awe-inspiring Wisdom Goddesses *(Mahāvidyās),* embodying power of action. Though her name is often translated simply to mean "black," the root word, *kāla,* means "time," wherein the manifest universe is both created and destroyed. As the shakti of time, she is identified with chaos, the power of action, and the expansiveness of physical space. She is described as "sky clad," or completely nude, to symbolize her complete fearlessness. She wears only a garland of heads (severance of obsessive thoughts) and a girdle of arms (severance of grasping). Her head-chopper cleaves real from unreal, while the severed head in her front hand symbolizes an end of the ego, or conditioned mind, and its many desires. She is often described laughing loudly, drunk on the blood of demons. She is a renowned protector, and it is said her worship removes all fear, hence the fear-dispelling gesture *(abhaya)* with her fingers pointing upward. She is also kind and generous to her devotees, hence the boon-granting gesture *(varada)* with her fingers pointing downward.

Kālī is said to have a mirrorlike quality, and all the Wisdom Goddesses are aspects of her primordial power. Though she is commonly portrayed as Shiva's fearsome consort, bliss and beauty are also expressions of her play, apparent to those who overcome their fear of death. The most famous depiction of Kālī is in her wrathful form, but historically there are many others, ranging from seductive to horrific and including different skin colors, from black to blue, green to golden. The word *Kālī,* like *devī* and *shakti,* seems to have been used as an epithet to describe many different goddesses that came to be associated and consolidated into a single identity, and her widespread worship resulted in many regional variations. She is bewildering, both literally and figuratively, but only so long as we are attached to the world of forms, conceptions, and categories.

INVOCATION: *Oṁ Kālikāyai Namaha (Ohm Kah-lee-kah-yai Nuh-muh-huh)*

IMAGE DESCRIPTION: This portrayal of Kālī's wrathful form originates from Bengal and has been copied innumerable times. Images of her in this regional style portray her as black with dark sapphire blue highlights. The background is ominous, with dark grays, browns, flame red, and splashes of blood red to hint at the pandemonium she has unleashed. Fearful gods in the sky above pray for mercy. The figure at her feet is the great god Shiva, his body white with ashes. The insect on her rear leg is a tiger centepede. According to one traditional artist from Bengal, it is considered by some to be her vehicle *(vāhana).* Although utterly terrifying to behold, the head-chopper in her left hand signals that her power of ego annihilation is being wielded more gently than if the blade were being held on her right.

This image is done in the calendar art style first popularized by Ravi Varma. This particular image was inspired by a nineteenth-century lithograph produced by the Calcutta Art Studio.

VIRTUES: wisdom, discernment, nonattachment, freedom, vigor, wrathful compassion, spaciousness.

Tārā Yantra

You are my lama, my patron, my protector, my refuge, my dwelling, my wealth, my friend . . .

—Lama Lozan Tenpe Jets'en

This yantra emphasizes the wide gates, showing that Tārā's powers are easily recognized in our earthly experience and her practice is easy to enter. The large petals practically overflow out of the central figure, hinting at her nurturing qualities. True to the nature of her spiritual practice, yantras for Tārā are very simple, and this one is no exception: it has only one large upward-pointing triangle at the center. This image is inspired by an eighteenth-century Nepalese manuscript that included a great deal of extra ornamentation, which you may add, if you wish.

COLORS: The outer frame of wavelike forms represents water, and the lines may be left blank or filled light blue. Inside the waves are two decorative lines, red and gold (yellow ocher). The large square area behind the yantra is a light leaf green. The outer line around the yantra is black. The *bhūpura* is divided into four quadrants: the top is red, the right is green, the bottom is blue, and the left is golden yellow. These areas may be filled with floral ornamentation, if desired. The dots between the petals are white. The petal colors, clockwise from the top, are red, yellow, red, green, red, white, red, and black. All have colorful decorative highlights in yellow and white. The inner ring of dots is white, like little pearls. The circle of fine lines that look

like rays of light goes from golden yellow at the tips to yellow-orange at the bases. The area behind the triangle is black. The main triangle is blood red. (In the yantra on which this one is based, the artist varied the red hue for decorative effect.) If you wish to add the center dot *(bindu)* after you finish coloring, it may be made white (effulgence), black (void), or gold (divine knowledge).

CONTEMPLATION: The central characteristic of Tārā across all traditions is her compassionate nature. She is always ready to help those in need. Is there anyone you know who feels troubled or unlucky? It is said that the one of the most powerful spiritual remedies *(upāya)* is the unexpected arrival of a deity. Consider giving one of the finished artworks away. It is important not to assign a goddess to our friend as a lesson or intellectual exercise. Rather, rely on intuition and give the gift as an act of compassion. Remember, compassion doesn't always mean nice. Wrathful goddesses are fierce protectors and have just as much to give as the benevolent ones. It is also important not to give with any agenda or expectation of results. Our goal is simply to cultivate our own compassionate nature. As spiritual artists, the easiest and most obvious way to do so is by giving away a powerful artwork.

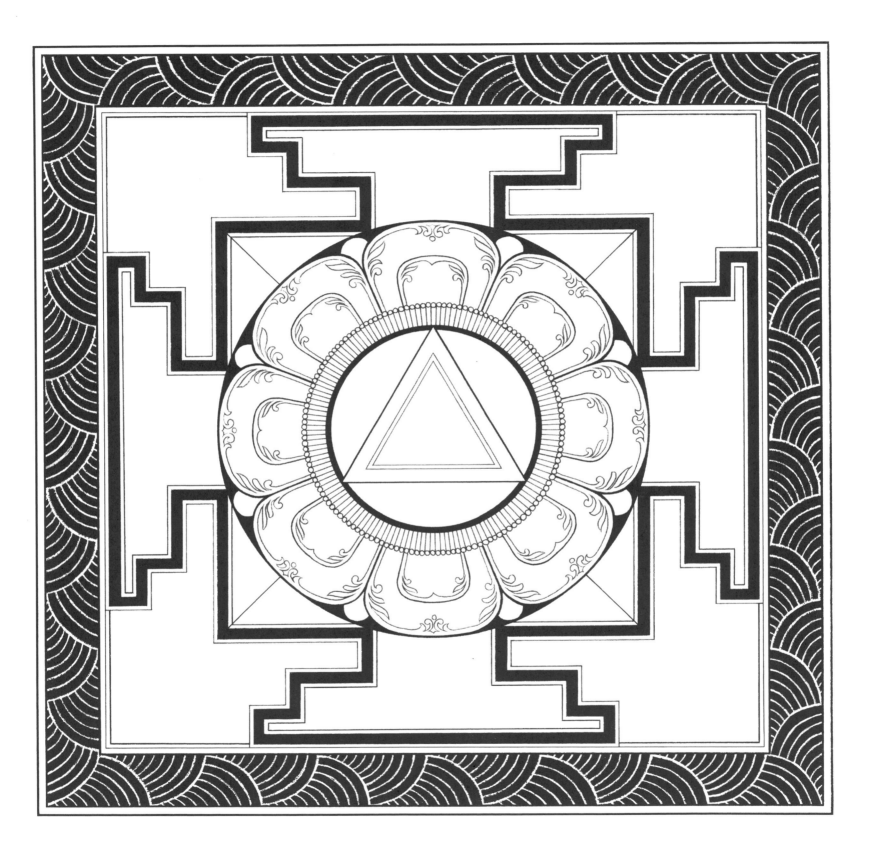

Tārā Yantra तारा यन्त्र

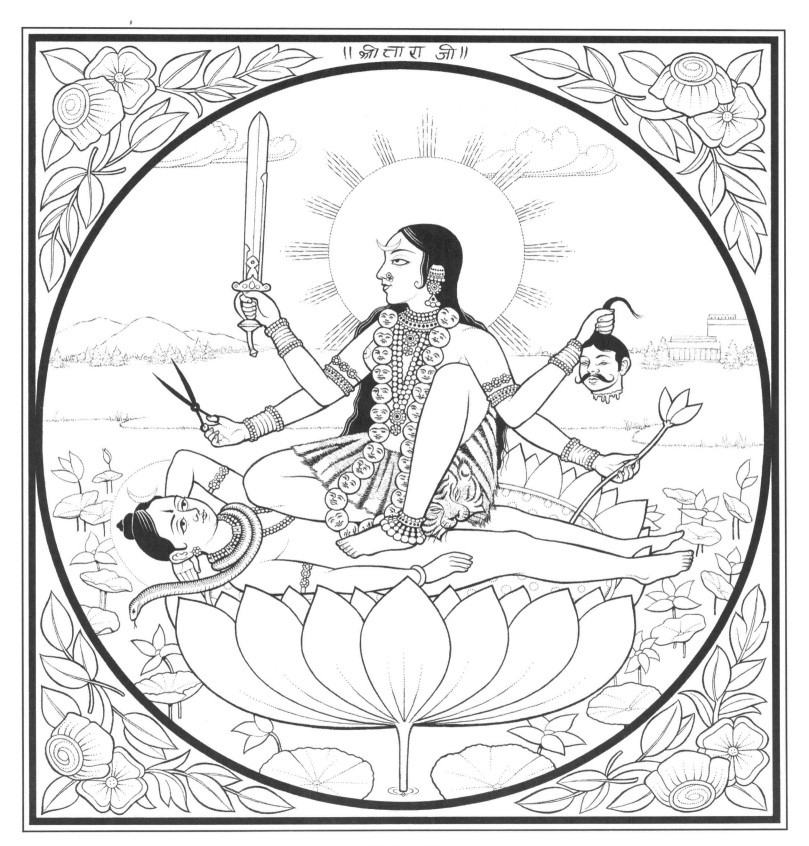

॥ श्रीतारा जी ॥

Tārā तारा

Tārā

Redeemer Who Carries Souls Across Tribulations

Thou art the presiding devī of speech. Thou art the creeper (fruiting vine) which grants all desires.
Thou art the giver of all siddhi (spiritual attainment), And the power to write both verse and prose.
Three are Thine eyes, as it were blue lotuses. Ocean of kindness and compassion art Thou.
I pray Thee of Thy mercy shower upon me the nectar of prosperity.

—Nīla Tantra

TĀRĀ is "She Who Crosses Over," the liberator, the savioress, the guiding star, power of the guru. She is immensely popular throughout Asia, especially in the north of India and the Himalayas among Tantric Buddhists. They worship her in twenty-one colorful forms for longevity, preservation from harm, and protection from supernatural beings. One of her best-known forms is the pure white Prajnāpāramitā, the "perfection of wisdom." Another is the ferocious deity Ekajatī, "one lock of hair," a one-eyed goddess who sees only unity. Even among Hindus, she appears in many forms. In one of her wrathful forms she is called Nila (blue) Sarasvatī because she has powers similar to those of Sarasvatī in regards to mantra and divine knowledge, yet she is a wrathful blue in color. She is associated with sound, breath, the manta *Oṁ,* and the power of mantras to carry us past sorrow. She is widely invoked at crossroads and in connection with the crossing of waters for this reason. Her rituals run the gamut from the most benign and gentle to the wildest and most shocking. She can be worshiped anywhere, but her fierce forms are especially associated with cremation grounds. As Ugratārā (fierce Tārā), she exemplifies wrathful compassion and is often mistaken for Kālī because of her dark complexion, but can be distinguished by the lotus she holds and the tiger skin she wears.

Tārā is said to come quickly whenever she is sincerely called, and among all the practices *(sadhana)* of the ten Wisdom Goddesses, hers is said to be easiest.

INVOCATION: *Oṁ Namo Āryatārā (Ohm Nuh-mo Aarya-tah-rah)*

IMAGE DESCRIPTION: Of her many forms, it is her wrathful blue form (Ugratārā) that is honored as second of the Wisdom Goddesses. The colors of images in this regional artistic style are fresh, gentle, and springlike. In this depiction, the goddess is dark blue, her halo iridescent gold, her tiger skin skirt orange and black. She sits upon the blue-throated Shiva, whose skin is white with ashes from the cremation ground where he meditates. They rest on a white water lily (shaded with light blue) in the middle of a placid pond, representing "waters covering the universe." She holds the scissors (detachment), the sword (discernment), the blue water lily (peace), and a severed head (ego). The tiger skin she wears indicates that her practices may be fearsome in nature, but ultimately subdue our passions. This image is inspired by a painting from Rājasthān made in 1926. The Sanskrit at the top says, *"Śrī Tārā jī,"* which translates roughly as, "The Auspicious Lady Tārā."

VIRTUES: compassion, discernment, focus, non-attachment, loving-kindness, sexual integrity.

Tripurasundarī Yantra

Shiva, when united with Shakti, is endowed with the power to create, protect,
and destroy the universe; otherwise he is unable even to stir.

—Sri Saundarya Laharī

Lalitā is also known as Tripurasundarī, "Beauty of the Three
Worlds." These three worlds are represented by the three upward-
pointing and three downward-pointing triangles, reflecting her
status as ruler of the "three cities" *(tri-pura)*. These three "cities"
have many interpretations. They correspond to waking, dreaming,
and deep sleep. They are also said to be the heavens, sky, and earth,
or thought, energy, and matter.

The overall shape of the yantra is standard, with four gates
representing four primary ways that we may approach the deity
through yogic practice: mind, discernment, attention, and
self-awareness. The three circles around the lotus petals symbolize
her power over past, present, and future. There are twenty-four
petals, corresponding to the elements of reality, or *tattvas* (other
traditions assign as many as thirty-six *tattvas*). The three circles
inside the ring of petals symbolize her mastery of the three pri-
mordial states of reality *(tri-guna)*. She has a six-pointed star as
her central motif, but the triangles are elongated to emphasize
her fiery transformational nature, as the fire element is associated
with verticality. This yantra also includes a very abstract *linga*
(phallus), the mark of Shiva, inside the hexagon formed by the
three overlapping pairs of triangles. The hexagon shape represents
the wind element, which is associated with the region of the body
just above the heart. So the *linga* within the hexagon shows she
always has Shiva in her heart.

This yantra is based on the Shākta Pramod, a Tantric text, and this
composition is inspired by the work of renowned author and teacher
Harish Johari (1934–1999) of the northern city of Haridwar.

COLORS: The outer line is iridescent gold; the next is light yellow.
The *bhūpura* is a rich, dark green. All the circles are iridescent
gold. The spaces between the lotus petals are iridescent silver. The
small petals are pastel pink, while the large petals in front are a
rich, warm pink. The bases of the petals are dark pink, almost red.
The area behind the triangles is black, as are the spaces inside the
triangles. (Meditation on a black-colored object creates an inspiring,
effulgent golden-orange afterimage when the eyes are closed.) The
triangles, *linga,* and *bindu* are all iridescent gold.

CONTEMPLATION: Lalitā Tripurasundarī is said to be queen of
the Wisdom Goddesses. All her depictions show her authority, dignity,
and confidence. Can we, as artists, be as equanimous about our own
beauty or talent? Are we able to accept praise for our artworks? Self-
depreciation and self-conceit are two sibling demons killed by the
Great Goddess in battle, and we can learn from her example. Many
creative people put their work down in a polite way, to avoid appear-
ing vain. Many others brag about their work to avoid appearing weak.
Receiving compliments can be as awkward for those who admire
humility as critique can be to those who admire confidence.

This concern for appearances and social status is problematic
because it is based on a sense of being separate. This is the opposite
of yoga, which is union. Politely accepting accolades is actually an
expression of humility, just as gracefully accepting critiques is
an expression of strength. Both are opportunities to learn. Can
we emulate Lalitā and conduct ourselves with unpretentious
dignity? Are we able to avoid self-denigrating or self-aggrandiz-
ing phrases when speaking of ourselves or our artworks?

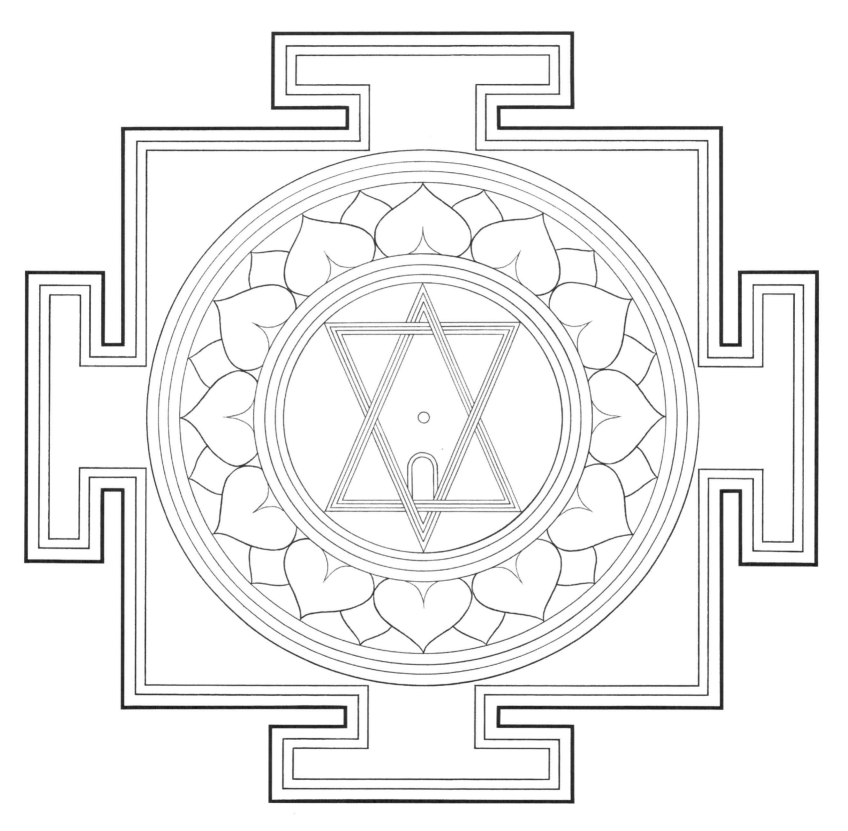

Tripurasundarī Yantra त्रिपुरसुन्दरी यन्त्र

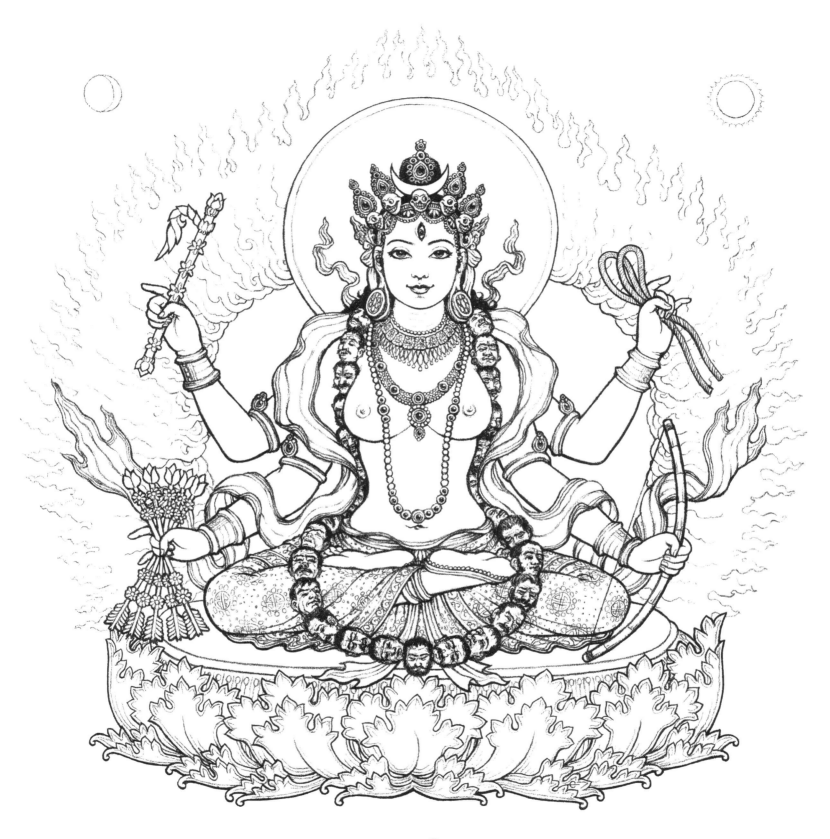

Lalitā ललिता

Lalitā

Erotic Play of Manifestation

Let my mutterings become the chanting of Thy mantra, my movements become gestures of veneration,
my travel become circumambulations around Thee, my eating and drinking become oblations to Thee,
the stretching of my limbs become prostrations to Thee, and let all pleasurable actions
become offerings of Thy worship.

—Sri Saundarya Laharī

LALITĀ (a.k.a. Tripurasundarī, Rajarajeshwarī, Shodashī, or Shrī) is called by many names with delightful translations, such as "She Who Plays," "Beauty of the Three Worlds," "She Who is Sixteen," and "She Who is Desired." The three worlds she rules are the realms of our experience of reality: the waking, dreaming, and deep-sleep states. She is often portrayed sitting on a throne held up by the mighty gods Shiva, Vishnu, Brahmā, and Indra.

In Tantric lore, the power of desire is said to be the motivating force of creation. Lalitā Tripurasundarī is the shakti of desire and thus supreme ruler of the manifest universe. She is always depicted as a voluptuous sixteen year-old girl on the cusp of womanhood. She is associated with light, bliss, and *soma* (divine nectar). Though she is lovely and erotic, her power is much more than simple physical attraction. She is the desire that all conscious beings have to perceive reality, the pleasure that arises when awareness delights in all appearances, the blissful stage of realization just before the indescribable state beyond form. A sage named Shankarāchārya wrote an epic hymn in her honor called the "Waves of Beauty" ("Saundarya Laharī"), which serves as the basis for an entire spiritual regime. Should there be any doubt as to her erotic nature, he gushingly praises every intimate detail of her luscious form. She is the main deity of the Shrīvidyā

("Auspicious Wisdom") tradition and one of the most widely worshiped of Hindu goddesses.

INVOCATION: *Oṁ Tripurasundaryai Namaha (Ohm Tree-pur-uh-soon-dar-yai Nuh-muh-huh)*

IMAGE DESCRIPTION: This original image is in the modern Newar style, where Lalitā is depicted as queen of the universe, adorned with sumptuous silks and scintillating jewels. The sky behind her is dark, glowing from below with reddish browns. She is surrounded by red flames and a yellow-gold halo. Her skin is brilliant ruby red. The highly stylized lotus petals of her throne are meant to evoke flames, but are colored white with pink tips like more conventional lotus thrones. She holds a goad (power) and a noose (restraint) in her back hands, and arrows (love) and a bow (release) in her front hands. It should be understood that she is not nude, but rather heavily ornamented in the fashion of an ancient queen of a tropical empire where both men and women bared their chests. Her silk scarf is swept aside by the subtle energetic wind of her heart chakra, which gives us a thrilling glimpse of her sumptuous figure. This is a very traditional visual device meant to symbolize her open, nurturing heart and fearless nature.

VIRTUES: love, playfulness, sweetness, generosity, dignity, vigor, liberated sexuality.

Bhuvaneshvarī Yantra

Thou art the primordial One, Mother of countless creatures, Creatrix of the bodies of the lotus-born (Brahmā), Vishnu, and Shiva. Who creates, preserves, and destroys the three worlds. O Mother! by hymning Thy praise I purify my speech.

—Tantrasāra

This complex yantra is recreated from an eighteenth-century Nepalese manuscript. Details are not given, but worship of Bhuvaneshvarī's yantra entails two rings of eight deities, according to the Tantrasāra. It appears that the eight smaller yantras in the corners of the two overlapping squares correspond to the "inner ring" of deities. They are also similar in form to depictions of the chakras of the body, explicitly linking the practitioner's own body to the cosmic body of the goddess. This yantra emphasizes Bhuvaneshvarī's majestic qualities as mother of creation, invoking her powers in a harmonious and stable fashion.

COLORS: The outer two lines are both red. The *bhūpura* may be colored black to invoke the womblike quality of space element or in the colors of the four directions (red, green, blue, yellow) to invoke her as the spaciousness of manifestation itself. The two circles are red and white. The dots between the petals are white. The petal colors are, clockwise from the top, red, golden yellow, red, dark green, red, white, red, and black. All have colorful decorative borders of yellow and white. The circle of fine lines is golden yellow. The triangular tips of the squares are white with decorative gold lines. The large octagon is red, the rearmost triangle is golden yellow, the upward-pointing triangle is dark green-gray, and the innermost triangle is blood red.

In some Himalayan traditions, the center dot, representing the goddess herself, is not added until the ritual awakening *(prāna-pratishthtā)* ceremony. If you wish to add the center dot *(bindu)* to use this yantra for meditation, it may be made white (effulgence), black (void), or gold (divine knowledge).

The small yantras are each different and correspond with chakras of a human body. The colors provided here are only suggestions, and if you are trained in a tradition that utilizes other colors for the chakras, feel free to use them. The top one is dark green-gray with a white crescent moon. Moving clockwise, the next small yantra has two petals; the left petal is red, the right is white. The small circle is gold; the center triangle is red. The next small yantra has many white petals, a small gold ring of rays, and green inner circle. The hourglass shape at the center is red on the top and white on the lower half. The next small yantra is black, with red petals, a gold ring, and a green inner circle behind the black star. The small yantra at bottom has four red and gold petals, a green inner circle, and a black square. The next has six red petals, a gold ring, a gray or blue oval, and a white crescent moon. The next little yantra has ten red petals, a gold ring, green inner circle, and a red triangle. The last has twelve white petals, a gold ring, a green inner circle, and a white star.

CONTEMPLATION: Bhuvaneshvarī hosts all beings and lovingly treats no one as separate from her own expansive Self. All actions are intrinsically valid expressions of her primordial presence. Well-trained artists may be able to view the natural world this way, yet feel compelled to be judgmental when looking at other artists' work. The urge to express our love or hate of an artwork (or another person) can feel almost painful if we are unaccustomed to being in such a highly energized state. Powerful emotions or vast energy can feel almost like an embarrassment of riches. The urgent desire arises to *do* something with the emotional energy and relieve our discomfort. Yet if we react impulsively, be it by attraction or aversion, this energy carries all of our contracted patterning. It might be expressed in the form of offering advice without being asked. Sometimes a compliment erupts out in the distorted form of self-denigration, like "That's so much better than my art."

What would a simple compliment with no strings attached sound like? What would it be like to react in an honest way without any evaluation at all, to simply share how we feel in that moment? Are we able to appreciate and affirm our own work this way? What would it be like to simply abide in loving awareness?

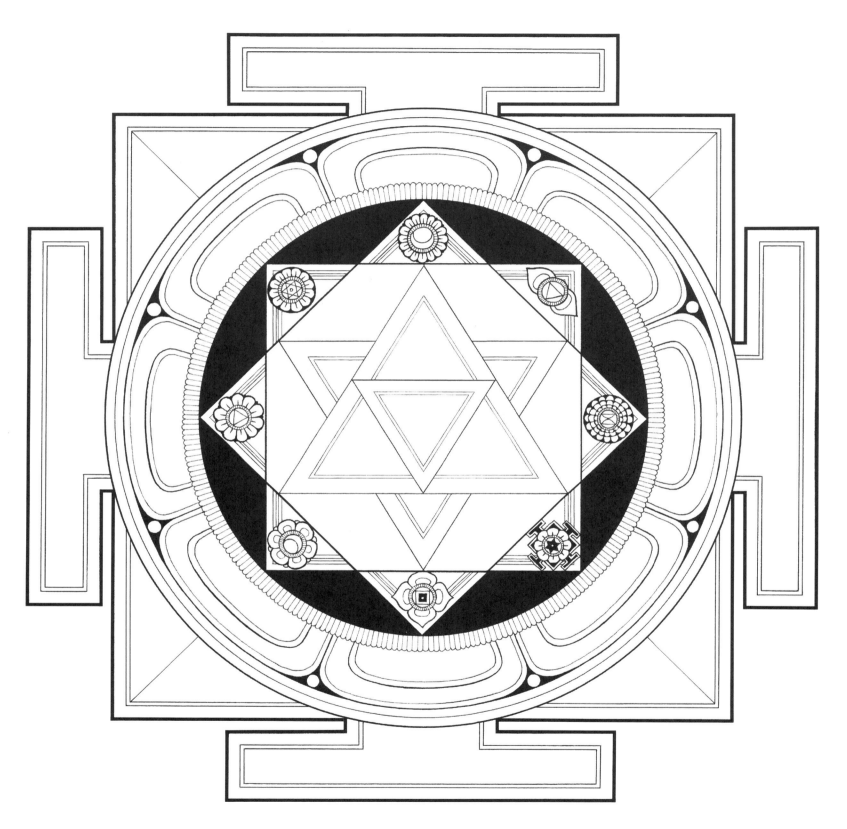

Bhuvaneshvarī Yantra भुवनेश्वरी यन्त्र

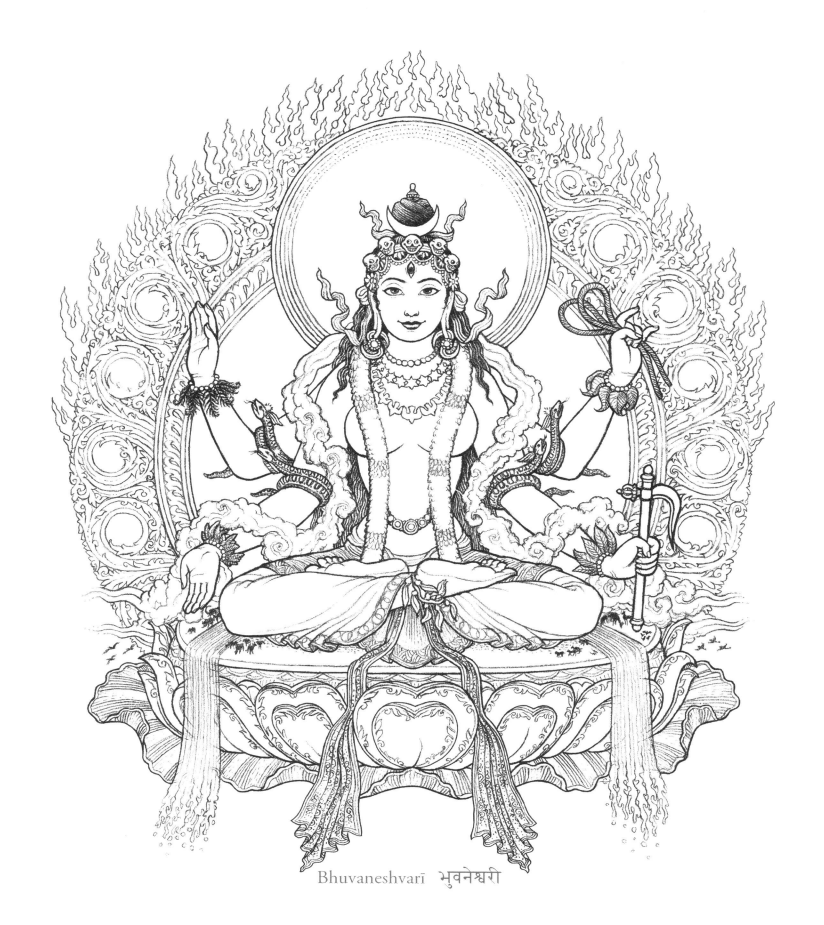

Bhuvaneshvarī भुवनेश्वरी

Bhuvaneshvarī

Universal Earth Goddess of Love

Although Thou art the primordial cause of the world, yet art Thou ever youthful.
Although Thou art the Daughter of the Mountain-King, yet art Thou full of tenderness.
Although Thou art the Mother of the Vedas, yet they cannot describe Thee.
Although men must meditate upon Thee, yet cannot their minds comprehend Thee.

—Tantrasāra

BHUVANESHVARĪ (a.k.a. Aditī, Vishvarupa, Mahāmāyā) is the goddess of spaciousness, regent of manifest creation, the universal earth mother. *Bhu* means "earth" in the sense of physical manifestation, and she is the associated with the five great elements *(mahābhūtas)* in particular. In one text, the universe is said to emerge from her like a web from a spider. She is the womb of creation, from which all that is knowable emerges and will return. She is located everywhere, but most associated with the heart. Hers is the peace and equanimity that is found in the open space of divine love. She is described as being regal, amicable, and even as "she who nurses the world." Her beauty is repeatedly emphasized in visualization texts and invocations, alluding to the powerful desire beings have to remain alive so they may continue to embrace physical existence. Hymns say that all other goddesses are forms that Bhuvaneshvarī takes to oversee and protect the world. Like all the Wisdom Goddesses, she can reveal ultimate truth, but she is often propitiated for well-being and material success. When only part of her full being is recognized, she is known as Māyā, the divine illusion. In Bhuvaneshvarī, mystics recognize the Great Goddess taking form for the sheer delight of *being*. Thus, all creation is Bhuvaneshvarī's body, all illusions are her play, and all beings within it are her ornaments.

INVOCATION: *Oṁ Bhuvaneshvaryai Namaha (Ohm Bhoo-vuh-naysh-wuhr-yai Nuh-muh-huh)*

IMAGE DESCRIPTION: Depictions of Bhuvaneshvarī vary greatly depending on how she is invoked. This original image is in the modern Newar style, where she is typically dark blue, but her attributes are based on the visualization text in the Mantra-mahodadhi, where she is described as "the color of a sunrise." She appears in other texts as gold or dark green. She holds the elephant goad (power) and the noose (restraint), implying control, but they are held in her left hands to indicate they are being wielded gently. She can goad spiritual aspirants toward liberation or bind them with desire for material gain. With her right hands, she makes the gestures *(mudrās)* for dispelling fear *(abhaya)* and granting boons *(varada)*. On her body are all the creatures of creation, which she wears as her ornaments. Her sitting posture and the symmetry of this image indicate she is being invoked for a stable and harmonious experience of her blessing power.

VIRTUES: loving-kindness, expansive openness, contentment, compassion, generosity, equanimity.

Tripurabhairavī Yantra

O Tripurā, I take refuge at Thy lotus feet, worshipped by Brahmā, Viṣṇu, and Maheśvara; the abode of bliss,
the source of the Vedas, the origin of all prosperity; Thou whose body is Intelligence itself.

—Tantrasāra

This yantra has wide gates, indicating great powers of creation and destruction, but the openings are very narrow, implying that the inner teachings of this goddess may be difficult to reach. The lotus petals are practically bursting through the openings, however, meaning her nourishing powers will be immediately felt by those who persevere and pass through the portal. The thin, innermost triangle emphasizes Bhairavī's fiery, transformative nature, as verticality is associated with the fire element. This image is inspired by the work of contemporary Newar artists from the Kathmandu valley of Nepal.

COLORS: The outer framing lines are red and gold (yellow ocher). The square area behind the yantra is black, though this color is optional and other colors may be used. The yantra itself is outlined in white. The *bhūpura* is divided into four quadrants: the top is red, the right is green, the bottom is blue, and the left is golden yellow. The colors of the quadrants indicate this yantra is for approaching Bhairavī in the east, the direction of the rising sun. These quadrants may be filled with floral ornamentation, if desired. The petal colors, clockwise from the top, are yellow, blue, red, green, yellow, blue, red, and green. The inner ring of dots is white, like little pearls. The circle of fine lines that look like rays of light goes from golden yellow at the tips to yellow-orange at the bases. The area behind the triangles is black. The downward-pointing triangle is golden yellow. The upward-pointing triangle is white. The slim, innermost triangle is blood red.

If you wish to add the center dot *(bindu)* to use this yantra for meditation, it may be made white (effulgence), black (void), or gold (divine knowledge). It should be at the center of the entire composition, rather than the center of the smallest triangle.

CONTEMPLATION: Self-observation is a fundamental yogic technique. With it, we may soberly and honestly assess our patterns of body, speech, and mind to evaluate those that are out of alignment with our spiritual path. Self-discipline to modify our behavior (and thus our energy body) is the quintessence of yogic practice. It has a purifying and clarifying effect.

Most of us have at least one unhealthy habit. Consider modifying or halting that habit for a specific period of time, perhaps during the time spent coloring Bhairavī's image. Beginners are wise to pick a small and attainable goal: perhaps giving up use of electronic devices for a day or abstaining from sugary foods for a week. It is customary in some cultures to fast (abstain from food) the day before making devotional art for important rituals. We can use this example to regulate impulsive behavior, even when fasting is not appropriate. Observe if the chosen restriction results in any helpful life changes. Even if none are immediately apparent, the discipline of controlling, redirecting, and ultimately transforming our impulses into *dharmic* action builds character and spiritual power.

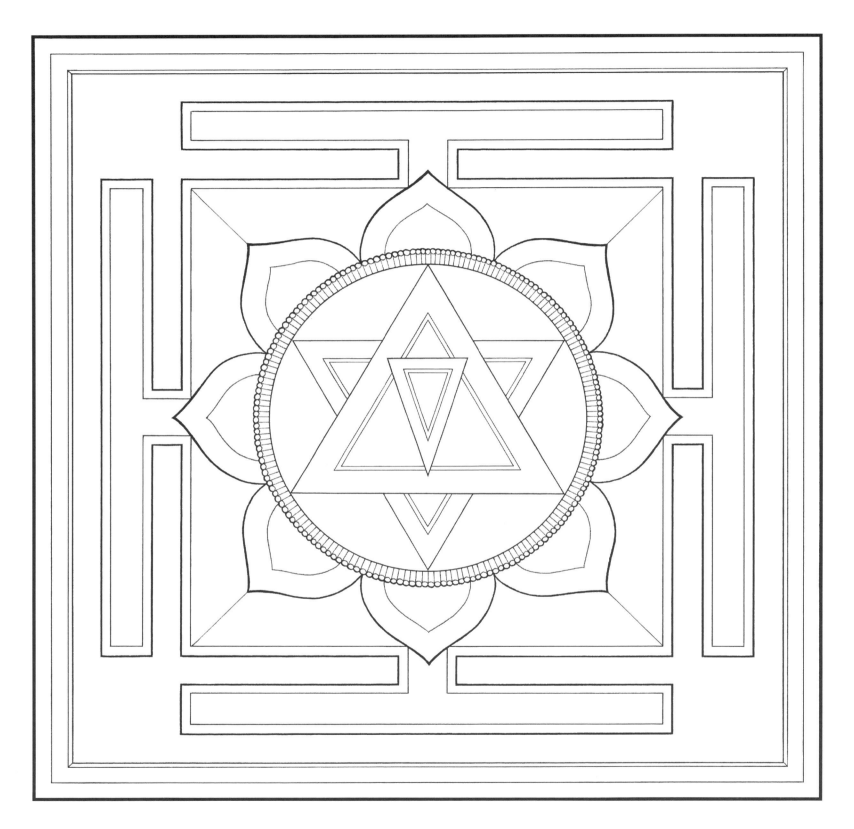

Tripurabhairavī Yantra त्रिपुरभैरवी यन्त्र

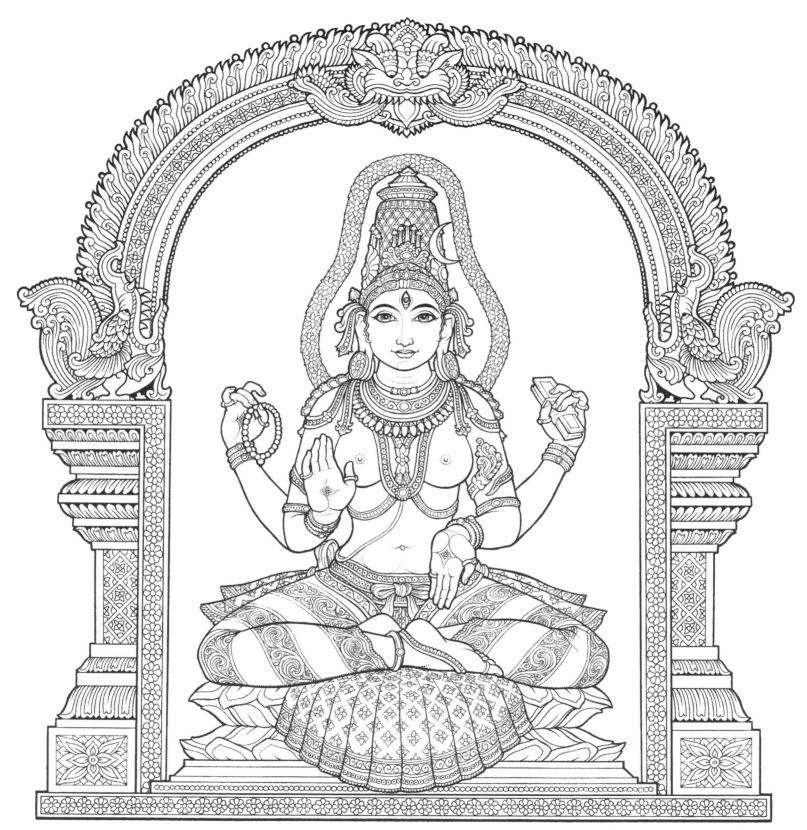

Bhairavī भैरवी

Bhairavī

Divine Wrath Triumphant

I worship in my heart the Devī whose body is moist with nectar (from her union with Śiva), Beauteous as the splendour of lightning, Who, going from Her abode to that of Śiva (mūlādhāra chakra to the śivasthāna chakra), Opens the lotuses (chakras) on the beautiful way of the Suṣumnā (the central channel).

—Tantrasāra

BHAIRAVĪ (a.k.a. Tripurabhairavī, Kālarātri) is the triumphant warrior goddess, the fire that dissolves the universe. She is terrifying (her name literally means "terrible" or "frightful"), red and fiery, smeared with blood, and dangerously erotic. Hers is the power of divine anger and wrath—energy personified. Her wrath is not random; it is like that of a protective mother and directed toward our impurities. She is *tapas,* the fierce form of transformational heat, a term used to describe rigorous yogic discipline. Historically, she has more different forms than any of the other Wisdom Goddesses, including both horrifying and beautiful forms, all of them awesome. She is *kundalinī-shakti* in her fully aroused state, also known as the victorious Durgā, which is why she carries no weapons. Her consort is the ancient wrathful form of Shiva known as Bhairava or Rudra. Like Sarasvatī and Parā Vāch, she exemplifies ultimate knowledge, though it is expressed through destruction rather than creation. She exemplifies the fully realized state experienced after all negative patterns have been annihilated, and she is invoked by yogis to defeat lust, greed, delusion, intoxication, jealousy, and anger. To her devotees she grants many blessings, including nourishment, sexual gratification, and awakened consciousness.

INVOCATION: *Oṁ Bhairavyai Namaha (Ohm Bhai-ruhv-yai Nuh-muh-huh)*

IMAGE DESCRIPTION: This original image is inspired by the ancient imperial style of the South Indian Chola Empire. Devotional arts flourished in this culture, and their iconography continues to strongly influence how people around the world think of Hindu deities. This image was inspired by the work of the eminent architect V. Ganapati Sthapati (1927–2011).

In this image, Bhairavī holds the book (knowledge) and prayer beads (devotion) in her back hands, and in her front hands displays the gestures *(mudrās)* dispelling fear *(abhaya)* and granting boons *(varada)*. Her skin is red like a hibiscus or "burning gold." Her jewelry is gold, set with brilliant gems, and her apparel is red with gold trim. The throne and arch around her are golden. The background is blue. Deities in Himalayan traditions are often portrayed amidst idyllic landscapes, but Tamil images are usually set in temple settings. Atop the two columns are mythological half-terrestrial and half-aquatic monsters known as *makaras,* one of the most widespread symbols in Asian art. They represent the chaotic power and abundance of the natural world. At the top of the arch is the Face of Glory *(Kīrtimukha),* a guardian created by the god Shiva. Together, these elements comprise a very stable, symmetrical, and orthodox portrayal of a terrifying goddess. Thus, those who utilize this icon are more likely to have a stable and harmonious experience of her power.

VIRTUES: intense energy, divine knowledge, truthfulness, fearlessness, generosity.

Chinnamastā Yantra

No sacrifice is worth the name unless it is a joy.
Sacrifice and a long face go ill together.

—Mohandas Gandhi (1869–1948)

This dramatic yantra has extraordinarily large and wide gates, demonstrating Chinnamastā's great powers of creation and destruction. The inner square is very small, indicating that she does not express much of the stability associated with the earth element. The lotus petals are also relatively small, indicating little of the flowing and nourishing qualities of the water element. The *bindu* is unusually large, however, indicating a powerful expression of the space element. This yantra invokes a goddess that is immediately and powerfully experienced for the purpose of unity, with little else in between. This image is inspired by the work of contemporary Newar artists from the Kathmandu valley of Nepal.

COLORS: From edge to center, the outer framing lines are red, then gold (yellow ocher). The yantra itself is outlined in white. The tiny *bhūpura* and four large gates are divided into four quadrants: the top is red, the right is green, the bottom is blue, and the left is golden yellow. The colors of the quadrants indicate this yantra is for approaching Chinnamastā in the east, direction of the rising sun. It is traditional to fill these areas with sinuous floral or fiery ornamental patterns. The petal colors, clockwise from the top, are yellow, blue, red, green, yellow, blue, red, and green. The inner ring of dots is white, like little pearls. The circle of fine lines that look like rays of light goes from golden yellow at the tips to yellow-orange at the bases. The downward-pointing triangle is scarlet. The concentric circles are pale green, pale yellow, and white at the center.

CONTEMPLATION: All of us have benefitted from the compassionate action of others. Parents protect and care for their children no matter what the personal cost. Firefighters, warriors, and other valiant people leap into action to protect others without any regard for personal safety to ensure that the rest of us may thrive. If you are on a life path of self-sacrifice or in a career that puts your life on the line for the benefit of others, then you are already expressing Chinnamastā's shakti.

If not, then ask yourself who has had a positive impact on your own life? Who has made a personal sacrifice on your behalf? Perhaps it is a military veteran, a parent, mentor, best friend, favorite teacher, or the person who inspired your love of art. Consider thanking her or him in person, or with a phone call, a message, or a care package. Perhaps visiting a grave or monument is in order. While the hero's path of self-sacrifice is not for everyone, we all enjoy the benefits; we all can return the favor in some small way by showing our appreciation.

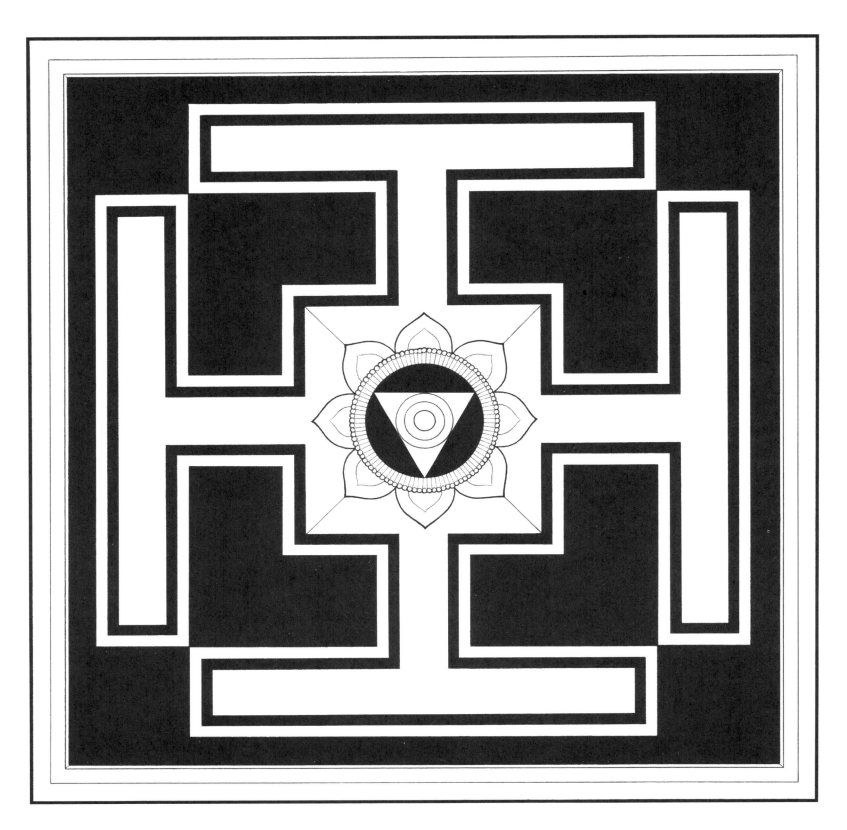

Chinnamastā Yantra छिन्नमस्ता यन्त्र

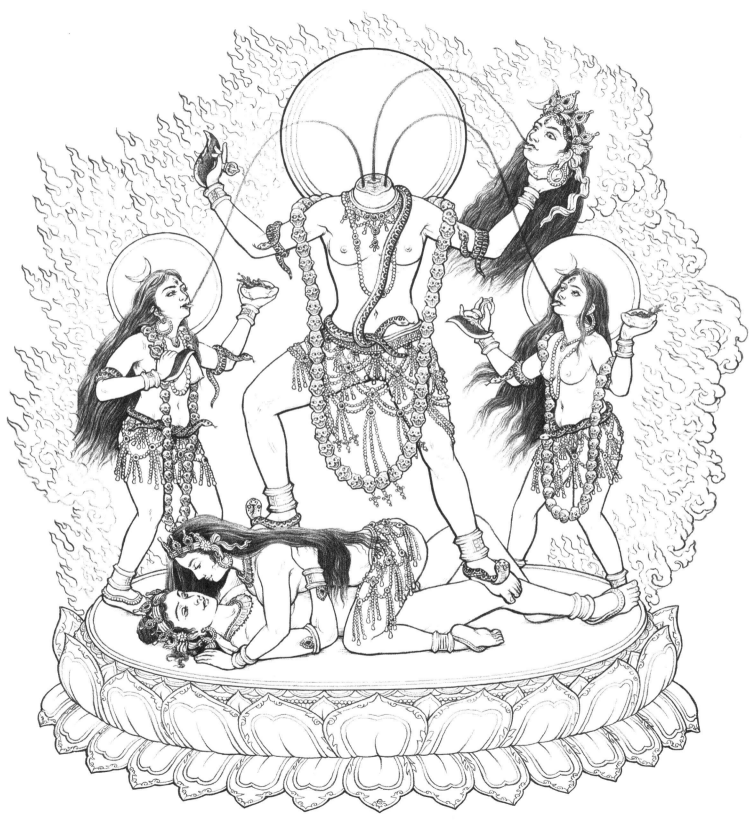

Chinnamastā छिन्नमस्ता

Chinnamastā

Self-Sacrifice and Action beyond Reason

The extent of your power is unknown even to yourself.

—Devī Gītā

CHINNAMASTĀ (a.k.a. Indranī, Vajrayoginī) can be depicted as a headless goddess, which is perhaps the most disturbing of any Hindu deity and meant to shock us into heightened awareness. *Chinnamastā* means "a severed head," and she is related to the power of perception itself. She is associated with lightning and thunder and the body's nervous system. Clearly, this is an intense goddess, whose practices must be treated with great care by beginners. In Hindu icons, the goddess's lithe body bridges the polarities of life and death, showing how she directly transmutes the intense power of sexual desire into compassionate action. She stands or sits on a copulating couple, holding her head in one hand while streams of blood emerge from her body to satiate her two shaktis. The three streams correlate to the three main energetic channels of the body: *Idā, Pingalā,* and *Sushumnā.* It is particularly notable that her icon shows this valiant act to be self-nourishing. Worshiped by those who wish occult powers and by warriors before battle, she embodies the nature of selfless sacrifice. Widely worshiped in the form of Vajrayoginī by Tantric Buddhists, it is said that hers is the lightning path to enlightenment, swift and dangerous. Once begun, it should not be paused until completion.

INVOCATION: *Oṁ Vajra-Vairochani Svāhā! (Ohm Vuh-jra Vairo-chani Swah-haa!)*

IMAGE DESCRIPTION: This depiction is executed in a style typical of North India and Nepal. The fearsome goddess stands atop a conjoined couple (Kāma and Rati) demonstrating her triumph over sexual desire. She carries a skinning knife, which cuts away all false identities, and a skull cup overflowing with the nectar of realization. In this special case, the skull cup holds her own head, which is nourished by her sacrifice. Her shaktis hold similar implements and are also nourished.

The main figure of the goddess is ruby red. Her shakti to the left (Dākinī) is dark blue or black, and her shakti to the right (Varninī) is white. These three skin colors signify the three primordial states of reality *(tri-guna):* dynamism, entropy, and stasis. They wear garlands of skulls, showing the emptiness of discursive thought. The main figure stands in the wrathful *alidh āsana* posture (with the left leg straight and the right knee deeply bent), and all the figures are in motion. This indicates her power is vigorous in nature and likely to be intensely experienced by those who dare to engage her practices.

VIRTUES: self-sacrifice, generosity, vigor, nonattachment, freedom, truthfulness, self-discipline.

Dhūmāvatī Yantra

The family with an old person in it possesses a jewel.

—Chinese saying

According to one of my sacred art teachers, the drawing of lines is related to Shiva, while coloring and ornamenting is related to Shakti. In recognition of Dhūmāvatī's status as the only Shakti with no Shiva, the pattern of this yantra has no lines. It is up to you to draw the lines, connect the dots, and bring the goddess into manifestation. If you need an example to use as a reference, this yantra is very similar to the Tripurabhairavī Yantra. This yantra has wide gates, indicating great powers of creation and destruction, but the openings are relatively narrow, implying that it may be challenging to invoke the nourishing and transformational powers of this goddess. The lotus petals are large, however, so her nourishing powers will be immediately felt by anyone who succeeds in passing through one of the gates. According to one source, these petals represent the five senses and three powers of divinity (knowledge, will, and action). Her powers of dissolution (upward-pointing triangle) and manifestation (downward-pointing triangle) are balanced, but the innermost triangle shows she is being invoked in this yantra as a mother goddess. This image is inspired by the work of contemporary Newar artists from the Kathmandu valley of Nepal.

COLORS: The outer framing lines are red, then gold (yellow ocher). The square area behind the yantra is black, though this color is optional and other colors may be used. This area may also be ornamented, if desired. The yantra and its gates are outlined in white. The *bhūpura* is divided into four quadrants: the top is red (east), the right is cool green (south), the bottom is indigo blue (west), and the left is golden yellow (north). These quadrants may be filled with floral ornamentation, if desired.

The petal colors, clockwise from the top, are golden yellow, blue, red, green, golden yellow, blue, red, and green. Once the lines are drawn in, a circle will be apparent inside the ring of petals. This circle is golden yellow, while the circular area behind the triangles is black. A ring of decorative white dots, like little pearls, may be added. The downward-pointing triangle is golden yellow. The upward-pointing triangle is white. The slim, innermost triangle is blood red. A center dot *(bindu)* may be added if one wishes to "open the eye" of this goddess or use the yantra for meditation.

CONTEMPLATION: If we are lucky and resourceful, we will grow old. Our body will eventually become wrinkled and die. This prospect is scary to most young people, which may explain why Dhūmāvatī is often portrayed as fearsome and grotesque. Yet mystics also understand her as the wise crone who cares nothing for appearances or the opinions of others. Her energy is expressed by the impoverished and elderly, especially those who have grown wise from their trials.

Popular media and movies do not give us much guidance on how to age gracefully. Luckily, most of us are surrounded by experts. Consider befriending an elder—if possible, an elder artist. What wisdom does she or he have that is rooted in real-world experience? What advice might she or he have on our artworks or spiritual journey? Do we have any resistance to asking for guidance?

Dhūmāvatī Yantra धूमावती यन्त्र

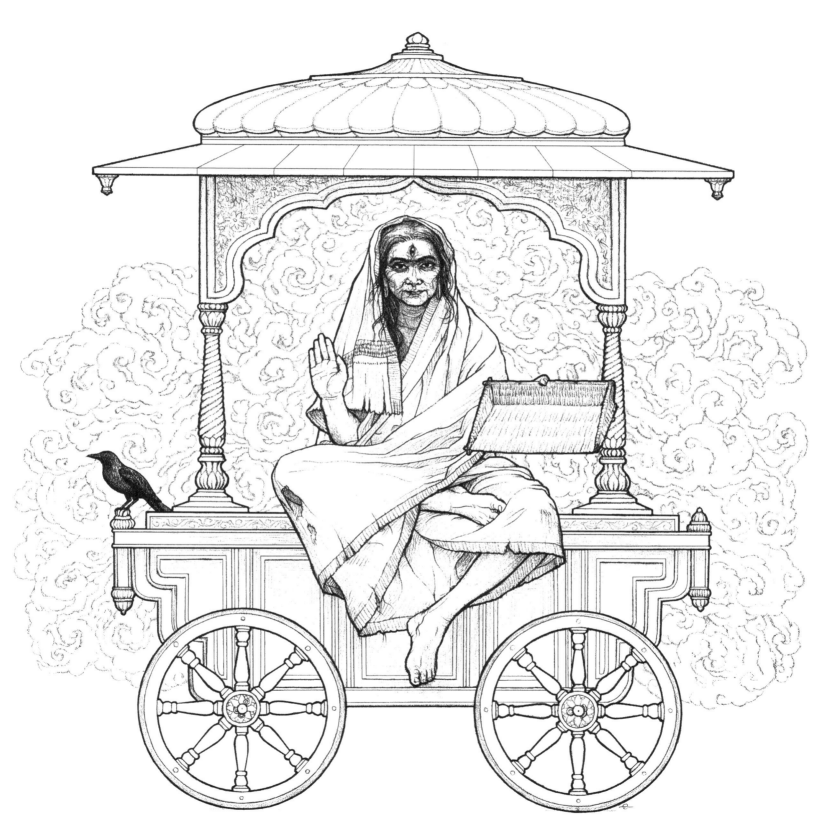

Dhūmāvatī धूमावती

Dhūmāvatī

Smoky One Free of All Attachments

The older I get, the greater power I seem to have to help the world;
I am like a snowball—the further I am rolled, the more I gain.

—Susan B. Anthony (1820–1906)

DHŪMĀVATĪ (a.k.a. Jyeshthā, Kutilā) is the widow, the crone, the ancient one who bestows the lessons of birth and death. She is the primordial darkness, the original chaos underlying creation, the silence of the void itself. *Dhūma* means "smoke," and hers is the power of ignorance, obscuration, loss, humiliation, suffering, and loneliness, when all objects of desire have been burnt to ashes. She is all that is inauspicious, disdained, rejected, and the wisdom we gain by living through hardship. Therefore, she is also the bliss of forgetting, and she grants the powers of patience, perseverance, forgiveness, and detachment. When we make her our ally, she obscures distractions so that we may focus on our goals; she reveals our destination so we do not stray from our path.

Dhūmāvatī is said to be extremely unpleasant yet fantastically generous to those who are able to see past her inauspicious appearance. She is Shakti with no Shiva, the pure feminine principle portrayed as an impoverished widow. She the only one who remains after cosmic dissolution, having eaten her own husband! In one myth, she is said to have appeared from the smoke of the sacrificial fire that consumed the ancient goddess Satī, whose act of self-destruction sprang from rage. Though commonly portrayed as a gruesome hag dressed in robes scavenged from corpses, there is another way to understand her image: she is totally independent. A widow is free to pursue spiritual pilgrimages and reject all that is oppressive about polite society. As a widow with no children, she is no longer bound to a husband and possesses something rare for women in traditional Indian society: sexual freedom. This may explain why she is also described in her thousand names as beautiful and occupied by sex. Bound to nothing, she is thus a symbol of liberation from all attachments.

INVOCATION: *Oṁ Dhūmāvatī Svāhā! (Ohm Dhoo-mah-vuh-ti Swah-haa!)*

IMAGE DESCRIPTION: Dhūmāvatī is described as "dark" and is typically surrounded by grays and browns. This image is inspired by popular contemporary prints produced in North India. She sits on a cart with no ox to pull it, meaning she is going nowhere. Sometimes she is portrayed sitting on a crow, here shown roosting beside her. The crow is an intelligent, aggressive, and opportunistic scavenger with a jarring call that is considered inauspicious in India because it frequents cremation grounds, trash heaps, and other unclean places—much like this goddess. She sits with her left leg dangling, indicating the feminine qualities of the lunar channel *(Idā)* predominate and implying that her blessings flow down to earth through left-hand (heterodox) practices. She displays the gesture dispelling fear *(abhaya)* and holds a winnowing basket, used to separate nourishing grain from the inedible chaff. This basket is a rare attribute, implying her ability to discern truth (the grain) from falsity (the chaff). It also relates to the how we sift through sensory information to focus on what we desire, how we sift through memories to recall what is treasured, and how our subtle impressions *(samskaras)* follow us from one lifetime to the next. Yet her winnow is empty, showing she is beyond mind, memory, and even karma—completely free.

VIRTUES: wisdom, nonattachment, discernment, perseverance, simplicity, humility.

Bagalāmukhī Yantra

As the body is to the Jiva (soul), as oil is to the lamp,
so is Yantra the established seat of all the Deities

—Kulārnava Tantra

This yantra has modest-sized gates with wide apertures to the main square, signifying this goddess's blessings are likely to flow abundantly to aspirants who find their way to her practices. The eight petals represent the five great elements and the three primordial *gunas.* The "seeds," or small triangular shapes, inside the petals show that the goddess's blessing power radiates in all directions. The six-pointed star indicates that her fiery powers of transformation are being invoked in a harmonious balance between the masculine principle of dissolution and the feminine principle of manifestation. Yet the innermost triangle points downward, so the fruit of practices done with this yantra are likely to be expressed in manifest form. This yantra is from the tradition associated with the renowned author and teacher Harish Johari (1934–1999), of the North India holy city of Haridwar.

COLORS: The outer line is iridescent gold; the next is light yellow. The *bhūpura* is a deep maroon red. The main color of this yantra, maroon, is said to be the color of fear. When meditated upon, however, this color produces a dark green after-image when the eyes are closed, removing fear and hatred. The two circles are iridescent gold. The spaces between the lotus petals are iridescent silver, modifying the effect of all the warm colors. This iridescent color is associated with the moon and the nourishing qualities of the water element. The petals are peach in color, mixed with the maroon to give them a slightly darker hue. The small triangular shapes at the base of the petals are even darker, almost the same color as the *bhūpura.* The area behind the six-pointed star is iridescent silver. The star is made with gold lines and filled with vivid yellow. The innermost downward-pointing triangle is the same maroon color as the *bhūpura,* representing the goddess' stupefying power. The center *bindu* is brilliant yellow, like the goddess herself.

CONTEMPLATION: One of the core practices of the yogic path is to stop wasting energy on needless activities, thoughts, and desires. One of the fastest ways we lose energy is though our speech, most of which is unnecessary. Try observing silence for a day. This is easily done in a remote place, but it can be more rewarding when done in community. Writing notes is a bit of a cheat but a great first step. The point is to stop the impulse to give or receive acknowledgement, which helps stop our own internal dialogue. An advanced version of this discipline is to avoid any verbal or nonverbal contact with others. What communications are most challenging to halt? What do we seek most often from others? When are we most likely to slip and forget our commitment? What emotions arise during the observance? How do we feel afterward, or the next day?

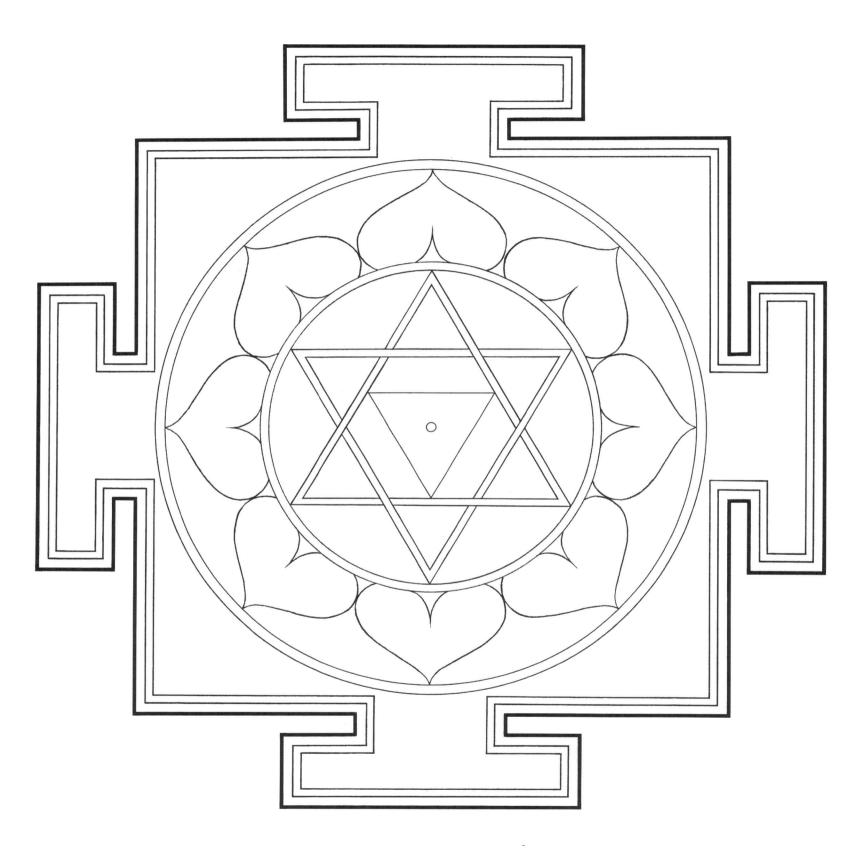

Bagalāmukhī Yantra बगलामुखी यन्त्र

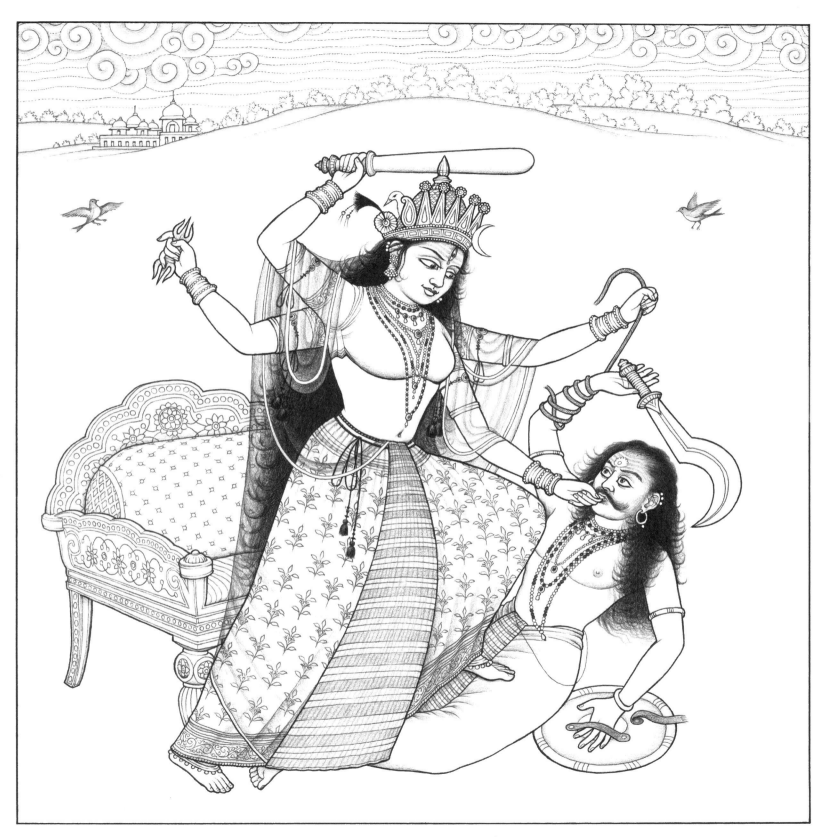

Bagalāmukhī वगलामुखी

Bagalāmukhī
Stunning Beauty That Halts Falsity

Smaller than an atom, greater than the greatest is the Self dwelling in the heart of each being.

—Devī Gītā

BAGALĀMUKHĪ (a.k.a. Pītāmbara-devī, Valgāmukhī) embodies the hypnotic power of divinity. Her stupefying beauty stuns or leaves witnesses dumbstruck. If the nature of the universe is vibration, hers is the ultimate power of stillness, and she is described as sitting in the middle of an ocean of nectar. Like the crane (her name means "Crane-Faced One"), she is patient and poised, yet swift to strike. Commander of the divine army, she is the power of speech that leaves others silent, the one who ends all confusion and conflict, the truth that crushes all illusions and false constructions. She is renowned for killing the demon Madan, who was granted a boon that everything he said would come true. Here she is depicted holding his tongue while she strikes him with a club, symbolizing blunt truth. As a goddess of yoga, she is the self-awareness that grants mastery of our own thoughts and energy, and she is commonly invoked to help devotees win debates. Her temples are rare, though she is popular in Nepal. More than any other Wisdom Goddess, she is renowned for giving her devotees magical abilities. She demonstrates the principle that conserving one's energy is a path to power, granting yogis the ability to control the five *prānas* (breaths) of our energy body.

INVOCATION: *Oṁ Bagalāmukhī Svāhā! (Ohm Buh-guh-lah-mook-hee Swah-haa!)*

IMAGE DESCRIPTION: She is strongly associated with the color yellow, and her skin is golden. (*Pītāmbara-devī* means "She Who is Dressed in Yellow.") She holds a noose (restraint) and a thunderbolt (revelation) in her back hands, and a club (truth) and the demon's cruel tongue in her front hands. She is commonly portrayed standing in a wrathful posture with one knee bent, to indicate that her power is vigorous in nature. The crescent moon on her forehead associates her with Shiva and lunar practices, while the tiny crane's head hidden in her crown alludes to her name. Both she and the demon wear stripes of white ash across their foreheads, indicating they are devotees of Shiva. In visualization texts for meditating on her form, she is described sitting on a jeweled throne, yet all portrayals show her leaping from it (or it isn't shown), indicating she has no attachment to comfort when duty calls. This image is inspired by the work of Mahaveer Swami, a contemporary artist based in Rājasthān. Like most deity images in this regional style, the goddess is depicted in an idyllic landscape of grass-covered slopes, tree-covered hills, and celestial palaces.

VIRTUES: truthfulness, focus, patience, self-discipline, vigor, dignity, stillness

Mātangī Yantra

Beings are bound by passion and are released by utilizing passion.

—Hevajra Tantra

Because Mātangī originated as a tribal goddess, the yantra included here is drawn in a rough yet lovely folk style. The decorative patterns, leaves, and flowers that surround and fill the yantra should not be mistaken as merely decorative. Because ornamentation *(alankara)* is a manifestation of Shakti's power to attract and bewitch, it is believed to enliven, empower, and protect.

The yantra itself has very wide gates, indicating great powers of creation and destruction, yet the openings are very narrow, implying that it may be challenging to reach this goddess's secrets. The lotus petals are well balanced, showing that her nourishing powers flow easily through the five great elements and the three internal "organs" (mind, intellect, and ego). The largest triangle points upward, showing that this yantra invokes her power to transform diversity into unity, yet the inner six-pointed star indicates that the inner experience of the aspirant is likely to be one of harmonious balance between dissolution and manifestation. This image is inspired by the Madhubani folk art of Bihar.

COLORS: Madhubani art is filled with bold patterns and colors, with little or no blank spaces. There is tremendous variation in the depictions of deities among artists, who improvise freely. Colors seem to be applied intuitively with an emphasis on bright, cheerful compositions, though the distinctive colors associated with specific deities are respected. Feel free to color in the same spirit.

This style of folk art seems to favor areas of red, orange, yellow, and green surrounded by black and white patterned borders. Blues and purples are rarely used in the older artworks. In the case of Mātangī's yantra, it seems that no two examples from this region are identical. The ornamentation surrounding the yantra may be freely colored with bold hues. In several examples I have found, the large square area of the *bhūpura* is brilliant red-orange; the ruby red lotus petals are outlined in white, while the small inner ring of flowers is yellow. The main circular area behind the triangle is leaf green. The upward-pointing triangle is outlined in black and white and filled with orange. The six-pointed star is dark green or blue. None of the yantras from this region that I have seen include a center *bindu,* which may be reserved only for artworks used in ritual.

CONTEMPLATION: We can evoke Mātangī's love of wilderness by spending time in a natural environment. Consider taking a long hike or doing something playful, like flying a kite in a park. Maybe spend an evening stargazing away from artificial light—not as an indulgence or a vacation, but as spiritual medicine, a way of realigning with the rhythms of nature. Dedicated artists develop the habit of carrying a sketchbook during such walkabouts. In the wilderness we may study the handiwork of the greatest artist of all: Mother Nature. Why not color this yantra outdoors? Be sure to have a snack during the trip and leave some small amount of leftover food behind as an offering of gratitude for the inspiration.

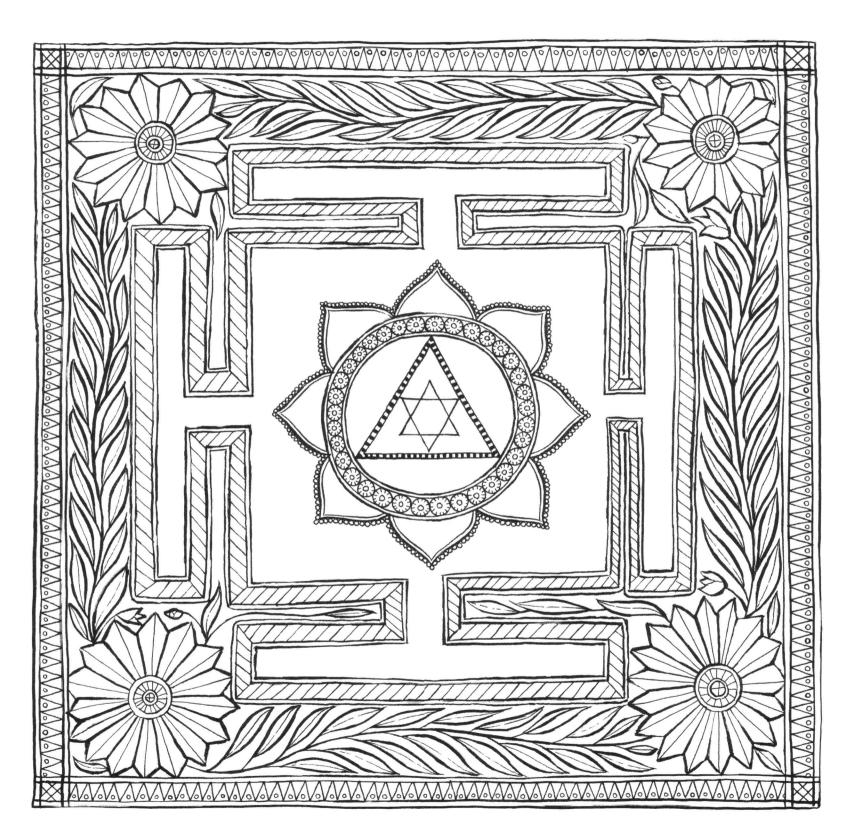

Mātaṅgī Yantra मातङ्गी यन्त्र

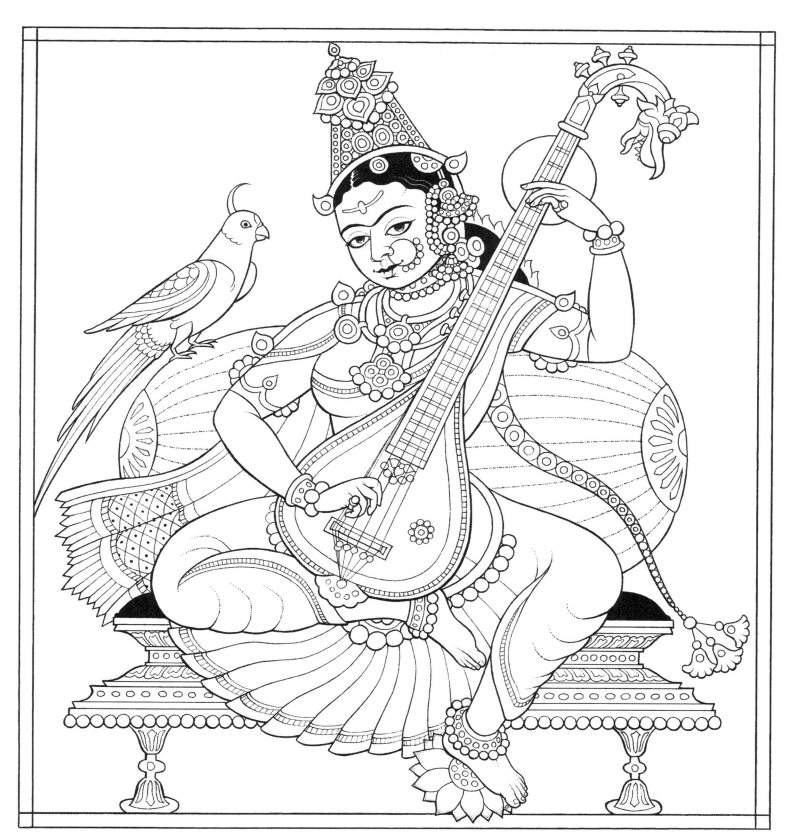

Mātaṅgī मातङ्गी

Mātangī

Wild Creativity outside Propriety

Thou art the dark blue butterfly, and the green parrot with red eyes.
Thou art the thundercloud, the seasons and the oceans.
Thou art without beginning, and beyond all time and space.

—Shvetāshvatara Upanishad

MĀTANGĪ (a.k.a. Ucchishtacāndālinī) is known as a Tantric form of Sarasvatī, bestower of knowledge, talent, and expertise in all the arts. The literal meaning of her name, "Female Untouchable," associates her with outcasts, showing that divinity exists even in the most ritually impure people and places. *Mata* means "thought," and some spiritual teachers see a link between the sound of that word and her name, because she is the power of divinity that has entered into the mind. Another similar-sounding word, *Matta,* which means "wild" or "intoxicated," is also associated with her name, implying that her energy is sinuous and undulating. She is indeed playful, erotic, mystical, and ecstatic, thriving at the periphery of society.

She is associated with jungle animals (especially elephants and parrots), tribal people, hunters, and all that is forbidden. She is said to be friendly to her devotees, not requiring them to act subordinate, and resides on a jeweled throne amidst an ocean of liquor. Remarkably, leftovers and impure foods are offerings she enjoys, and her devotees may worship in an impure or unclean condition. Her rituals are said to result in magical powers, poetic skill, and the ability to attract (and control) both people and wild animals. Mātangī is renowned for her power over communication and mantras, and her invocational mantra is rare in that it may be used successfully even by those who are not ritually initiated.

INVOCATION: *Oṁ Mātangī Svāhā! (Ohm Mah-tun-gi Swah-haa!)*

IMAGE DESCRIPTION: Mātangī is typically depicted with dark skin, often green or blue, sometimes black. She holds the vina, the official musical instrument of India. It is an allegory for the human body, with the two sound boxes (usually made of gourds) representing the torso and the head; the frets are vertebrae of the spine, and the strings are nerves. This sweet, mischievous depiction is from an eighteenth-century Mysore publication called the Shri Shakti Nidhi. She is adorned in the chaste garb of a queen, rather than that of a tribal outcaste, but this is typical of icons made by professional artists. It is notable that her posture and expression convey her playful nature in spite of the conventions of this regional style.

She sits on her throne with her left leg touching the earth, implying that she is invoked through left-hand (heterodox) practices and that her blessings flow to devotees through the feminine dynamic of manifestation and practices of embodied realization. Her vehicle *(vāhana),* a parrot, is perched beside her. It symbolizes not only mastery of speech, but also intelligence and love (parrots mate for life). Carved on the top of her musical instrument is the head of a ferocious makara, a mythological beast that symbolizes the abundance of nature.

VIRTUES: creativity, freedom, humility, skill, playfulness, friendliness.

Kolam with the Goddess's Feet

I dwell in the midst of the lotus-heart of one who knows me.

—Devī Gītā

One form of public art found throughout India is the tradition of making beautiful patterns by skillfully sprinkling rice flour on the ground. *Kolams* are often created near the thresholds of homes as a way of welcoming guests, blessing the area, and creating a festival atmosphere. They may be created for special holidays or as a daily ritual. Creating *kolams* is considered to be a woman's craft in most regions, but men make them, too. There are dazzling variations of this folk art found across India. As brilliant commercial pigments became available (and inexpensive), colors were incorporated and have now become part of the tradition.

According to some, these decorative patterns are said to attract Lakshmī, bringing luck and making rituals more auspicious. Traditional motifs include stars, lotuses, conch shells, spirals, and stylized footprints that are meant to attract the presence of Lakshmī. The two curving lines at the center of this design are her abstract footprints; they can be recognized by the toes drawn on top. Creative improvisation is encouraged, and contests are held each year during the Tamil month of Margazi (December through January). Often the grandest examples come from the humblest of homes. *Kolams* share many elements in common with more formal mystic diagrams, but most people think of them only as a pleasant part of one's household chores. This lacy design was inspired by the work of Rukmini Krishnamurthi.

COLORS: The most basic *kolam* is made of rice flour, so the lines are white on the earth. Yet today most are made with explosive color combinations. Feel free to use any colors desired. The brighter, the better! The only rule is they should be beautiful.

CONTEMPLATION: True generosity is given without any evaluation of the recipient's merit. It is an expression of our enlightened nature, not a deed done with a specific agenda. Artists have the opportunity to give in this way: public artworks continuously inspire and delight all who see them. Consider making a public artwork. Perhaps it is a pattern made on the ground. Chalk can be bought in most any toy store or art supply shop. Perhaps it is a mandala of leaves left anonymously in a field or uninhabited place. It could be a pattern created on a sandy beach or in a snow-covered field. There are many other examples of public artworks, from murals to street performances. What would you like to share? An audience is not necessary—this is an exercise in expressing delight. The universe itself is our canvas.

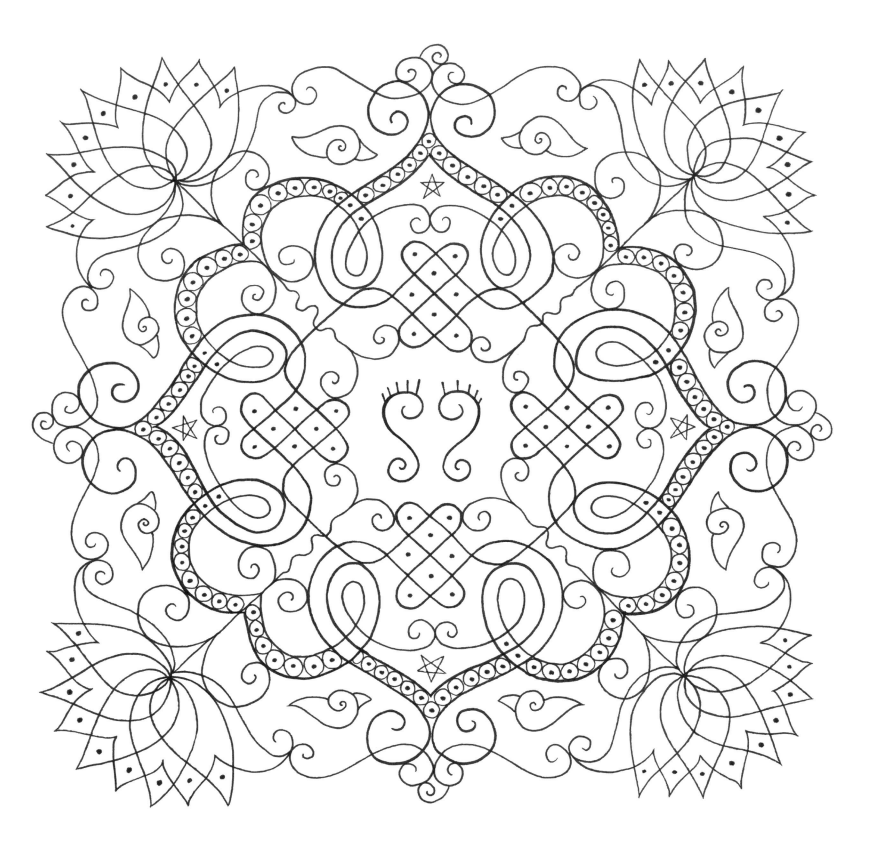

Kolam with the Goddess's Feet लक्ष्मि पाद कोलम्

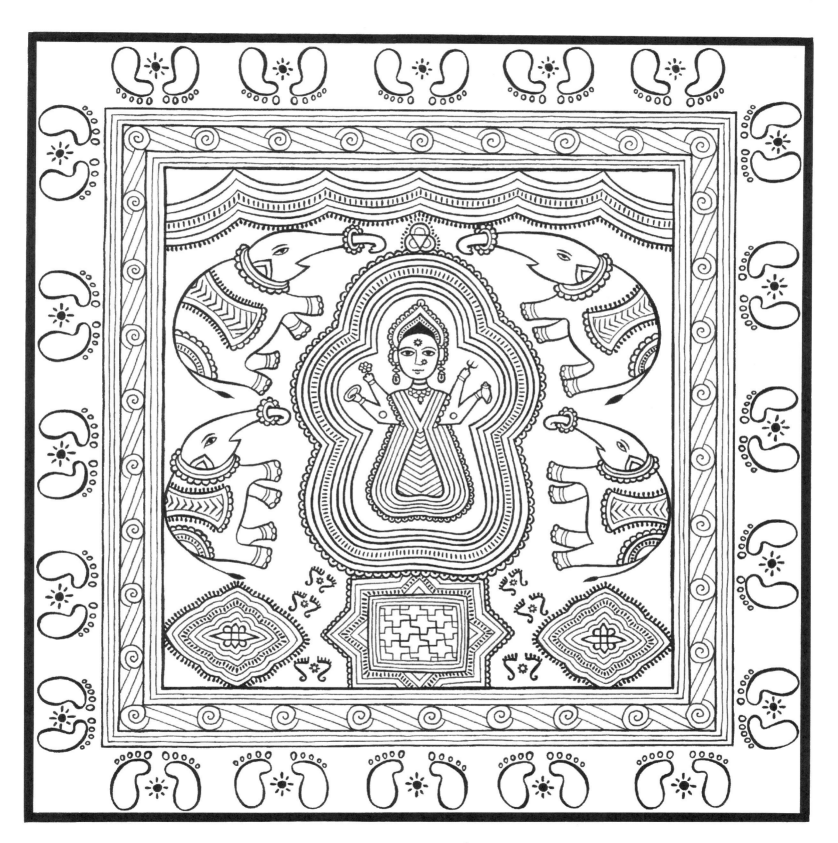

Lakshmī लक्ष्मी

Lakshmī

Pure, Delightful Abundance

O Devī clad in white raiment [brilliant light], adorned with varied gems,
Mother and upholder of the world art Thou.

—Mahā Lakshmī Stotra

LAKSHMĪ (a.k.a. Kamalātmikā) is the lotus goddess of delight, last of the Wisdom Goddesses, she who enjoys and is enjoyed. Perhaps the most familiar of Hindu goddesses to Western viewers, her image appears both in temples and on packages of household goods. When the gods and the demons teamed up to churn the primordial ocean of milk (a semi-secret metaphor for yogic training), she was among the treasures to appear, mesmerizing one and all. She is wealth, beauty, fertility, love, devotion, and safety. Wife of Vishnu, the deity in charge of maintaining cosmic order, goddess Lakshmī governs the outer form of beauty as the full unfolding of divinity. Yogis understand her power as the true wealth of generosity, that which cannot be taken away, the abundant nature of the universe itself. She may appear as Kālī to remove our heads if we become attached to her delights, yet when we release our urge to possess objects, Kālī may appear as Lakshmī. All forms of devotion and worship are aspects of her energy.

INVOCATION: *Oṁ Shrī Mahālakshmyai Namaha (Ohm Shree Muh-hah-lucksh-myai Nuh-muh-huh)*

IMAGE DESCRIPTION: This simple image is inspired by a charming piece of folk art made by an anonymous group of tribal women from Kumaon, in Uttar Pradesh. This type of folk art is called an Alpana, and it is drawn on the floor using a paste made of rice flower and water. It is a remarkable example of yantras and figurative images seamlessly blended together. Colors were only added to these designs in recent times. Feel free to improvise while coloring. Generally, Lakshmī is shown with golden skin, red clothing, and surrounded by cheerful, springlike colors. Her elephants are always white.

The composition is encircled by footprints, symbolizing Lakshmī's own feet. It is her feet that touch our world, and thus they are the portion of her form through which blessings flow into our experience. This is why disciples reverently touch the feet of gurus. Inside the ornamental frame, an elaborate cloth awning across the top shelters the goddess and establishes her exalted status. She is surrounded by elephants, symbolizing intelligence, equanimity, and wealth. Below her is a yantra comprised of two overlapping squares (a harmonious representation of the earth element that signifies civilization) filled with swastikas, symbols of effulgence and good luck. Just above her is the primordial goddess yantra, a simple downward-pointing triangle. The goddess herself is surrounded with pulsing lines of radiant power, and her figure is so abstract it is almost a yantra itself. In her hands she carries a lotus (purity), trident (knowledge, will, action), discus (illumination), and conch (fearlessness). These are not her typical attributes, and along with the four elephants, it indicates she is being invoked in a particularly powerful form.

VIRTUES: generosity, equanimity, dignity, contentment, gratitude, loving-kindness, devotion.

MANIFESTING SHAKTI

A Step-by-Step Guide for Creating a Five Elements Yantra

I found I could say things with color and shapes that I couldn't say any other way,
things I had no words for.

Georgia O'Keeffe (1887–1986)

Manifesting Shakti

Now you will learn to create a simple yantra suitable for use with the Five Elements Meditation *(Tattva Shuddhi)*. This meditation is a purification practice and is a foundation for higher-level yogic endeavors. Purification here does not mean rejection; rather, it implies the release of attachments so we may directly experience our inherent unity with all creation. Aspects of this Five Elements Meditation have been incorporated into the yantra instructions. Utilizing the given steps, you can make an accurate image of any size using only a straight edge, a compass, and a drawing instrument.

Remember, this pretty picture itself will not do anything to you. It is an instrument that you may utilize to repattern your inner landscape. When engaged mindfully and vigorously, the practice of creating a yantra has the benefits of harmonizing both sides of the brain, calming the nervous system, focusing attention, building eye-hand coordination, and balancing the elements that comprise your physical and energetic body. Plus, it's just plain satisfying to make something lovely.

Overview of the Practice

All of us are manifestations of Shakti, but making a conscious choice to align with her creative power by making a yantra is a transformative experience. When we do so, we recognize our inherent creativity and become a clearer channel through which this power may flow. Making a yantra can have a profound effect on the creator, so take time to prepare carefully before making one for the first time. Dedicating your first yantra to a friend in need, a beloved teacher, or to all beings is a wise way to begin.

Please do not skip any of the given steps, as they have been carefully arranged to give the most beneficial results.

While drawing, it is important to proceed in a meditative manner, rather than fixating on a certain deadline. The process is as important as the product. We seek to craft an elegant artwork as an expression of our love of the process, rather than to match some external standard. That said, while it is okay to finish the yantra over several days, it is best not to let it sit incomplete for too long. It is important to finish your yantra, even if the final product is less than perfect. In fact, the opportunity to learn and grow from this practice depends upon a willingness to look soberly at any "mistakes" or lapses in awareness.

It is normal to experience some challenges your first time making sacred art. Any difficulties, frustrations, strong emotions, or even coincidences that arise may be related to the karmas being rectified. If your experience becomes too intense, feel free to take a break and schedule a specific time to resume.

It is not necessary to color the finished yantra, but if you intend to leave it as a line drawing, please use red ink and erase any gray pencil lines. If you detect an error or make a "big mistake," please skip ahead to step 22 before discarding the yantra. If you must leave the yantra incomplete for any reason whatsoever, do not trash it. Please treat it respectfully as you send the elements back to their origins by recycling the paper. Burning it, placing it in a stream, and giving it to the ocean are customary ways to return the elements to nature, if you haven't used toxic pigments and you honor local laws.

Tools and Materials
- Sharp graphite pencil
- Loving awareness
- Eraser
- Playful curiosity

- Ruler with a clean, straight, undamaged edge
- Patience
- Compass for drawing circles
- Sense of humor
- A thick sheet of hot-pressed (smooth) watercolor paper. Any size may be used, but beginners may find the size of a sheet of typewriter paper (8.5" x 11") to be easiest.
- A wooden board to use as a work surface. This is to prevent the needle of the compass from harming household furniture. The board should be slightly larger than the sheet of paper you have selected.

The Steps

1. **Preparation and orientation.** Clean yourself, tools, and work space. Choose an appropriate work setting free of disturbances and distractions. Select an auspicious time to begin, perhaps at sunrise, a new-moon day, a full-moon day, and/or a holy day. Determine which direction to face (usually east or north) while working. Or simply imagine facing the rising sun and feeling the brightness and expansion of energy. Organize your tools and materials.

2. **Purification.** Choose a purification technique, such as burning incense, sprinkling rosewater, or ringing a bell. Purify your body, tools, materials, and workspace.

3. **Divinization.** Divinize the body *(nyāsa)*. Place the heel of the right hand on the forehead so that the wrist is over the third eye and the middle finger is on or near the top of the head. Chant *Oṁ* three times, drawing the energy of this sacred mantra into the hand. Then place the right hand on the lower belly and chant *Oṁ,* imagining a ruby red light in the center of the pelvic bowl. Move the right hand over the heart, chant *Oṁ,* and imagine a brilliant cobalt blue light in the heart center. Then place the hand on top of the head, chant *Oṁ,* and imagine a radiant white light in the center

of the skull. Pause and recognize that you have invoked your most expansive Self. Visualize the finished yantra as a living presence, brilliant and pulsing with life.

4. **Declare your resolve.** Once you are ready to begin, clarify your motive and intention for making this yantra. Set your resolve *(sankalpa)* by speaking it out loud. Here is an example: "I resolve to make a yantra of the five elements for the benefit of all beings." Pause for a moment and consider the blank drawing surface, which represents the formless void where all creation will appear.

5. **Establish the orientation.** Write Ganesha's mantra, *Oṁ Gaṁ Ganapatye Namaha,* in small letters at the top left side of your drawing surface. This will help orient the work. It also blesses the project.

 Usually, the top of a deity yantra is mystically understood as the eastern direction, direction of the rising sun and expanding energy. In these instructions, we will use directions like a map to help describe where to make marks

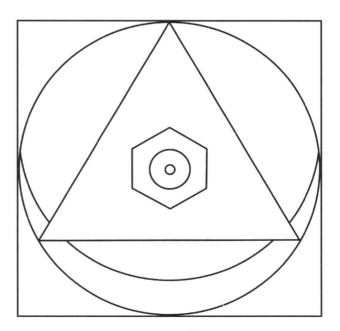

Five Elements Yantra

on the yantra. The top of the drawing is east. In the rest of these instructions, the word *east* will be abbreviated to the letter *E. South* is *S, west* is *W,* and *north* is *N.* It may be helpful to actually write down the compass directions lightly near the edges of your paper.

At the top of your paper, next to Ganesha's mantra, write *Oṁ* and the mantras of the five great elements *(mahābhū-tas): Oṁ, Laṁ, Vaṁ, Raṁ, Yaṁ, Haṁ.* We will chant each of these mantras in a specific sequence as we work. You may chant silently or in a quiet, even voice. Begin chanting *Oṁ.* If the chanting falters at any time during this project, simply pause and restart the chanting.

6. **Find the center.** By choosing to place a mark in a specific location, you have moved the energy of your intention into manifestation, setting the wheel of karma in motion. With this choice, creation begins. It is only out of convenience that you will measure the page at the center, or *bindu;* it could be drawn anywhere and is everywhere all at once. Lightly draw two diagonal lines, from corner to corner, crossing in the center.

7. **Draw a small circle.** It is the force of desire that causes us to expand outward from the center. Because this primordial desire moves in all directions, it is drawn as a circle and represents the radius of desire. In general, we start at the top of the figure and work in a clockwise direction when creating yantras. The east is the direction of the rising sun, so the clockwise motion symbolizes expansion of awareness.

The exact size of the circle we draw is unimportant, but one with a radius of approximately two inches (5 cm) will be helpful in the next steps. Place the needle of the compass at the center point and gently draw a small circle in the clock-wise direction. It will be erased later, so don't press too hard. This compass setting (the distance between the needle and lead) will be used in the next step, so be careful to keep it.

8. **Measure for horizontal and vertical lines.** Move the compass to the top right side of the drawing, the south-east (SE) corner, and place the needle where the circle crosses the SE diagonal line. Swing the lead to make a new mark at the top (E) of the drawing, outside of the small circle and approximately halfway between the top two diagonal lines. Next, move the needle to where the circle crosses the NE diagonal line, and swing the lead to cross the new mark, making an X shape exactly halfway between the two diagonal lines at the top of the page. Continue this process, making an X between the two diagonal lines on the right (S) side of the drawing. Move the needle of the compass to the other diagonal lines and repeat. When you are done, there will be four small, X-shaped marks outside the circle, each halfway between the diagonal lines (figure 1).

9. **Make the brahmā line and horizon line.** So far, you have been making only preparatory marks for the sake of orien-tation. They will be erased later. In this step, you will make your first important mark, symbolizing the first creative act. This is the *brahmā* line, dividing the drawing surface in half vertically, from east to west. You will keep this line until the drawing is complete. It is said to have the quality of fire, which rises. Straight lines are said to have the quality of light rays, piercing the gloom of ignorance. Here, duality comes into being as we divide the formless void into "this" and "that."

Pause for a moment, take a breath, and remember your motive for making this yantra. Gently draw a vertical line from the top of the drawing surface to the bottom, passing exactly through the top X and the bottom X. This line will be erased later, so draw gently.

Next, gently draw the horizon line. It connects the two X marks on either side, running through the middle of the circle and bisecting the *brahmā* line (figure 2).

This line is said to have the quality of water, which flows and spreads. The qualities of fire and water are naturally opposed, but it is their interaction that makes everything else possible (figure 2).

10. **Erase the original diagonal lines, X marks, and small circle.** These preparatory marks may be confusing later. Only the vertical *brahmā* line and the horizon line are left intact.

11. **Draw a large circle.** The next circle you draw will determine the overall size of this yantra. This circle represents the universe and the quality of fullness. There is some freedom to choose the size, but leave a healthy margin, at least two fingers wide, between the circle and the outside edge of the drawing surface to allow for measurements and

corrections. If you are using an 8.5-by-11-inch sheet of paper, a circle with a radius of approximately 3.5 inches (9 cm) from the center is convenient. This circle will be erased later, so be certain the lines are faint.

Place the needle of the compass again at the center, then gently draw a large circle. Keep this compass setting, as you will use it later.

12. **Draw a square.** You will now draw a large square inside the circle. The square represents the earth element *(prithvī),* symbolically grounding the energy of this yantra in our physical reality. Begin silently chanting the earth-element mantra, *Laṁ,* continuously.

First, you will use the compass to measure for true forty-five-degree diagonal guidelines. Using the same compass setting as the one you used for step 11, move

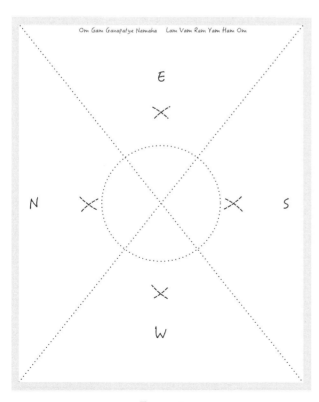

Figure 1

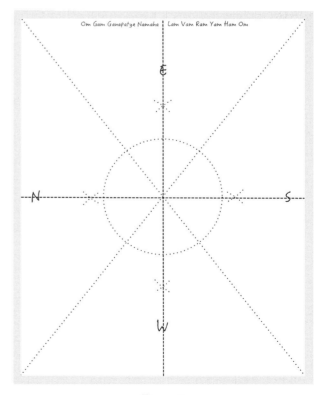

Figure 2

the needle toward the top (E), where the vertical *brahmā* line intersects the circle. To the right, gently make a small mark with the compass, approximately halfway between the vertical *brahmā* line and horizon line, in the NE area outside of the circle. Repeat on the left side of the *brahmā* line (SE). Move the needle of the compass to each of the other three locations (S, W, and N), and continue making the small marks where the vertical and horizontal lines cross the circle. There will be four small X-shaped marks in the corners when you are done (figure 3).

Next, draw in the forty-five-degree diagonal guidelines. Use the ruler to connect two of the X marks, making sure your line passes exactly through the center point. Connect the other two. Diagonal lines are said to have the quality of wind, which is always in motion.

Now you can draw the square inside the circle by connecting the points where the diagonal lines cross the circle. (See figure 4.)

The earth element is associated with stability, weight, cohesion, and the sense of smell. This is an excellent time to pause and become aware of your physical body, especially from the knees down to the feet. Be aware of the weight of your body on the ground, of your alignment with gravity.

13. **Erase the diagonal lines.** Erase the diagonals, the X marks used to create them, and any other unnecessary lines. Only the square shape, the vertical and horizontal lines, and the large circle remain.

14. **Draw the main circle.** This circle will help form the shape of a crescent, like a new moon. The crescent represents the

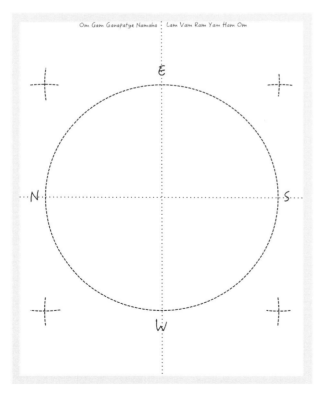

Figure 3

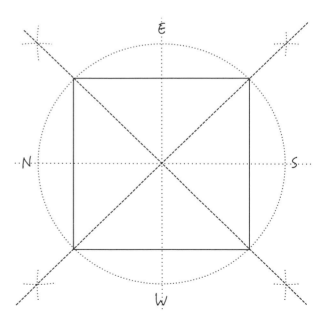

Figure 4

water element *(apas),* creativity, taste, nourishment, and flow. Begin silently chanting the water-element mantra, *Vaṁ,* continuously.

The main circle is drawn inside the square. Place the compass needle in the center point and the lead on the top line of the square, where it intersects the *brahmā* line. Moving the compass lead clockwise, draw the circle; be certain that the outside edge of the main circle touches inner sides of the main square. (See figure 5.) Save this setting on your compass, as you will use it in the next two steps.

The water element is associated with the pelvis and, consequently, the reproductive organs. Pause for a moment and consider your revered ancestors who passed down spiritual teachings across the vast sea of time. Invoke a sense of awe and wonder, of being nourished by this knowledge.

Cultivate a sense of gratitude, which is an enlightened virtue. Gratitude is not simply an experience that happens *to* us; it is also a disposition we *choose.*

15. **Draw inner arc of the crescent.** Place the needle of the compass on the *brahmā* line, a short distance above the center point. How far the needle is moved up from the center point will determine the thickness of the crescent moon shape. A distance of approximately one quarter the radius of the main circle is suggested. If you are making your yantra on an 8.5-by-11-inch page, this distance is about a half inch (1.5 cm). Using the same compass setting you used to make the main circle, swing the lead of the compass from side to side inside the lower half of the main circle, creating the inner arc of a crescent shape. (See figure 6.) Save this compass setting, as you will use it in the next step.

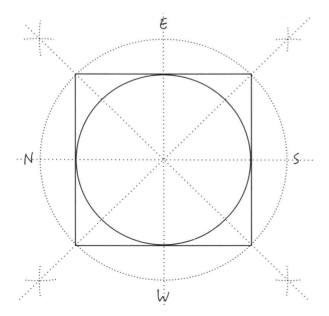

Figure 5

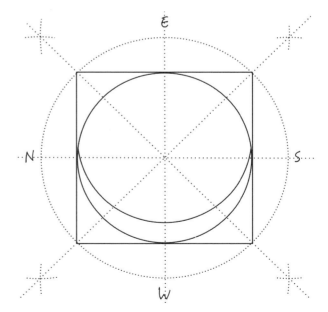

Figure 6

16. **Draw the upward-pointing triangle.** Triangles are associated with the fire element *(agni)* and the process of transformation. Upward-pointing triangles are used in ritual to transform our experience of duality to unity. Begin silently chanting the fire-element mantra, *Raṁ,* continuously. The three tips of this triangle will touch the inside of the main circle and overlap part of the crescent moon shape.

Mark where the base of the triangle will touch the main circle. Place the needle of the compass at the lower point where the *brahmā* line crosses the main circle, which is also the bottom arc of the crescent. Using the same compass setting as was used to make the main circle, swing the compass to make two faint marks on either side, crossing the circle (figure 7). These two marks will be used to make the horizontal line that forms the base of the triangle.

Use a straight edge to draw a horizontal line between the places where the two marks and the circle intersect. Then draw two diagonal lines connecting the lower two corners of the triangle to the upper tip, where the *brahmā* line intersects the main circle.

The fire element is associated with brightness, sight, sharpness, perception, digestion, radiation, and verticality. It is also associated with the region between the heart and the navel. More esoterically, this upward-pointing triangle represents the power of dissolution, of moving from diversity (wide base of the triangle) upward to unity (tip of the triangle). It is said that we need to cultivate our inner fire to "digest" memories and experiences, transforming them from obsessions and attachments to liberated wisdom. If our physical digestion is upset, it is unlikely we will be able to process challenging experiences, either.

17. **Draw the hexagon.** We are now ready to draw in the hexagon, which symbolizes to the wind element *(vāyu)*. So begin silently chanting the wind element mantra, *Yaṁ,* continuously. This shape is more complex than the others and will require several substeps of its own. We will draw a circle, and then create a six-pointed star from two overlapping triangles (pointing to either side). The hexagon shape we will keep is naturally formed inside this six-pointed star. Please draw lightly, so the unneeded preliminary shapes and lines can be erased after the hexagon is formed.

17a. *Lightly draw a small circle.* This circle will be inside of the large triangle drawn in step 16 and touch each of the three sides. Place the needle at the center point, touch the lead to the diagonal right side (SE) of the triangle, and draw clockwise (figure 8). This compass setting will be used in the next step, so be careful not to change it. If the circle does not touch all three sides of the triangle, do not move the circle. It isn't the circle that's off; it's the triangle. Go back and adjust the triangle until it is symmetrical, then

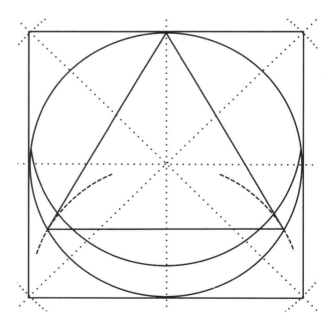

Figure 7

120

redraw the circle within it. Making sure the triangle is symmetrical and the circle touches all three sides ensures that your yantra has been accurately drawn.

17b. *Make two triangles.* Now we are going to make two triangles—one pointing left and one pointing right—inside the small circle. This will form a six-pointed star. Place the needle of the compass on the right side of the small circle, where it intersects the main horizontal line. Swing the lead of the compass to make two short marks on the circle, above and below. (See figure 9.) Repeat on the left side of the small circle, so that there are four short marks.

17c. *Draw the six-pointed star.* Draw a vertical line connecting the upper and lower mark on the right side (S) of the circle. Repeat on the left side (N). You will now have two parallel

vertical lines inside the small circle, one on either side. Now draw a diagonal line downward from the top end of the vertical line on the left side (NE) to the location where the horizon line crosses the small circle on the right (S). (See figure 10.) Now connect the bottom end of the line on the left (NW) diagonally upward to the point of the triangle on the right (S). Repeat on the opposite side to form two overlapping triangles, one pointing left, one pointing right (figure 10).

17d. *Erase around the hexagon.* The six-sided shape created within the two interlocked triangles is the hexagon. Simply erase the unneeded triangular points of the star and the small circle around the hexagon. Allow all other lines to remain in case the figure needs to be adjusted or redrawn. (See figure 11.)

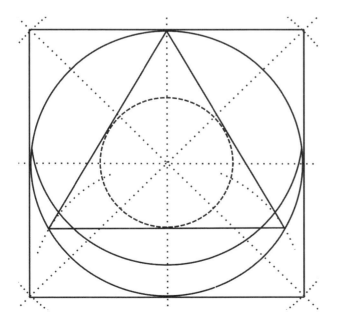

Figure 8

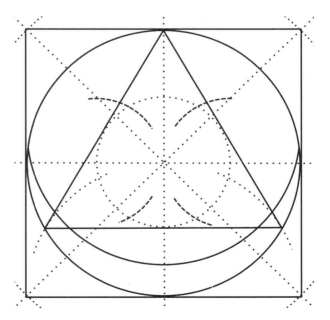

Figure 9

The wind element represents kinetic energy and is associated with the subtle breath *(prāna)* as well as with motion, gaseousness, contraction, expansion, and the sense of touch. This element is associated with the region of the body from the heart to the eyebrows. The hexagon relates to the mind, so it is fitting that any lapses in awareness made earlier in the drawing process become apparent here as a distorted, uneven, or asymmetrically shaped hexagon. If it is distorted, go back and determine where the error occurred. Rectify the issue and methodically work your way forward to this step. If you've made a "big mistake," please skip ahead to step 22 before adjusting the drawing.

Once the hexagon is complete and symmetrical, pause for a moment and meditate on the breath. A simple meditation technique is to count while inhaling and

exhaling. Slowly breathe in for a count of six, and then breathe out for a count of six. Do this six times in honor of the wind element.

18. **Draw a small circle inside the hexagon.** You are now ready to draw a small circle within the hexagon to represent the space element *(ākāsha)*. This circle should be visualized as a three-dimensional sphere, not just a two-dimensional circle. Begin silently chanting the mantra *Haṁ* continuously.

This circle may be of any size, so long as it is smaller than the hexagon. I suggest making it about half the size of the hexagon. If you would like a more precise measure, draw a horizontal line inside the hexagon from the NE corner across to the SE corner, skipping the top corner (E). Place the needle of the compass at the center point and touch the lead to where this new horizontal line crosses the

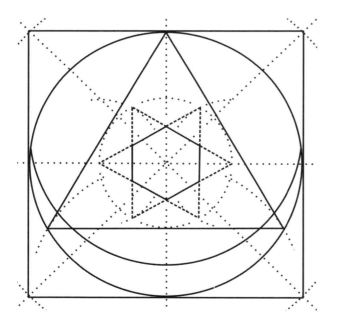

Figure 10

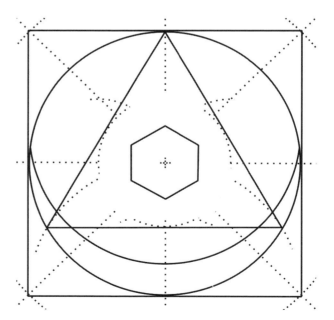

Figure 11

brahmā line. Draw a small circle in the clockwise direction. (See figure 12.)

The space element, or ether, is the most subtle of the five great elements; it is all-pervading and motionless. This element is associated with the sense of hearing and the area of the head from the eyebrows upward. This element is associated with that part of our spirit that simply *is*. Pause for a moment and do nothing. Simply witness yourself in this place and time. Be aware of the shape of your body in space, the weight of your body on your seat, the spontaneous movement of your breath, the beating of your heart.

19. **Compare your drawing to the diagram of the finished yantra.** Refer back to image of the Five Elements Yantra at

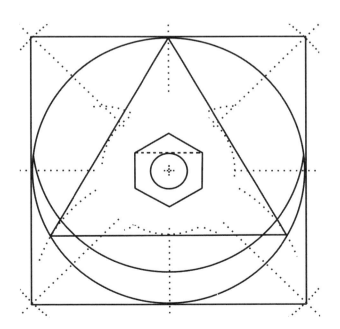

Figure 12

the beginning of the chapter. Make any final adjustments so that your drawing matches the yantra as accurately as possible. Darken in any lines as needed and thoroughly erase all unnecessary lines.

20. **Draw the bindu.** Begin silently chanting the mantra of ultimate unity, *Oṁ.* The ultimate is represented with the most fundamental mark an artist can make: a dot. To the practitioner, it is not a physical object. It represents the instant of manifestation, the first pulse of desire, and the final union of opposites. This is the last and most important step in the drawing of a yantra. This action is equivalent to "opening the eyes" of the deity in a figurative image. Pause and recollect your motive for this undertaking. There is no need to use the compass for this step. Simply draw a small circle at the center point.

21. **Add colors.** Work systematically from the outer edge toward the center, one color at a time. Work clockwise all the way around until each area of color is filled. Then move inward to the next color. As you work, feel the effect of each color; let it saturate your awareness. Recollect the attributes of each element.

The suggested colors for a five elements yantra are as follows:

- **Outer square (earth):** a rich golden yellow. Mantra: *Laṁ.*
- **Inside the crescent shape (water):** pure white. Be careful not to paint over the tips of the triangle. Mantra: *Vaṁ.*
- **Inside the rest of the large circle:** silver or a misty white-blue. Mantra: *Vaṁ.*
- **Triangle (fire):** scarlet red. Mantra: *Raṁ.*
- **Hexagon (wind):** gray-green or "smoky." Add a tiny amount of white and even less red to basic green for this color. Mantra: *Yaṁ.*
- **Small circle (space):** This element is completely invisible, so it is variously visualized as dark, crystal, or as

a scintillating mass of colored lights. Plain black is suggested. Mantra: *Haṁ*.

- **Center dot:** iridescent gold or pure white. Mantra: *Oṁ*.

22. **Self-reflection.** Pause and reflect on the process of making this yantra. Were any of the shapes particularly difficult to draw or paint? The moment when an "error" is made is a chance to reflect on the impulse, thought, or memory that caused the lapse of awareness. We must follow the sequence of thoughts or actions back to their origin and discover the root cause. It may be a personal issue that needs to be addressed or a karmic attachment needing to be rectified.

 When we create a ritual space in which to work, all actions have increased significance. Though any error could simply be a coincidence, it remains an opportunity to witness our reactive impulses as we cope with difficulty, disappointment, and change. An artist who simply copies this yantra perfectly without using the process to self-reflect has missed the entire purpose of this meditation, which is to come into greater awareness of our karmic relationship with the elements. In this sense, errors are to be treasured as glimpses of our own true nature and opportunities for personal growth.

 In the case of this yantra, we may also consider the element that was being invoked when the error occurred. Look for any correlation between the element and your own life. Even if there is nothing to "fix," this is an opportunity to contemplate deeply. For example, if you made a mistake while drawing or coloring the crescent moon, review the qualities of the water element and consider if there is any correlation between the water element's

associations and aspects of your daily life. Here are the elemental associations again:

- **Earth/square/yellow:** stability, mass, solidity, substance, sense of smell, the root chakra and/or lower legs.
- **Water/crescent/silver and white:** emotions, nourishment (too much or too little), sense of taste, elimination, birth, the quality of flow, and pelvic region in the body.
- **Fire/triangle/red:** transformation, digestion, heat, charisma, light, sense of sight, the region of the body from belly to heart.
- **Wind/hexagon/green:** motion, chaos, change, instability, mind, sense of touch, the region of the body from heart to eyebrows.
- **Space/sphere/black:** awareness, consciousness, witnessing, "enough room," sense of hearing, and the area of the head from eyebrows upward.

23. **Completion.** Seal the practice with a final mantra, such as *Oṁ Śhāntiḥ, Śhāntiḥ, Śhāntiḥ (pronounced Ohm Shahntee Shahntee Shahntee-hee)*. Then relax and enjoy the finished artwork. Release any evaluation or critique or story about the process. This moment of easeful contemplation is a traditional aspect of bringing the practice to close; experience the satiation of desire *(kāma)* and release all attachment *(moksha)*. Abide.

That is Full, this is Full, from Fullness comes Fullness; taking Fullness from Fullness, only Fullness remains.

—Brhadāranyaka Upanishad

Epilogue: Lakshmī's Gift

In the most widely recognized grouping of the ten Wisdom Goddesses, Kālī is first and Lakshmī is last. They are arranged in the traditional order as the final ten goddesses of part 3. It may seem strange to start with a wrathful goddess and end with a benevolent one. Why not give beginners an easy start? But when we understand that this sequence is a model of the spiritual journey, it makes much more sense. Kālī, among other things, is most excellent at severing attachments (hence the head-chopper sword). We need to let go of old social roles (hence the nudity), impulsive grasping desires (hence the severed arms), and even our own idea of who we think we are (the severed head) before we can begin to know our true nature. Rather than seeing a goddess as easy or scary, pretty or ugly, we learn that each is a model for the virtues, skills, and attitudes we need to cultivate in order to continue in our journey.

If we are able to embrace the wild and wrathful Kālī, our reward is fearlessness. Then we are able to meet the others boldly. As we encounter and practice with each of the goddesses, karmas and attachments are brought forward for us to recognize and transform into fuel for our journey. The transformation isn't always easy, pleasant, or swift. Nor is it linear. Each goddess is complete unto herself, and it is not necessary to practice with them all. One is enough. Yet practicing with each of them in this sequence is instructive. Only at the climax of our journey to self-discovery are we mature enough to engage the hypnotic power of physical pleasure without being ensnared all over again in the drama of life. It is when we are done with possessing objects for personal gratification that our delight at all things, just as they are, may overflow to benefit all beings. This is why Lakshmī is last.

A wise teacher once told me that he found it ironic so many people worshiped Lakshmī for material gain. If they are successful with their rituals, he explained, she may strip them of all possessions. *Then* they will value what they had in the first place, because life itself is the greatest gift. When we are stripped of comforts, we have no choice but to see the world with fresh eyes. Kālī, not Lakshmī, is popularly associated with hardship and austerity, but this is a misunderstanding. *All* the wisdom goddesses bring us to this state of complete nonattachment, each in her own way. When we are completely stripped, then we are most able to recognize our inner riches, the joy of conscious embodiment and the inherent beauty of the universe itself. Even the experience of loss is an opportunity to reflect on our ability to *feel*. This is the ultimate gift of any Wisdom Goddess: that which can't be taken away—just being. When we experience the full realization of our fundamental connection with all beings and our participation in the rhythm of nature, there is no more sense of "mine" or "not mine." It is a state of fullness with no opposite.

When we practice with these devīs for realization, we will express their virtues, which are ultimately our own virtues. With this understanding, we can see the image of Lakshmī in an entirely new way: her nature is *giving*, not grasping. To most people, those gold coins spilling from her hand symbolize material wealth to be gained through worship. They think of her dualistically, as someone outside of their own nature who has something they do not. The goddess's mystic practice is not about acquiring possessions, but about recognizing divinity in our own being. To embody Lakshmī's virtues, we do what she does. The most profound experience of abundance is a state of generosity, so it is up to each of

us to practice generosity. Lakshmī is not gazing longingly at some object to be possessed; she gazes lovingly at all beings. Her beauty and wealth are the experience of inner effulgence, which is more alluring than any object. It is said that there are four aims in life: *dharma, artha, kāma,* and *moksha.* Each must be experienced for life to be completely fulfilled, though none must be fulfilled at the expense of the others. Though described as stages in life, our experience of them is likely to be more cyclic than linear in nature.

Dharma is our duty, learning why we are here and what it is we are to do, the process of cultivating virtues. *Artha* is activity, gathering resources we need to do our *dharma,* and doing it. This is our life's work, which may necessitate the accumulation of material wealth. *Kāma* is desire, pleasure, or fulfillment. It is the fruits of our labor and may include love and sexual pleasure.

Pausing to enjoy ourselves is an important step in our journey if we are to be completely fulfilled and ready to release all attachments. A sense of satiation arises when we have ripened into full maturity. Lakshmī exemplifies this *kāma* stage. She is the last of the Wisdom Goddesses, but not the last step in our life's journey. *Moksha* is liberation or release. It is said to happen spontaneously, after all attachments are released. *Moksha* is up to you, dear reader. Fashion your life into a mandala of enlightened virtues and allow yourself to ripen; these goddesses show the way. Your own body is a yantra of realization. Release when it is time.

Jaya Mā!

GLOSSARY OF SANSKRIT TERMS

Entire books have been written on some of these terms and the wisdom traditions they represent. For the sake of brevity, only the Sanskrit terms used in this book that do not appear in English dictionaries are included, and definitions are short, addressing only how the word is used in this book. Curious readers are encouraged to dig deeper by consulting the "Resources and References" section.

abhaya: "peace, safety, security." A symbolic hand gesture *(mudrā)* of assurance, with the fingers pointing upward. As an attribute, it represents fearlessness.

agni: "fire." The fire element; the energetic quality of transformation, illumination, and heat, associated with upward movement, digestion, intelligence, charisma, mutability, the sense of sight, and the abdominal region of the body. Name of the god of fire.

ahaṃkāra: "I-maker." The mental faculty of personal ego or individuation.

ākāsha: "space" or "spiritual sky." The space element. An ethereal fluid filled with consciousness and power that pervades the manifest universe as well as the other Great Elements. It is associated with consciousness, expansiveness, the vibratory quality of sound, the sense of hearing, and the area of the body from the eyebrows to the top of the head. See also *mahābhūtas.*

alankara: "ornamentation." Invoking the power to attract (and thus protect) through physical and ritual beautification.

alidh āsana (a.k.a. *pratyalidham*): "drive back." A wrathful standing posture with the right leg straight and the left knee deeply bent.

alpana (a.k.a. *alpona, aipana*): "whitening" or "painting." A name used in the Bengal and Bihar regions of India for a type of folk art made on a horizontal surface. See also *rangoli.*

ap or *apas:* "water, watery." The water element; the energetic quality of fluidity, connection, and nourishment, associated with emotions, bodily fluids, the sense of taste, and the pelvic region of the body. See also *mahābhūtas.*

artha: "wealth, objective, prosperity." The activity of accumulation; the dharmic pursuit of wealth for basic material needs, quality of life, and the ability to be generous. One of the four aims of human life. See also *dharma, kāma, moksha.*

āsana: "seat." A physical posture or stance, usually with symbolic or ritual significance. Many are prescribed in yogic systems for improving physical and spiritual health.

asura: "anti-god." Titans; opponents of *devīs.* Not to be confused with lesser demons or malevolent spirits; they are also known as the "jealous gods" who exemplify vices.

Bhakti: "attachment, devotion, to partake in." Religious fervor felt as love for a specific deity. A devotional spiritual practice based on faith and a longing for personal union with the divine.

bhāva: "to become." A state of mind, sentiment, mood, condition, or emotion. Intrinsic states of being from which *rasas* arise.

bhukti: "enjoyment." Worldly success.

bhūpura: "earth wall." The large square area that encompasses most deity yantras, usually penetrated by four gates. It represents the earth element and symbolizes a deity's ability to manifest her or his power in physical form.

bīja: "seed." A sound form that carries an energy pattern. The potency of a mantra.

bindu: "seed." The center of a yantra and/or the center of the universe.

buddhi: "intellect, reason, discernment." The faculty of judgment. The intellectual or discriminating mind.

chakra: "circle" or "wheel." A circular object or group. Also used as a term for the many energetic nodes of the human subtle body, which are variously described as resembling lotuses or spinning wheels of colored light.

chitta: "mind, consciousness, thought." The faculty of mind. Mental activity, or that aspect of mind where mental impressions are stored.

devī: "shining," "playful," or "illuminated." A deity, celestial being, or pattern of consciousness who exemplifies virtues. Masculine: *deva.*

dharma: "duty, virtue, morality, observance." All that upholds the cosmic order. Spiritual duty or responsibility. Divine law. A righteous mode of conduct. Playing out one's destiny in an ethical manner, both in relation with others and according to one's own nature. One of the four aims of human life. See also *artha, kama, moksha.*

Dikpāla (a.k.a. *lokapāla*): "direction guard." Specific guardian deities invoked during rituals to protect a sacred space. There are four cardinal directions (north, south, east, west) and the diagonals (northeast, southeast, northwest, southwest). Depending on the tradition, another deity will be invoked for the center or two for the zenith and nadir.

Diwali: "rows of lights." A harvest festival known as the Festival of Lights celebrating the victory of knowledge (light) over ignorance (shadow), often associated with the legend of Sītā and Rama's return home.

gopi: "milkmaid" or "female guardian." The dancing consorts of Krishna.

guna: "string," "thread," or "quality." A state or principle or tendency of universal nature *(prakriti).* The three *guṇas* of *sattvas,* *rajas,* and *tamas* are present in various proportions in every aspect of reality.

icchā: "will, desire." One of three primordial powers of the Great Goddess. See also *kriyā, jnāna.*

Idā Nādī: "refreshing artery." One of three main channels of the subtle body, originating and exiting on the left side and depicted as white (or pink) in color. It is associated with the moon, coolness, passivity, what is known, and inhalation.

Jaya Mā: "Victory to the Mother." A rousing cheer celebrating a Goddess's power to conquer ignorance.

jnāna: "knowledge." One of three primordial powers of the Great Goddess. Super-consciousness, rather than book-knowledge or data. See also *icchā, kriyā.*

jnānendriya: "knowledge-organ." The five organs of knowledge (or perception), which include: eyes (sight), ears (hearing), nose (smell), tongue (taste), and skin (touch).

Jyotisha: "science of light." The Vedic astrology of India, based upon visible lights in the sky.

kāla: "time (destiny, fate, death)," "black (or dark)," "art (skill)," or "segment." A complex word that changes meaning depending on the context in which it is used. In regards to its use in (or as) the name of a deity, "time" and "black" are functionally inseparable.

kāma: "desire, wish, pleasure." Personal and social fulfillment. One of the four aims of human life. See also *artha, dharma, moksha.*

karmendriya: "action-organ." The five organs of action that create karma, which include bowels (elimination), genitals (procreation), feet (locomotion), hands (apprehension), and mouth (speech).

Kīrtimukha: "Glorious Face." A monster (or gargoyle) with bulging eyes, fangs, and gaping mouth. It appears as a decorative motif above doorways and the depictions of deities throughout Asia, signifying that that entering into the presence of the deity is spiritual reabsorption, which is akin to being eaten.

kolam: A name used in South India for geometric patterns made on the ground using rice flour or powdered pigments. They are usually symmetrical line drawings composed over a hexagonal grid of dots located outdoors at the threshold (or courtyard) of a home to invoke prosperity. See also *rangoli.*

kriyā: "action." One of three primordial powers of the Great Goddess. See also *icchā, jnāna.*

kula: "family." An extended family or group of spiritual practitioners guided by a guru or a tight-knit community held together by common beliefs and practices. There are no divisions based on caste, class, or gender within a *kula.* See also *sangha.*

kunda: "jasminum multiflorum." A type of jasmine vine with brilliant white flowers used to make garlands.

kundalinī-shakti: "coiled power." An aspect of the subtle body that rests at the base of the spine in a coiled form when dormant. Many yogic practices are designed to "awaken" this latent power and direct it up *Sushumnā Nādī* toward the crown, though it also moves spontaneously. A form of the Great Goddess.

lingam: "sign, mark." A symbol of ultimate consciousness beyond qualities (Shiva). It may be egg-shaped or phallic, usually made of stone and resting in a circular base, known as a *pitha* or *yoni.* It represents Shiva's generative power and is analogous to the cosmic pillar of fire from which Shiva emerges in myth.

mahā: a prefix meaning "great."

mahābhūtas: "great elements." The five densest elements that comprise manifest reality: space *(ākāsha),* air *(vāyu),* fire *(agni),* water *(ap* or *apas),* and earth *(prithvī).*

mālā: "garland." A string of prayer beads (rosary) or garland of fresh flowers.

manas: "perception, thought, mind." The faculty of attention. That aspect of mind associated with volition and the organs of perception *(jnānendriya)* and action *(karmendriya).* Sometimes used as "mind" in general terms. See also *chitta, ahaṁkāra, buddhi.*

mandala: "circle." A cosmic diagram. Seat of a deity. Sacred space.

mantra: "mind device." A power word. The energy pattern of a deity in linguistic or sound form. A phrase continuously repeated.

Mātrikās: "the Mothers." A significant group of seven or eight fierce and protective goddesses. The number and members of this group vary depending on regional and lineage interpretations. They likely originated as tribal goddesses who were invoked as village guardians and later appropriated into mainstream Hindu culture. The most common combination includes Brahmānī, Māheshvarī, Kaumarī, Vaishnavī, Vārāhī, Narasimhī, and Aindrī.

moksha: "liberation." Release from all attachments, the wheel of karma, and rebirth.

mudrā: "seal." A gesture (usually made with the hands) adopted to express a specific power or to direct the body's flow of energy.

mukti: "salvation." See also *moksha.*

murti: "embodiment, form." The body or physical representation of a deity.

nādī: "artery." Channels or conduits of energy in the subtle body. Of the many nādīs, three are most important: *Idā, Pingalā,* and *Sushumnā.*

nyasa: "applying." Placement of mantras to ritually divinize the body. Consecration.

Oṁ: "the Absolute, amen, so-be-it, yes." The primordial sound of all manifestation.

paubhā: "painted scroll." Intricate Nepalese religious artworks painted on a cloth scroll depicting deities, mandalas, and yantras of either Buddhist or Hindu origin.

Pingalā Nādī: "reddish artery." One of three main channels of the subtle body, originating and exiting on the right side, and depicted as red in color. It is associated with the sun, warmth, activity, knowing, and exhalation.

pītha: "seat." The location of a deity. See also *shākti pītha.*

prakriti: "nature, original substance." The primal motive force that is the basis of all action in the universe. The source of all matter and energy. The feminine half of divinity. See also *purusha.*

prāna: "breath." Life force, vital air, subtle breath of the body that flows through the *nādīs.*

prithvī: "earth." The earth element; the energetic quality of stability, continuity, and mass associated with sense of smell, the base of the spine, and the lower legs. A name of the Earth Goddess.

purusha: "spirit." Both the individual soul (without gender) and the quiescent Supreme Soul. Pure consciousness that permeates all manifestation. The masculine half of divinity. See also *prakriti.*

rajas: "activity, passion." The tendency of Nature to express motion, energy, transformation, and growth. The aspect of creation that upholds the activity of nature *(prakriti).* One of the three *gunas.*

rangoli: A type of ephemeral ornamental folk art, usually composed of intricate line drawings. Traditional rangoli are symmetrical geometric patterns made on the ground using rice flour, grains, beans, fresh flowers, and candles, but today chalk and colorful powdered pigments are common. There are many regional variations with characteristic motifs, colors, and patterns. They are created for holidays and rituals, but may also be a daily household chore. Similar to mandalas, they create a sense of sacred space and are believed to have blessing power.

rasa: "juice" or "taste." Essential emotional state, sentiment, or flavor of experience. A pure sensation before it is cognized.

rās-līlā: "sweet act" or "divine dance." An ecstatic nocturnal circular dance revolving around the deity Krishna. A metaphor for the dance of life.

rāsika: A person with "discriminating taste." An aesthete.

sadhana: "realization, means (of attainment)." Regular spiritual practice or discipline.

samskaras: "impression, memory, preparation." Imprints on the subtle body (or subconscious) from past actions and experiences that influence future behavior, color perception, and affect disposition.

sangha: "joining, association, community." Ordained monks, but the term is also used by some sects to include disciplined lay practitioners. See also *kula.*

sat-kona: "hexagram." A six-pointed star formed by two superimposed triangles.

sattva: "purity, equilibrium, essence, existence." That aspect of Nature that is pure, harmonious, rarified, orderly, peaceful, and lucid. It is depicted as white in color. One of the three *gunas.*

Shakti: "to be able" or "power." Primordial energy of the universe, creativity, fertility. Personified as the feminine dynamic, yet present in all things and beings. A name or epithet for the Great Goddess that can also be used for any female.

shākti pītha: "power-seat." One of fifty-one important goddess sites of India, where the pieces of the ancient goddess Satī fell to earth. Many are major pilgrimage destinations and the location of venerable temples.

Shiva: "kindly one" or "auspicious one." A name for God in his role as destroyer. Along with Brahmā (creation) and Vishnu (preservation), he is one of the three core deities of the Hindu tradition. The supreme god of Shaivites. The male dynamic *(purusha).* Consciousness.

soma: "divine nectar." A ritual drink enjoyed by both deities and humans, believed to produce immortality.

spanda: "vibration." The pulse of creation and destruction, the dance of Shiva.

Sushumnā Nādī: "gracious artery." Central of three main channels of the subtle body, located within the spine, depicted as golden or cobalt blue in color. Neither hot nor cold in nature, it is described as "the cool fire." The seven major *chakras* are apertures or expressions of *Sushumnā.* Many preliminary yogic practices are designed to clear blockages in this channel, allowing the primal energy of a yogi to rise

from pelvic floor to crown. It is associated with the knower and the upward-and-outward movement of subtle energy. See also *nādī, chakra, kundalinī-shakti.*

tamas: "darkness." Lethargy, ignorance, entropy, inertia, decay. Nature of transformation. One of the three *gunas.* Density, contraction, resistance, dissolution.

Tantra: "expansion-device" or "spreading wisdom-that-saves." A sacred text. A divinely revealed body of knowledge with practices for both spiritual liberation and worldly success.

tapas: "heat." Intense yogic disciplines, severe austerities, penance, purificatory practices. A spontaneous and intense desire for self-realization. The fire of self-transformation.

tattva: "true principle, essence, elementary property." The elements, states of realization, or aspects of reality described in yogic philosophy. There are various lists of different numbers of Tattvas, depending on the lineage, up to 36. They include the five great elements, or *mahābhūtas.*

Tattva Shuddhi: "element purification." The Five Elements Meditation, a yogic practice of purifying and harmonizing the elements within the body.

thangka: "painted scroll." Intricate Tibetan Buddhist artworks painted on cloth scrolls.

tri-guna: "triple thread." Three primordial principles of manifest reality: *sattvas, rajas,* and *tamas.* See also *guna.*

trishul: "trident." A weapon with a long handle and three sharp prongs. When held as an attribute of a deity, it represents will, knowledge, and action.

upāya: "expedient means." Spiritual remedy.

vāhana: "vehicle, carriage." The animal mount or conveyance of a deity. A pictorial device used in ancient art to help identify a deity.

varada: "conferring a boon." A symbolic hand gesture *(mudrā)* with the fingers pointing downward, representing generosity.

vāyu: "wind, blower." The wind element; the energetic quality of motion, thought, the sense of touch, the region of the body from the heart to the eyebrows, and life itself. Name of the god of the winds.

Vishnu: "all pervading one." A name for God in his role as preserver. Along with Brahmā (creation) and Shiva (destruction), he is one of the three core deities of the Hindu tradition. The supreme god of Vaishnavas. He is the unknowable divine that "enters into" and pervades everything.

yantra: "control-device" or "liberation instrument." A mystical symbol or ritual device.

yoga: "union, to yoke." A spiritual practice of yoking the individual to the Absolute. This practice can also be described as uniting Shiva and Shakti, or merging the immanent and the transcendent, the sun and moon, or the inward and outward breaths. One of six systems of orthodox Hindu philosophy. Modern postural yoga is a derivation of hatha ("sun-moon") yoga.

yogin: A gender-neutral version of *yogi.* A yoga practitioner.

yoginī: "sorceress." A class of wild semidivine women, often depicted with animal heads. Female attendants of the *Mātrikās.* A term of respect for an accomplished female yogic practitioner who is enlightened and/or possesses magical powers. A female initiate of Tantra.

yoni: "source, origin, vagina, womb." Symbol of Shakti, the dynamic creative power of nature and origin of reality. The most common depiction is a simple downward-pointing triangle. One common form of the yoni is a stone pedestal or elevated platter with a vertical hole in the center and an aperture or spout on one side. They are frequently triangular in shape when seen from above, but may also be square or circular. Usually, sculptural *yonis* are paired with a *linga* inserted in the center hole to represent the union of Shiva and Shakti.

yoni-kunda: "womb pit." A ceremonial fire pit used for ritual offerings.

Resources and References

Accurate, full-color examples of yantras in this book, as well as artworks for sale by the author, are available on his website, One Earth Sacred Arts (oneearthsacredarts.com).

Books with more detailed information on the goddesses:

Laura Amazzone, *Goddess Durga and Sacred Female Power* (Hamilton Books, 2010).

Thomas Coburn, *Encountering the Goddess* (State University of New York Press, 1991).

Sally Kempton, *Awakening Shakti* (Sounds True, 2013).

David Kinsley, *Hindu Goddesses* (University of California Press, 1988).

David Kinsley, *Tantric Visions of the Divine Feminine in the Mahāvidyās* (University of California Press, 1997).

S. Shankaranarayanan, *The Ten Great Cosmic Powers* (Samata Books, 2013).

Books with more detailed information about iconography:

Robert Beer, *The Encyclopedia of Tibetian Symbols and Motifs* (Shambhala, 1999).

Eva Rudy Jansen, *The Book of Hindu Imagery* (Binkey Kok, 2007).

V. Ganapati Sthapati, *Indian Sculpture and Iconography: Forms and Measurements* (Mapin Publishing, 2006).

Books with more detailed information on yantras and mandalas:

Gudrun Bühnemann, *Mandalas and Yantras in the Hindu Traditions* (D.K. Printworld, 2007).

Harish Johari, *Tools for Tantra* (Destiny Books, 1988).

Madhu Khanna, *Yantra: The Tantric Symbol of Cosmic Unity* (Inner Traditions, 2003).

Denise Patry Leidy and Robert A. F. Thurman, *Mandala: The Architecture of Enlightenment* (Overlook, 2006).

Gowri Ramnarayan, *Grandma's Kolams* (Oxygen Books, 2008).

More information on yogic philosophy, history, and practice:

Georg Feuerstein, *The Yoga Tradition* (Hohm Press, 2001).

Swami Satyananda Saraswati, *A Systematic Course in the Ancient Tantric Techniques of Yoga and Kriya* (Yoga Publications Trust, 2004).

Swami Satyasangananda Saraswati, *Tattva Shuddhi: The Tantric Practice of Inner Purification* (Yoga Publications Trust, 2000).

Satguru Sivaya Subramuniyaswami, *Dancing with Siva: Hinduism's Contemporary Catechism* (Himalayan Academy Publications, 2003).

Christopher Wallis, *Tantra Illuminated* (Mattamayura Press, 2013).

Websites with information about yogic techniques and art:

Dharma Inc.: International Non-Dual Dharma Community (dharmainc.org)

The Mattamayūra Institute (mattamayura.org)

Saiva Yoga: The Website of Christopher Tompkins (shaivayoga.com)

Sanatan Society (sanatansociety.org)

Sri Vaishnava Matham (srimatham.com/our-publications)

Himalayan Art (himalayanart.org)

Satyananda Yoga, Bihar Yoga (biharyoga.net)

ACKNOWLEDGEMENTS

THANK YOU to the countless yogins, gurus, and humble artisans who devoted their lives to alleviate suffering resulting from ignorance and the illusion of separation.

Teachers: Pranams to Dharma Bodhi, Dinesh Charan Shrestha, Mavis Gewant, Pieter Weltevrede, Andy Weber, and the formless guru who works through all beings.

Family: Thank you to my parents, Deborah and Noel Ellik, and the ancestors who generously gave me this body and an opportunity to play in the game of life.

Supporters: Felicia Betancourt, Kurt Keutzer, Vidyāyoginī, Lizzy Dhal and the Williams family, Yogachettana White, and Trish Ritchie. Without their combined support, this book would not exist.

Sounds True staff: Salutations to my editor, Amy Rost; acquisitions editor Jennifer Brown; fearless leader Tami Simon; and everyone who helped bring this book into our human realm of experience.

Advisors: Sally Kempton, Hareesh Christopher Wallis, Laura Amazzone, Christopher Tompkins, Aditi Devi, D. K. (Dave Kennedy), Mahaveer Swami, Halley Goswami, Midhun Madhav, and my many acquaintances on social media websites who helped make this project more accurate, authentic, and profound.

Translators: Many of the inspirational scriptures quoted are new translations, thanks to the scholarly work of Christopher Hareesh Wallis, Christopher Tompkins, Marcia Solomon, Jessica Kung Dreyfus, and Stéphane Dreyfus.

Advance readers: Deborah Ellik, Anna Weisman, Arundhati Saraswati, Ajit Graham Bond, Mira Deewani Krishnan, Umesh Udupi Vasudeva Rao, Rohit Arya, Bette Timm, Bhudevi Kim, Karen LaDuke.

Institutional support: John Stuckey and the wonderful folks at the Asian Art Museum of San Francisco, Cristina Star Ryan and the enthusiastic students of Mattamayūra Institute, and all the dedicated practitioners at Dharma Inc. in Thailand and Oakland, California.

ABOUT THE AUTHOR

EKABHUMI CHARLES ELLIK is a poet, artist, husband, student, and instructor. He holds a BA in Fine Arts from Cal State Long Beach, with an emphasis on figurative art. After college, he took a long journey away from visual art that included time spent as a surfer, a fast food restaurant manager, a hiking boot fitter, a poetic events producer, and a stock options broker. He quit finance to produce poetry events full time in 1999, the year his team of poets won the National Poetry Slam. Both he and the poets he coached won numerous national and regional titles over the next decade. His poems have been published in several journals and anthologies, including *The Poetry of Yoga Volume 1.*

After several years of *āsana* practice, he took initiation into a hatha yoga lineage in 2005. With the encouragement of his teacher, Dharma Bodhi, he retired from producing poetry events to focus exclusively teaching yoga *āsana.* At that time, he also became a regular student of Nepalese master painter Dinesh Charan Shrestha, who teaches the Newar style of *thangka* and *pāubha* painting. Later, he journeyed to India to study in the sacred art lineage of Harish Johari under the tutelage of Pieter Weltevrede and Mavis Gewant. Eventually, sacred art became his core practice, and he was blessed to study with other teachers, including respected Vajrayana Buddhist artist Andy Weber.

Currently, Ekabhumi is a full-time artist and art programs director for the Mattamayūra Institute. His artworks may be found in yoga studios, private homes, and on altars around the world. When not writing, painting, or practicing yoga, he can be found in his garden learning directly from nature. For more information, please visit oneearthsacredarts.com.

ABOUT SOUNDS TRUE

SOUNDS TRUE is a multimedia publisher whose mission is to inspire and support personal transformation and spiritual awakening. Founded in 1985 and located in Boulder, Colorado, we work with many of the leading spiritual teachers, thinkers, healers, and visionary artists of our time. We strive with every title to preserve the essential "living wisdom" of the author or artist. It is our goal to create products that not only provide information to a reader or listener, but that also embody the quality of a wisdom transmission.

For those seeking genuine transformation, Sounds True is your trusted partner. At SoundsTrue.com you will find a wealth of free resources to support your journey, including exclusive weekly audio interviews, free downloads, interactive learning tools, and other special savings on all our titles.

To learn more, please visit SoundsTrue.com/freegifts or call us toll-free at 800-333-9185.